The September 11 Photo Project

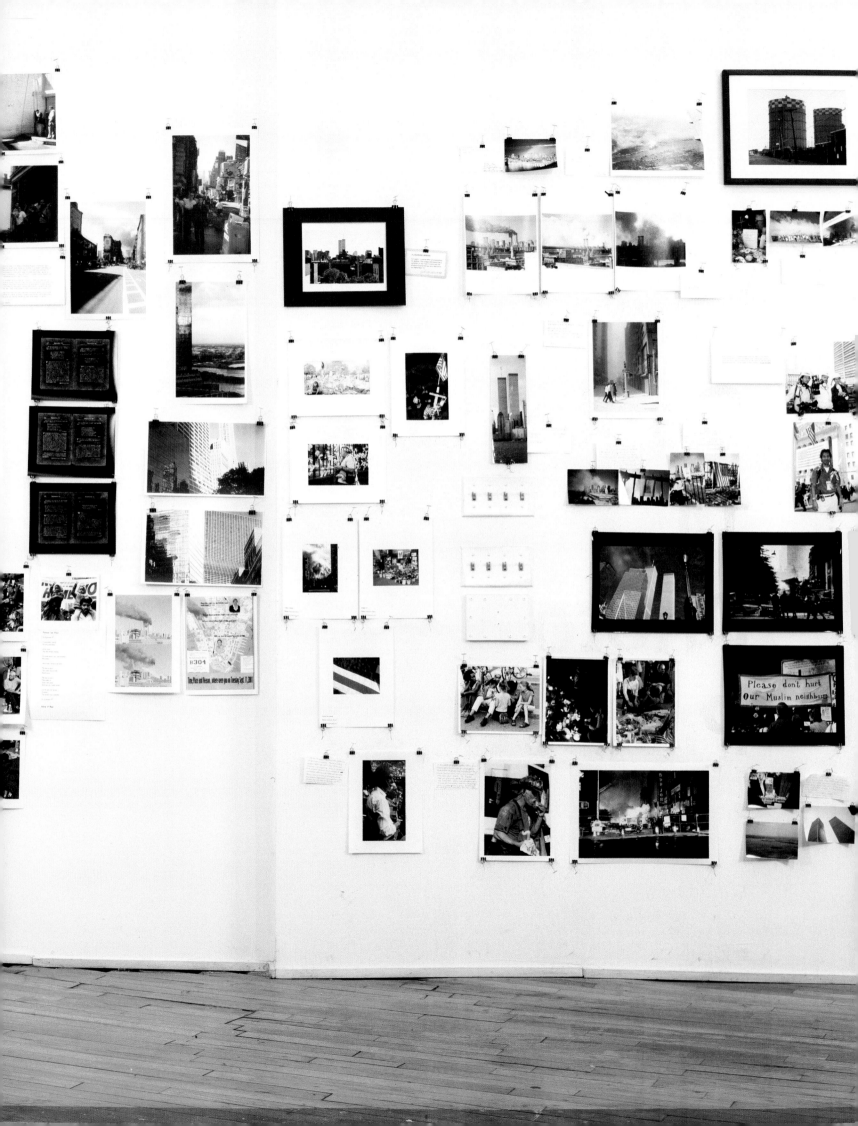

The September 11 Photo Project

Edited by Michael Feldschuh

ReganBooks
An Imprint of HarperCollins*Publishers*

HarperCollins books may be purchased for educational, business, or sales promotional
use. For information please write: Special Markets Department, HarperCollins
Publishers Inc., 10 East 53rd Street, New York, New York 10022.

FIRST EDITION

Designed by TODA

Printed on acid-free paper

Library of Congress Cataloging-in-Publication Data has been applied for.

ISBN 0-06-050866-3

02 03 04 05 06 PZ 10 9 8 7 6 5 4 3 2 1

For those who suffered
and those whose lives were changed

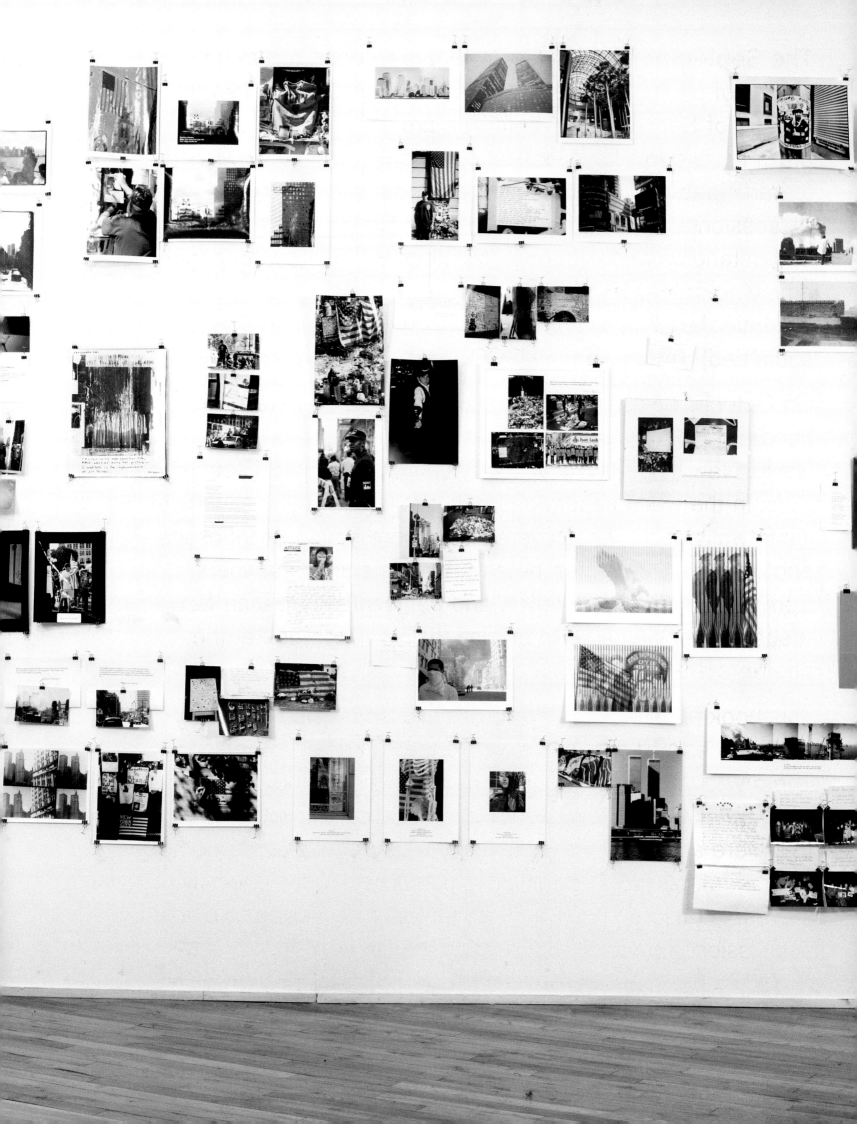

The September 11 Photo Project is an open forum for display of photographs and words in response to the terrorist attacks of September 11, 2001. The project began as a grass-roots effort to collect material from anyone who wished to participate. By allowing people to bear witness to the expression and pain of others, the project hoped to promote understanding of the tragedy on a human level and to begin a healing process. Our philosophy was simple: display, without exception, every set of photographs and words participants submitted; and welcome all who wished to see them.

On October 13, the gallery opened with approximately two hundred photos in a four-thousand-square-foot gallery in SoHo, New York City, less than twelve blocks from Ground Zero. In the weeks and months that followed, the expanses of white wall space were covered with more than four thousand photographs and written notes from community members from New York City, America, and the world. More than forty thousand people came to display their work or look at the photographs and read the thoughts of others.

This book represents the project's effort to bring the gallery experience to those unable to see the exhibition in person. The photographs are grouped, as they were in the gallery, by contributor, not thematically or chronologically. Photographs that were accompanied by text have been presented together wherever possible. The following pages reflect the diversity of the SoHo gallery's walls and the project's conviction that no submission is better or worse than any another.

The Heart Is the Truest Eye

When a human being is confronted with pure evil, sometimes the only course of action is to bear witness. From the first moments of the attacks on September 11, many people felt compelled to start recording what they saw and thought. They took photographs, made video and audio recordings, and relayed news to all they could reach by telephone and computer. A heaviness marked those moments, the mixture of pain and confusion as the mind struggled to make sense of the unfathomable. No one person can completely understand the events and implications of that day, but through a collective eye, the views of many may lead to a new understanding for all.

On September 11 I was shaken out of bed by an explosion — the second plane striking the World Trade Center. I witnessed the fall of the burning towers and the death of thousands of people just blocks from where I live. I had taken my camera with me that morning and in a crowd of people took photos while in deep shock, fearing for the lives of those trapped and the rescue workers rushing to help them. I have never felt so helpless in my life.

Thousands of people began taking photos of their communities as a way of making sense of the events around them. The grief, shock, fear, and anger was overwhelming, and crowds gathered spontaneously in public squares around the city. The squares quickly became shrines to the missing and the dead, filled with thousands of candles, photos, flowers, and signs. The atmosphere was filled with foreboding and confusion; people with cameras were everywhere. Within days, however, many of the items that composed the shrines were being destroyed by rain or removed by the city for historical preservation. The objects placed there were the different voices of a community that had witnessed an atrocity, and in the destruction or removal of the objects their purpose was undermined.

By September 20, public vigils were growing, and I had an idea. Why not create an indoor public space, safe from the elements, where anyone could put up a few photos with words of his or her own choosing that no one would sweep away, censor, or remove? I found an empty, partially demolished four-thousand-square-foot gallery in SoHo, just twelve blocks from Ground Zero, and asked the owner for permission to open the space to the public. He agreed instantly, and with the help of construction workers, who donated time and materials, three weeks later the gallery was ready. The September 11 Photo Project was born.

The public shrines had vitality and urgency — their emotional authenticity lay in the open nature of what was occurring. No one limited what was placed there; no one curated what was given; no one judged certain objects or statements better than others. The public was left to grieve and bear witness. The September 11 Photo Project embraced this ethos. To keep true to an egalitarian spirit of community and healing, the project made a crucial decision at its inception — it would be the contributors who chose what photos and words to include, not the organizers, and the project without exception would display every contributor's work. I began handing out flyers in public squares, asking everyone I saw with a camera, "Are you taking pictures in response to the tragedy?" I asked anyone who was to mail me up to three photos accompanied by any thoughts he or she wanted to share. I spoke with more than five hundred people that first weekend in Union Square, where thousands had gathered, and everyone had a story about where he or she had been on September 11.

I called on my friend James Murray, an artist and New York City firefighter, to help organize the opening of the project. We set guidelines to capture the

essence of the outdoor shrines. All contributions would be anonymous unless signed. Each contributor's works would be hung together so that the installation would read as a series of personal testaments. We rejected suggestions to group the contributions thematically or temporally. The work would be clipped to the gallery walls in a simple fashion without glass between the photos and the viewers. In contrast to the instant "preservation" efforts of city institutions, we would not treat the contributions as relics or artifacts, but rather as their creators had intended, as objects for direct display for all to see. We would not exploit these personal offerings — we would not sell copies of people's photos or words. The integrity of the project space depended on its not being seen as either an art museum or a photo gallery for shopping. We would not even accept donations in the gallery space; instead, we asked would-be donors to give directly to the New York City Firefighters Burn Center Foundation, an all-volunteer charity run by firefighters with which Jim is associated. We wanted people to come to a place of refuge and simply bear witness to the accounts of others, to begin coming to terms with the mind-numbing horror. We hoped that visitors would come away with a deeper understanding of what had occurred and a clearer sense of how to respond to the tragedy.

The gallery opened at 26 Wooster Street on October 13. We started with two hundred photos and six volunteers. Visitors — mostly curious neighbors out walking their dogs — began coming the night before the gallery opened. At a few minutes past midnight on October 13, our first official visitor came: a man from San Francisco who asked to see the exhibit that night, before his 6 a.m. flight home.

In the three months that followed, more than forty thousand people visited the gallery, and the number of photographic and textual submissions grew from two hundred to more than four thousand.

The contributors ranged in age from nine to seventy-seven, their photographic experience ranging from casual to professional. What they all had in common was the need to share their stories or thoughts. We were stunned by the broad response of the visitors — people from all parts of society came to see the project or contribute their work. Survivors, bereaved spouses, police officers, Ground Zero workers, firefighters, EMS personnel, construction workers, children, and tourists from all over the world visited the project. Many came, at first, just to look, then returned with contributions of their own to hang on the walls. We were overwhelmed by the diversity, creativity, and quality of what the contributors gave. We received color and black-and-white photographic prints, digital prints, collages of photographs, and photographs that had been manipulated digitally or physically with photo oils or paint. Some contributors shot in the style of photojournalism, consciously or not, focusing on the timing and composition of the images; some used photography as a tool of documentation (from its use on the missing person posters to pictures of the missing posters themselves, this was an attempt to capture what was); and others used photography as a means of personal or artistic expression. In a similar way, people chose many different forms of writing — from simple captions, to descriptions and stories, to poems and essays.

What began as an effort to create a community space to preserve the culture of the outdoor shrines had become a multifaceted experience. Some view the project as a healing exercise for the community, others as an important historical body of photos and stories, and still others as a community-building exercise, or even as an exercise in self-expression through art. In the future, it will likely be used to study what happened in New York and how New Yorkers responded: while the project displays submissions from around the world, its intimate temporal and

geographic connection to what happened in New York City on September 11 is undeniable.

The project can be experienced on many levels. Each individual image is its own world. Each grouping of photos with text represents one individual's viewpoint. Each wall of the exhibition becomes a collective testament from a group of individuals. From each perspective the meaning of what is there changes, and this shifting perspective is a powerful element of experiencing the project. The project also changes daily, as new pieces are constantly added. This makes for a dynamic and growing process that parallels our society's developing reaction to what has occurred. Every visitor found a particular set of images to be most powerful. With more than four thousand photos, looking at each even for a few moments would take more than a full day, but instead of being systematic in their approach, people were drawn to what spoke to them. Everyone's experience was a distinct and private one.

More than moving images or unadorned photographs, images combined with text have emerged as a powerful medium for understanding the atrocity on a human level. Moving images are engaging, but they do not give us time to think — we are too busy processing each unfolding moment. The still photograph, in contrast, gives us time to reflect upon what we are seeing; it is a moment frozen before us.

For some contributors the image alone sufficed. It is possible for viewers to look into some images and immediately make a connection to the subjects of the photograph, though it may be painful or difficult to view the raw suffering. On further reflection, it may be possible to make a connection to the photographer as well, by imagining what it was like to see that scene and take that picture. For some contributors words provided an important context in which to view their photographs. Together, the images and words become a testament. Reading the words while looking at the images invites the photographer into the viewer's experience. It was for this reason that the photos and words of each contributor were hung together, to foster an intimacy and understanding between the viewer and the contributor.

The project is preparing to move to Washington, D.C., for March and April 2002, where it will continue the work of displaying and collecting work relating to September 11. While nothing can replicate the experience of viewing the installation of the project, this book reflects an effort to convey it honestly. Each contributor's photos and words have been grouped together on the pages that follow, and attempts have been made to represent as much diversity of content, style, and point of view as possible. There is no particular order to the photos; some are shown as they were on the walls of the gallery, others enlarged with the words of the photographer next to them. Some contributors felt that only their photographs could speak for them, and their photos are shown without any text.

The decision to make this book presented a dilemma for the project; from the start we avoided anything commercial. Listening to the participants and visitors to the project settled it for us. They said that if a book could help fund a tour of the exhibition and bring even some of the experience to those who could not see it, we had to do it. We agree.

Has the project become a memorial to the attacks of September 11? Is it a moving shrine? Not exactly. It is not a memorial or a shrine to any one person; rather it has become a means of bearing witness to the pain and to the profound shift in our reality that has taken place since the events of September 11, 2001.

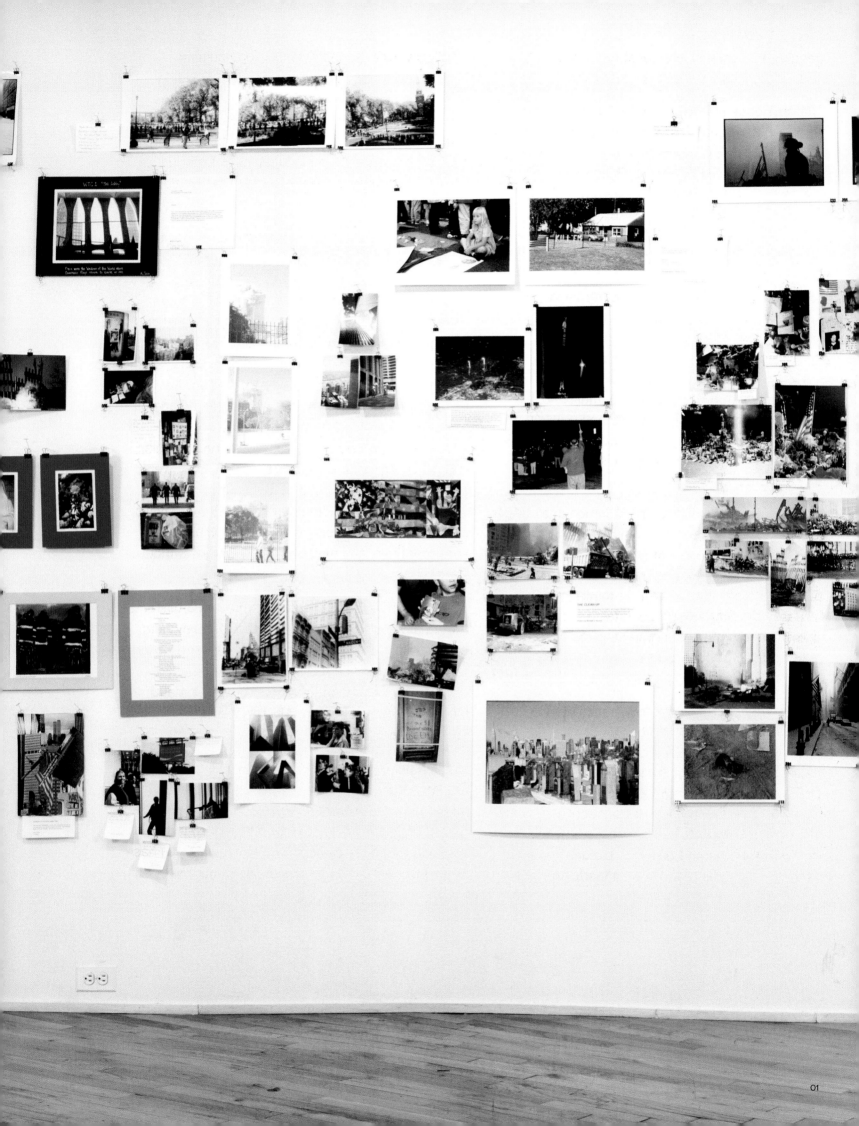

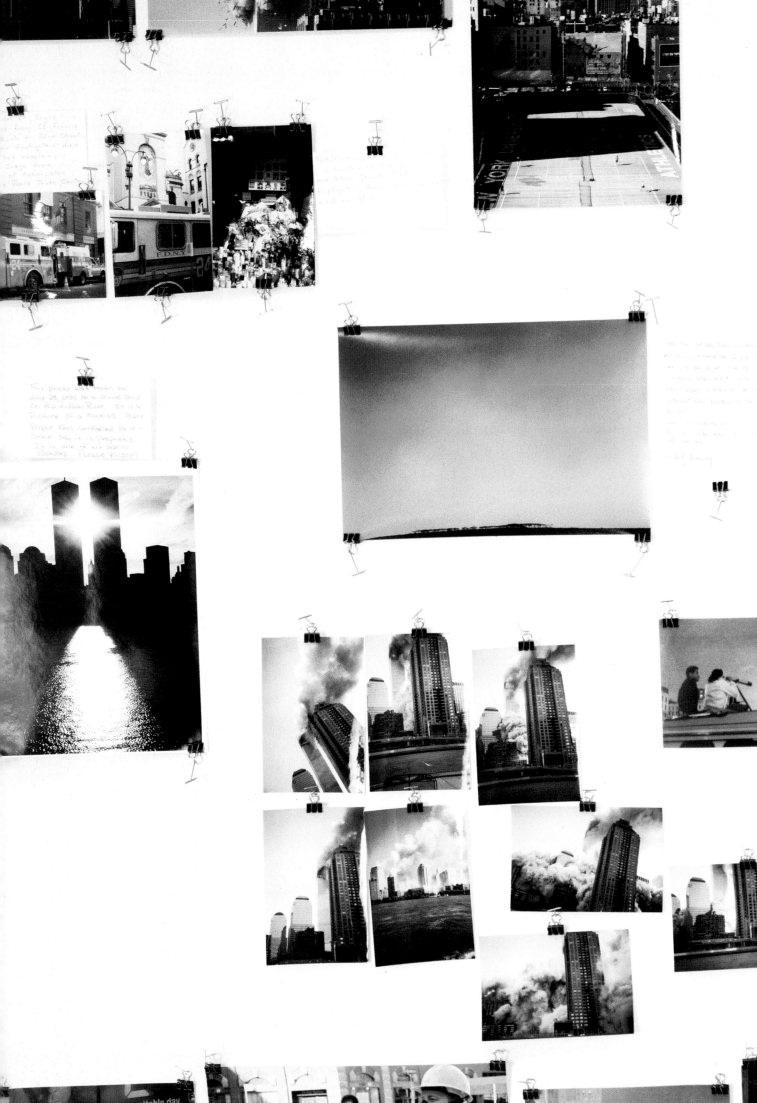

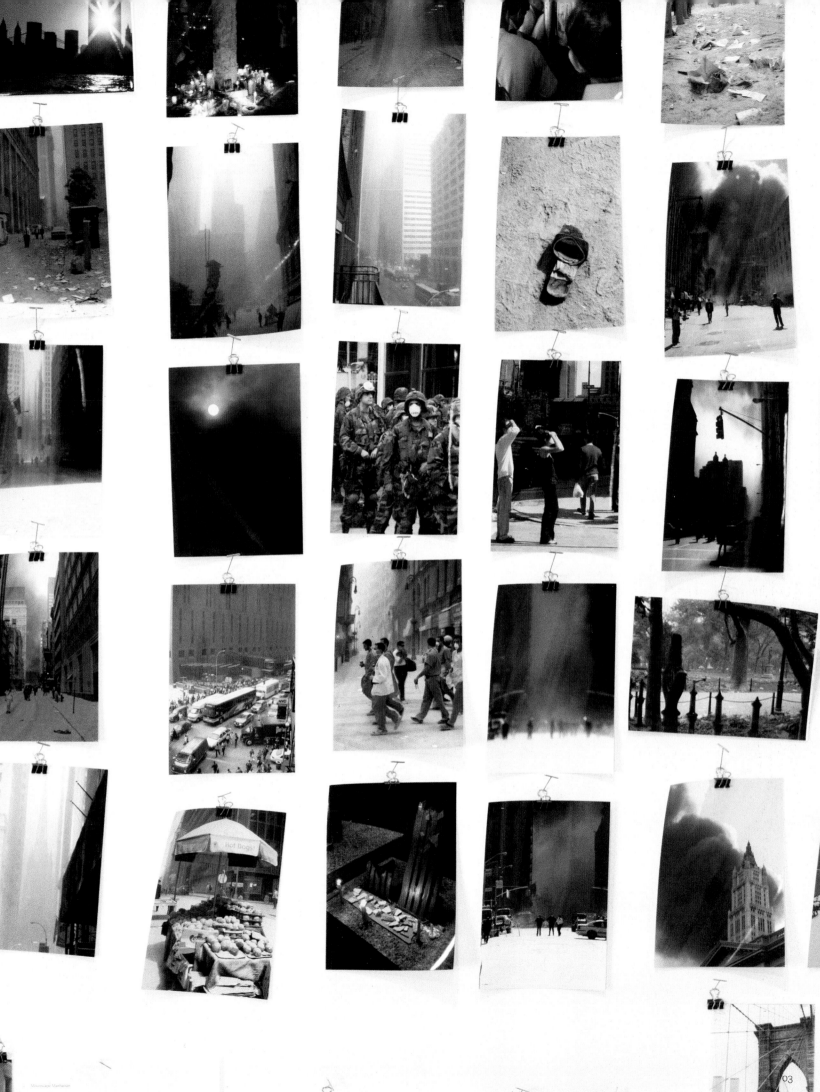

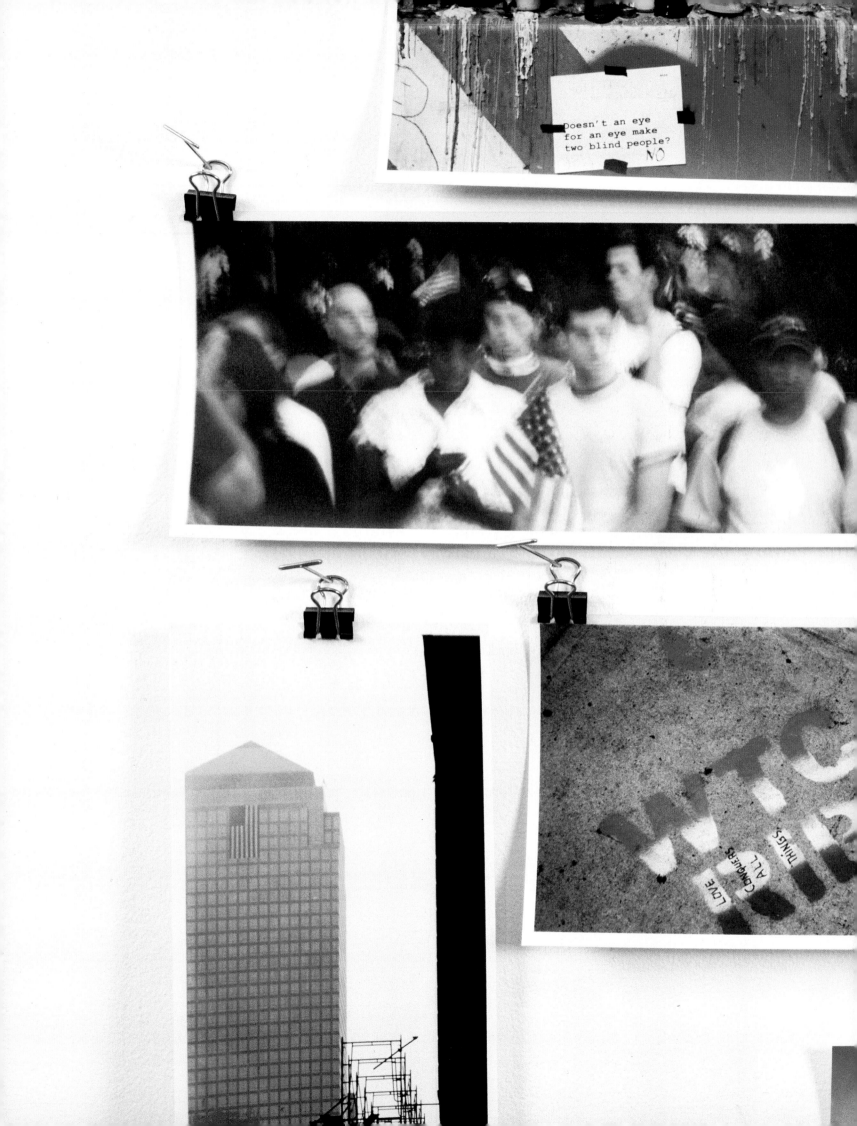

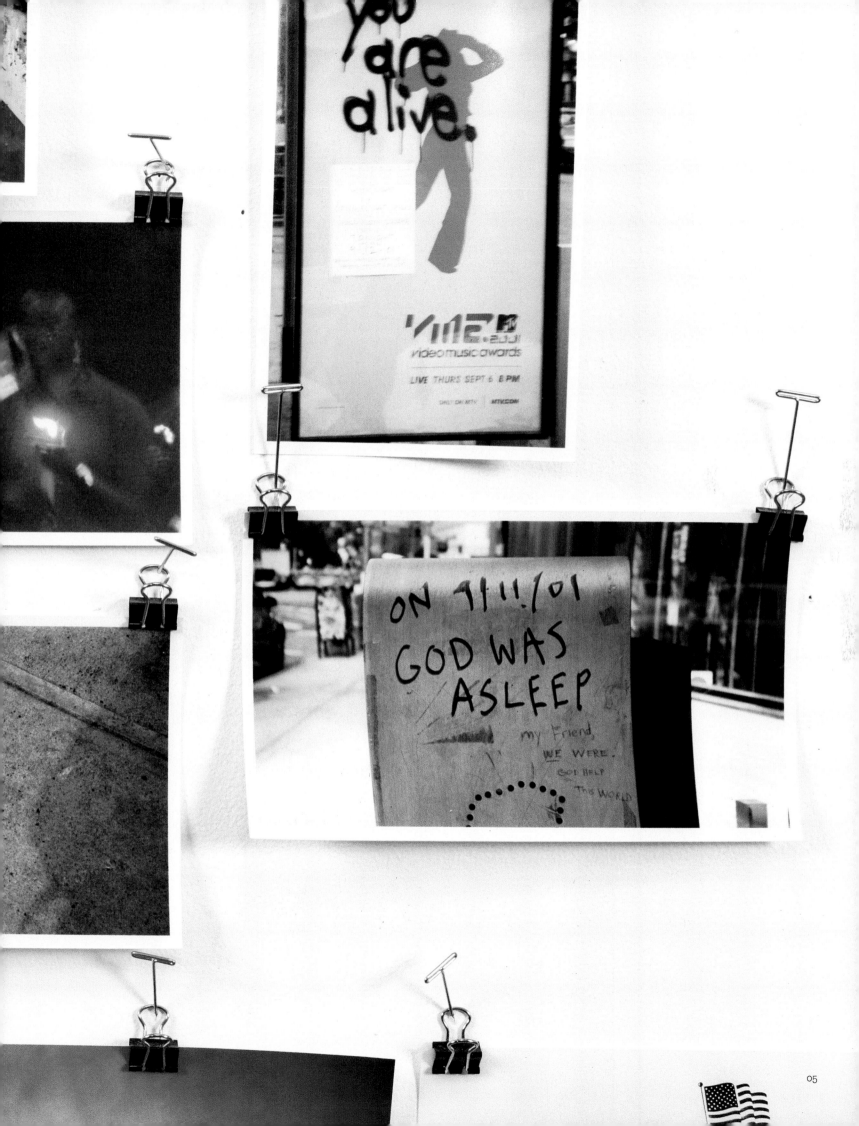

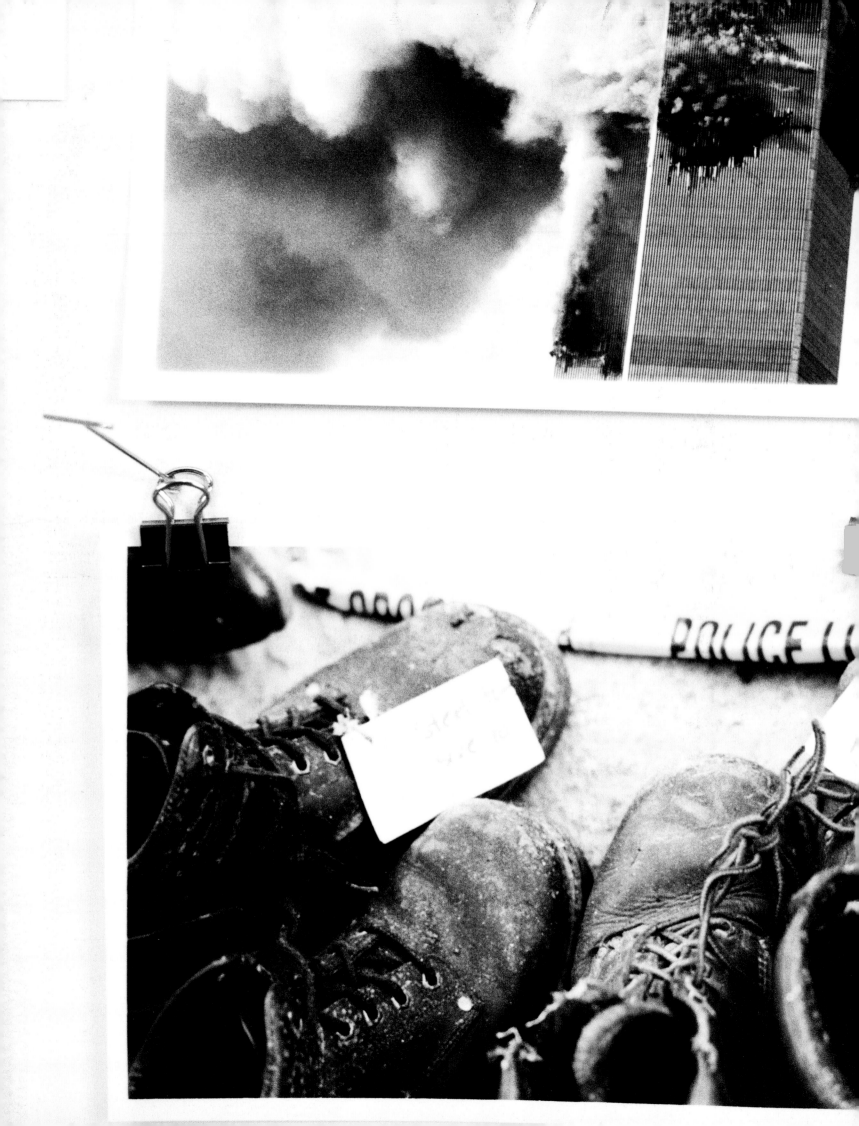

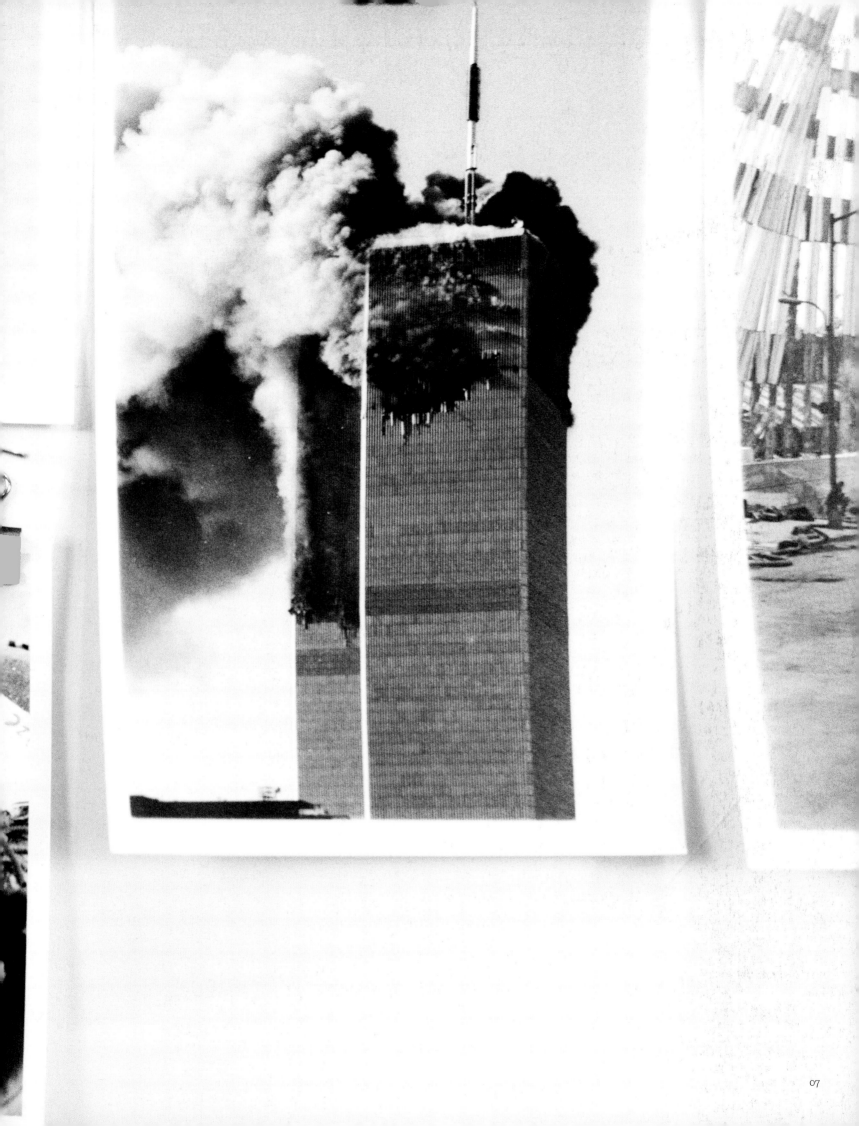

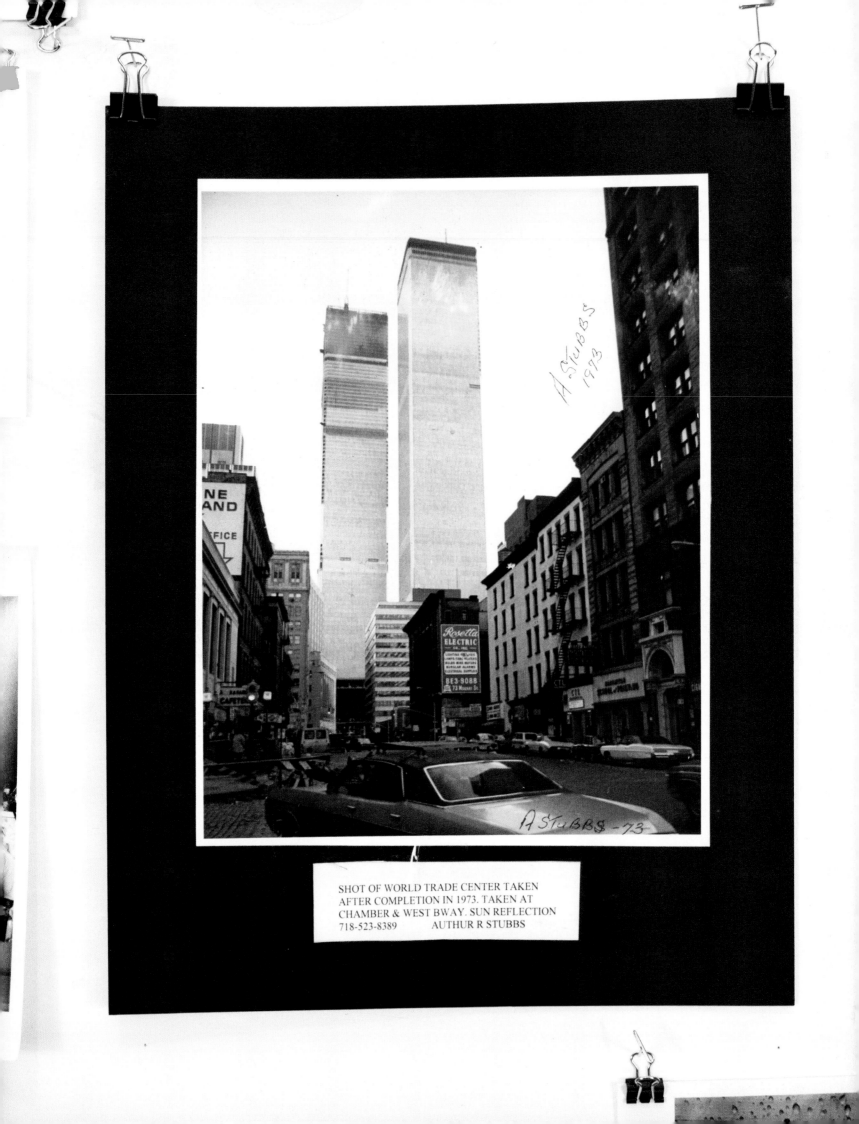

SHOT OF WORLD TRADE CENTER TAKEN
AFTER COMPLETION IN 1973. TAKEN AT
CHAMBER & WEST BWAY. SUN REFLECTION
718-523-8389 AUTHUR R STUBBS

My School Bus Didn't Show Up Today
My dad and I waited for a long time,
until 8:30, then we went back
up to our apartment to call
the bus company. While we
were waiting for a call back,
there was a big explosion, it
blew our curtains out our
windows. Me and my mom and
dad ran out onto our terrace
and we saw a really big hole
in the World Trade Tower with
lots of smoke and fire. We
started to pray for the people
in that tower, and then there
was another big explosion!
After that my parents said
"this is not an accident." I
was very scared, but I was
very glad the bus didn't
come and I was home with my parents because my
school is close to the World Trade Center. That day
was very scary but it was much better being at
home with my mom and dad.

Nayala J. Smith 7 yrs. old
New York City

Photographer's Note: This Picture was taken on Sept. 11th at
3:30 P.M., ~~from~~ on Nayala's 19th Floor Balcony.

— David Alm

09

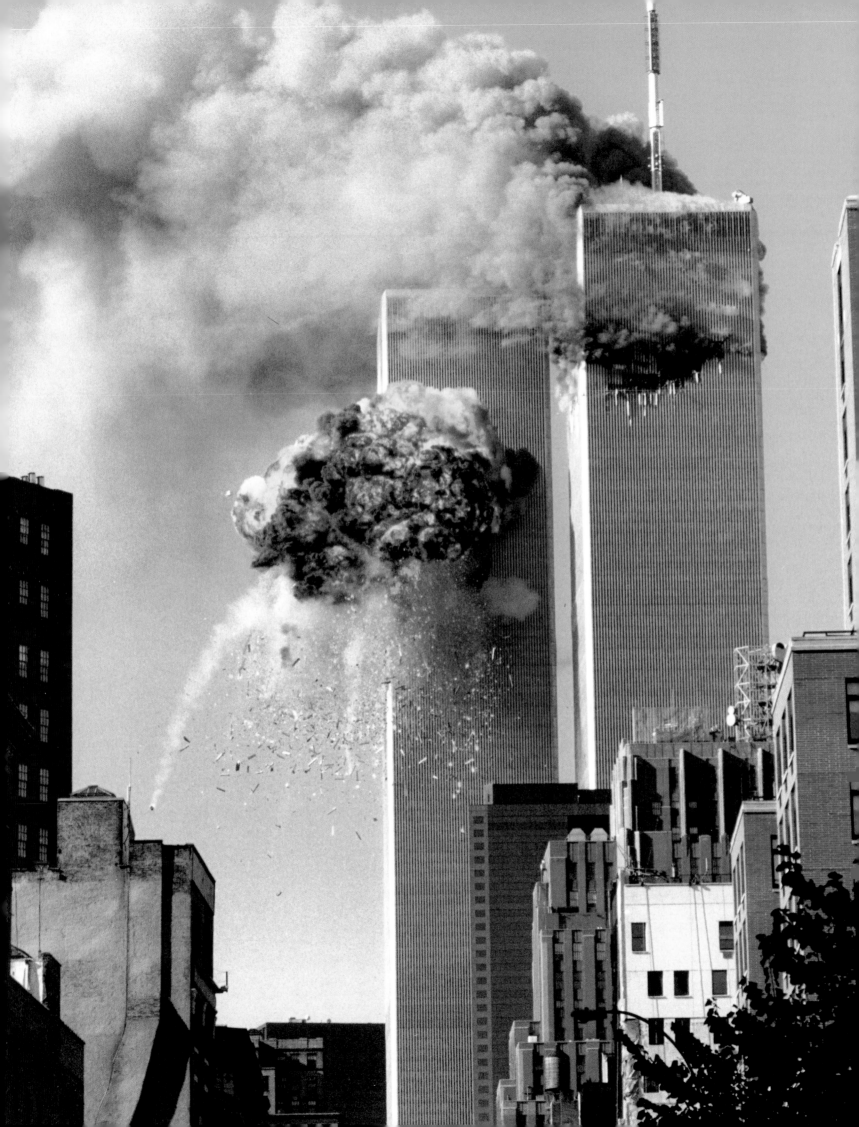

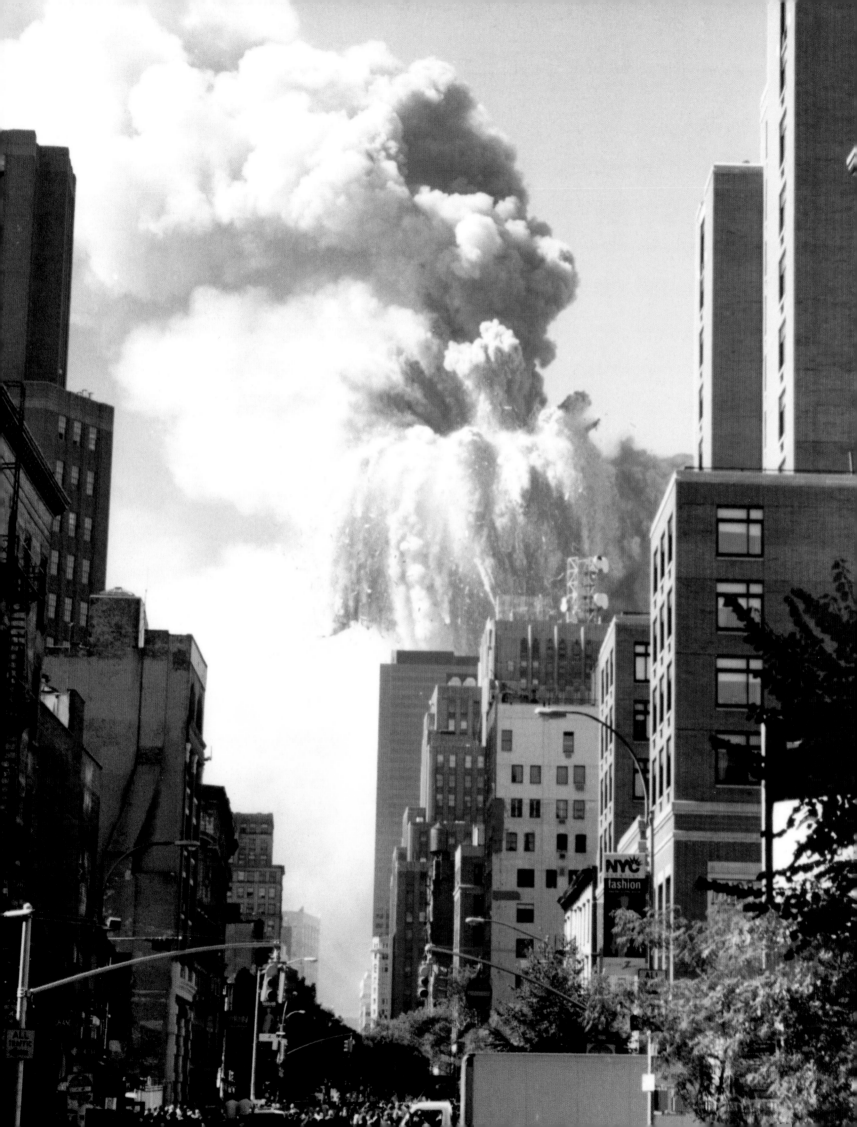

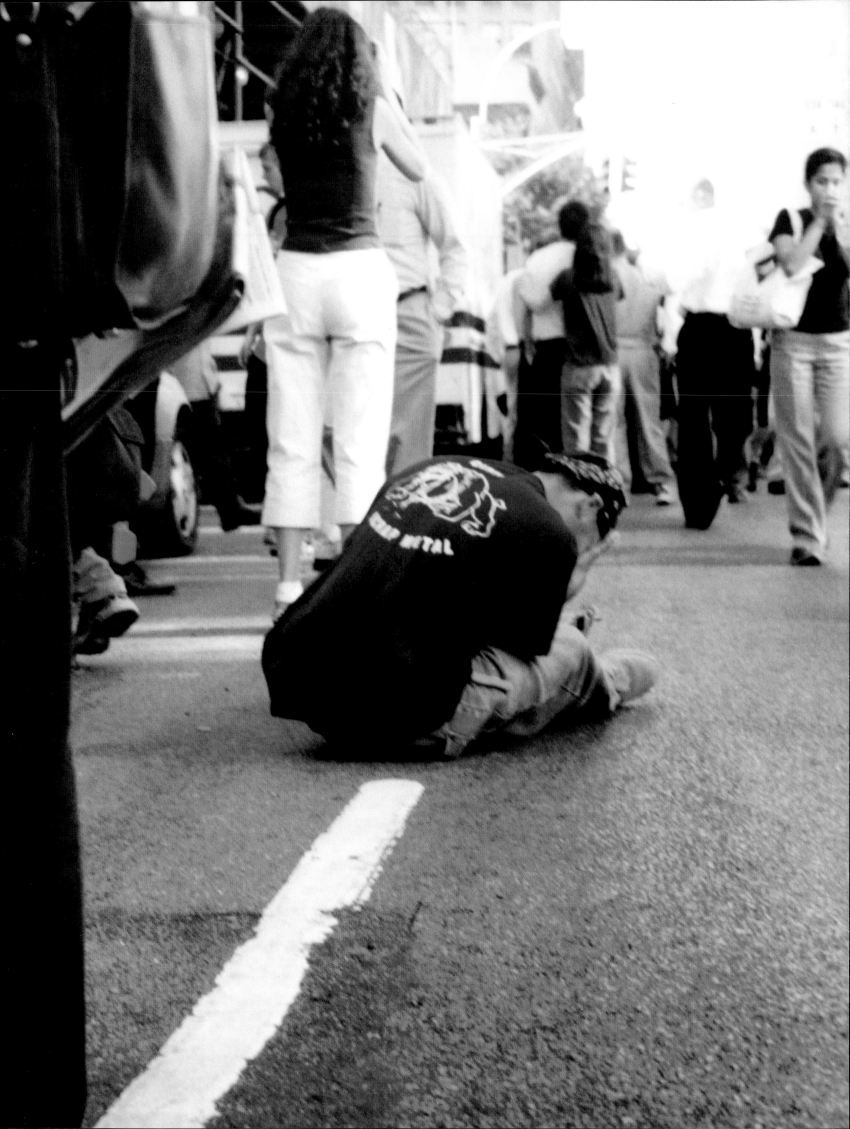

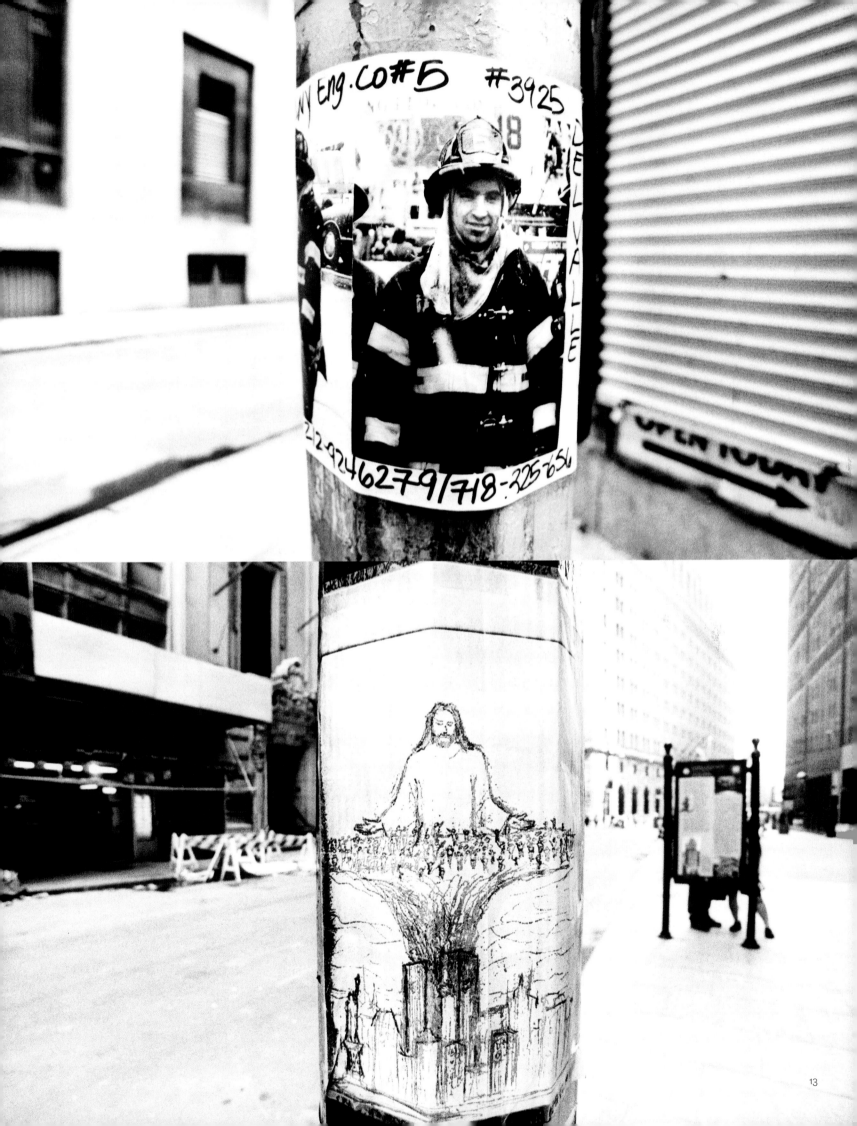

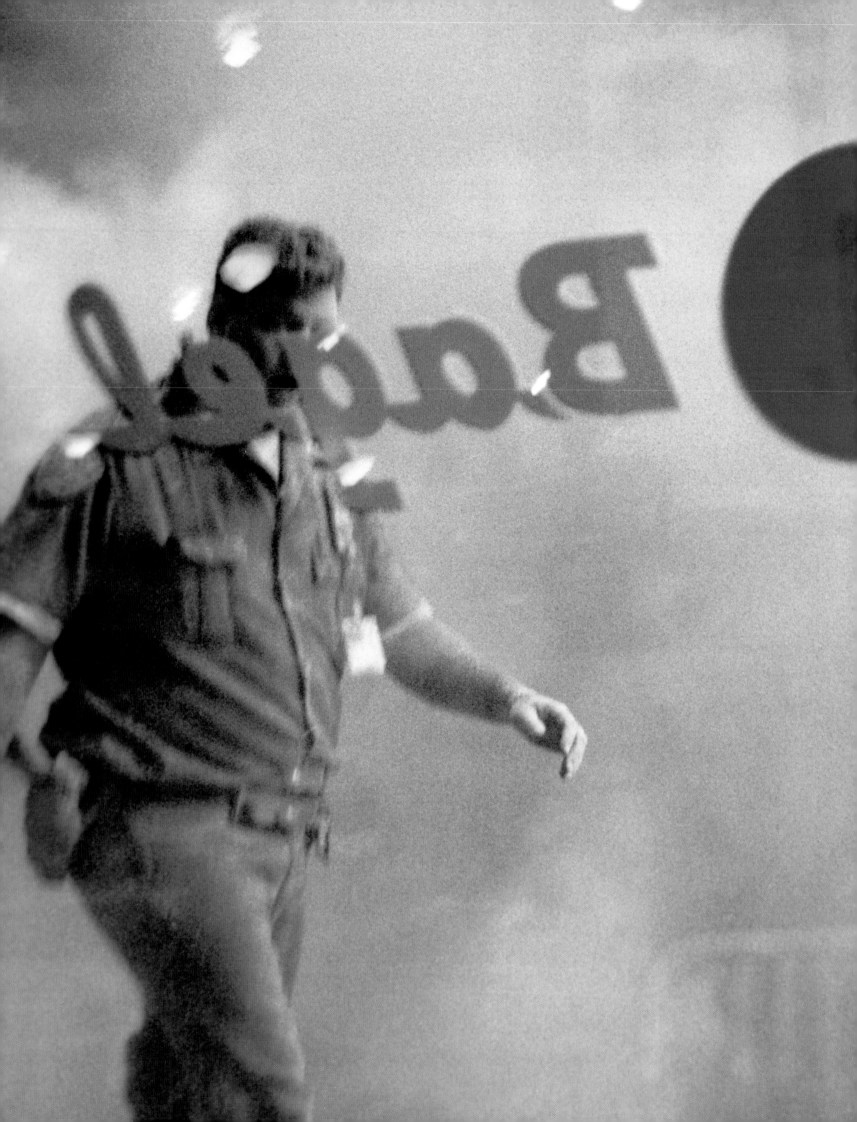

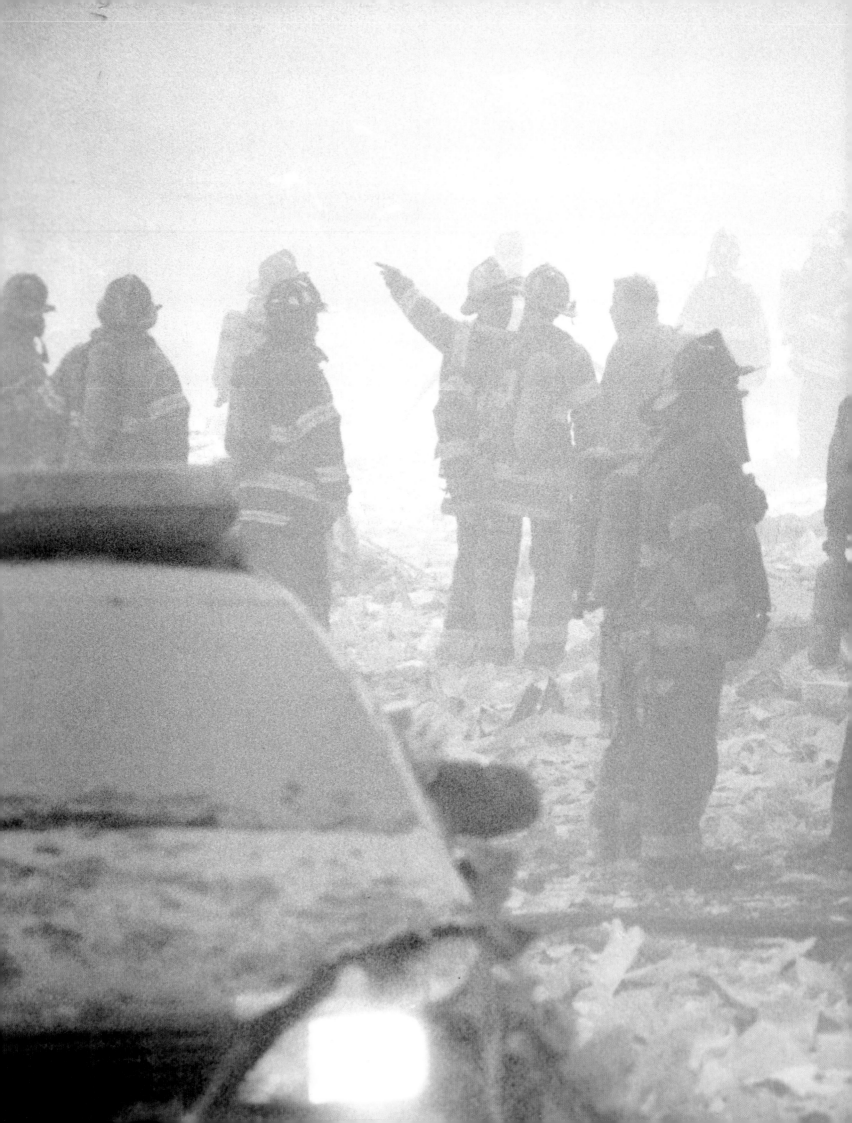

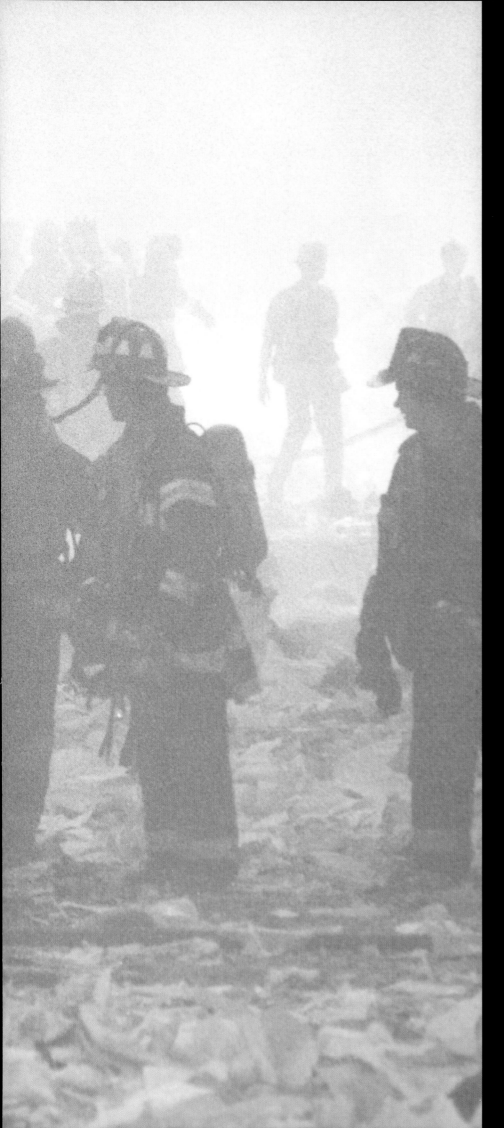

All entrances and exits to the borough of Manhattan had been shut down. We were authorized emergency personnel dispatched from New Jersey to document the operation. We proceeded through the Holland Tunnel with the Jersey City fire apparatus. Walking into the scene was unreal. Crowds of people in the street looking up as if they were watching Godzilla walk down the block. As we walked closer, pieces of the building were still falling. People were screaming and crying in shock.

We began taking photos. Until the sound. The unbelievable sound of tower one beginning to crack at the seams. Then you heard it, the snap. The last straw breaking. There was no time to think, just time to run. We couldn't even take photos we were running so hard. Along with Metro Unit 18, I dove behind a building only a block away and hid as the debris came flying past us like an avalanche.

The cloud began to drop and most of the debris was already on the ground as we started to make sure everyone in the area was okay. Clouds of smoke blocked our way, but we moved when we could. We turned a corner and found the initial response staging area. All the vehicles in the area were crushed, burning. Windows were blown out, and everything was covered with debris.

We had no time to take pictures. We immediately began washing off firefighters who couldn't breathe because of the ash and debris. After we rehabbed the brothers in the area, we started putting out debris fires with fire extinguishers. Then you heard it, cracking again. The same terrifying sounds that we heard with tower one we now heard with tower two. And then that snap, as the entire top of tower two, antenna and all, imploded on itself as it came crashing down. We had no place to go this time, so we dove through a door into a nearby bagel store. When we realized that the windows were still intact, Dave from Unit 18 immediately opened the door and yelled out to the emergency workers trapped in the smoke and ash. Whoever he couldn't reach, he had to go and find. Each one, coming in one after the last, was covered in ash and unable to breathe. We turned the bagel store into an emergency rehab/treatment area and started hosing off everyone coming in.

Once the area was stabilized, we returned to the "war zone" to reevaluate. We got right back to putting out even more fires and dodging exploding car fires. We photographed what we could when we could, helping everyone we found along our walk.

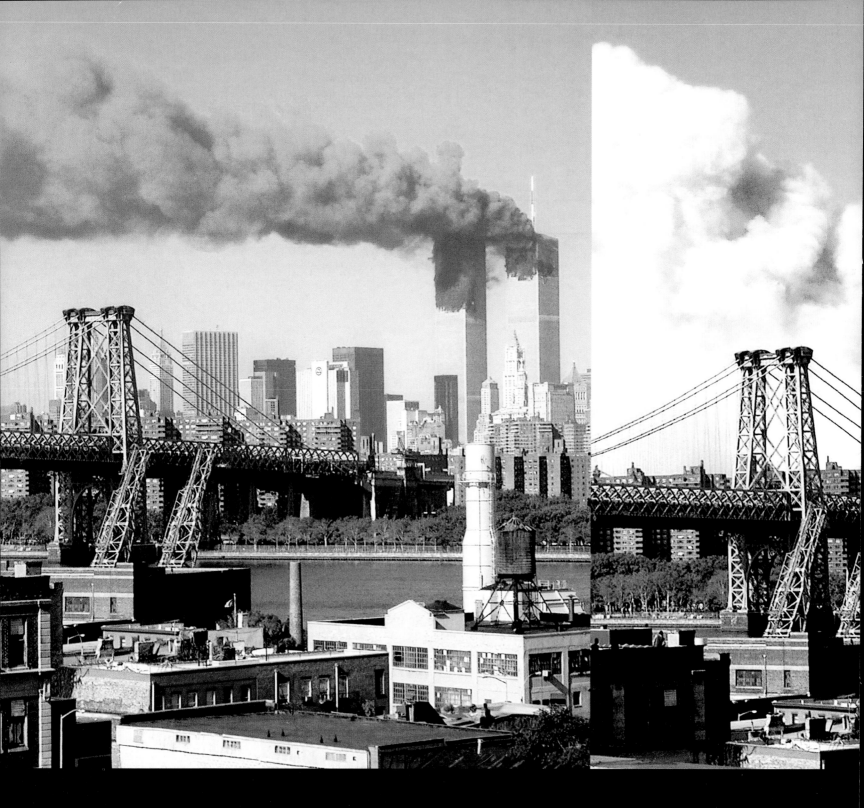

After receiving a frantic phone call from a friend, I ran up to the roof of my building in Williamsburg, Brooklyn, and watched the terror unfold.

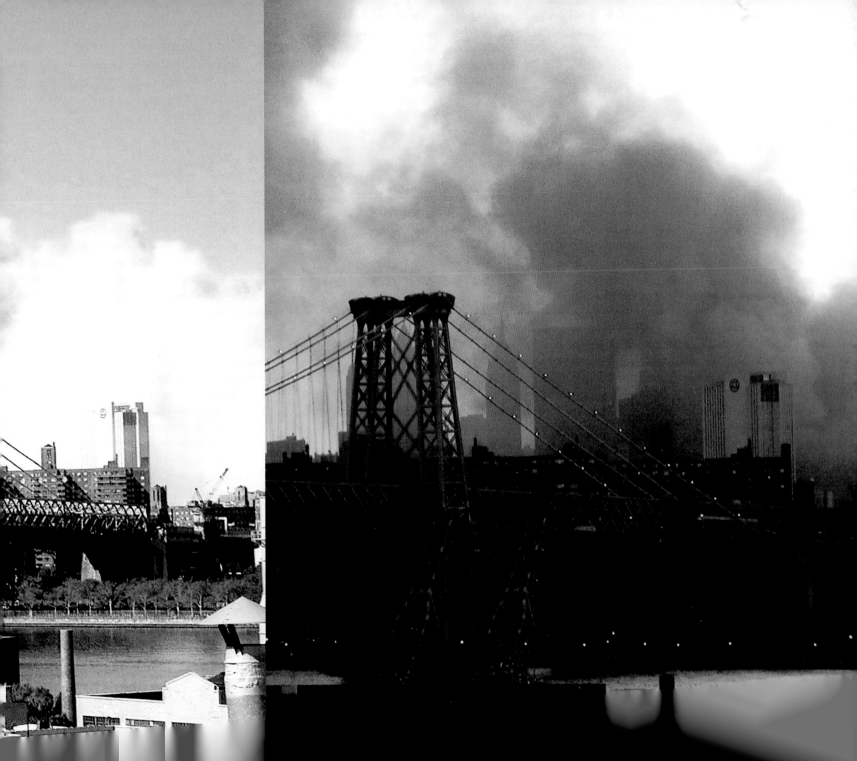

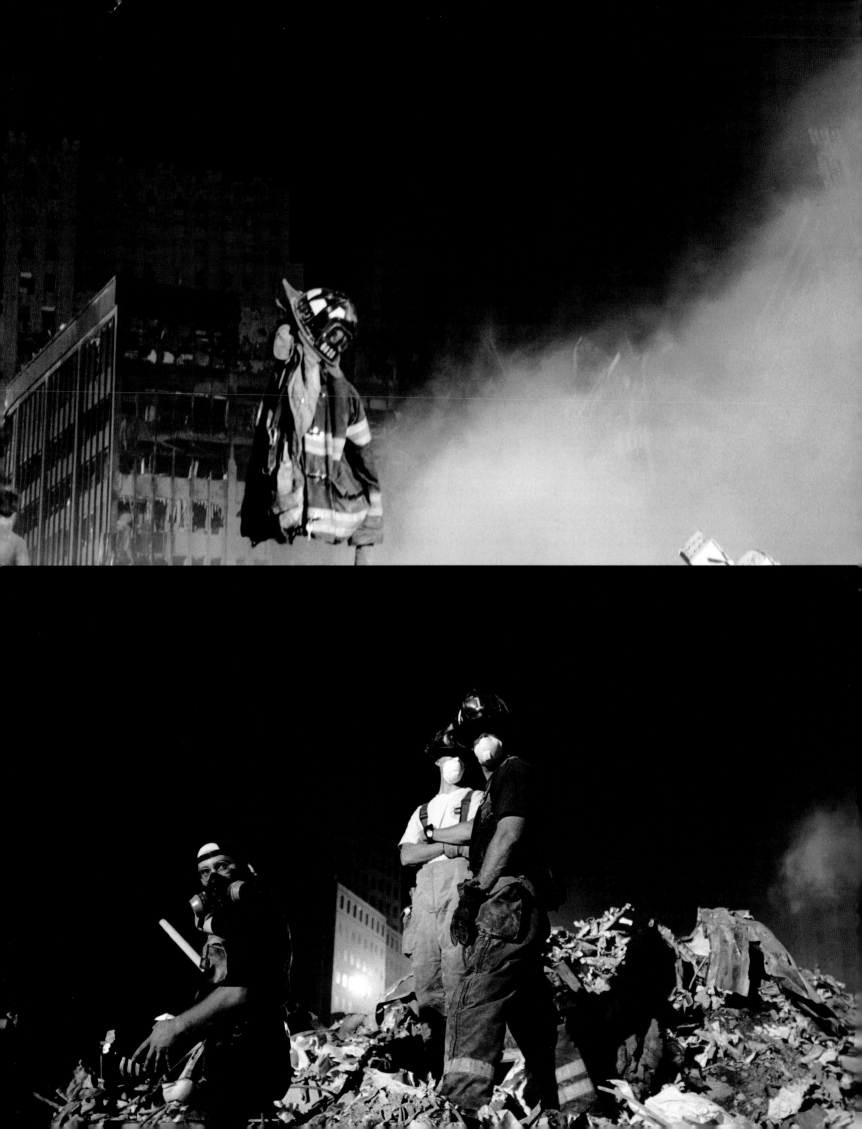

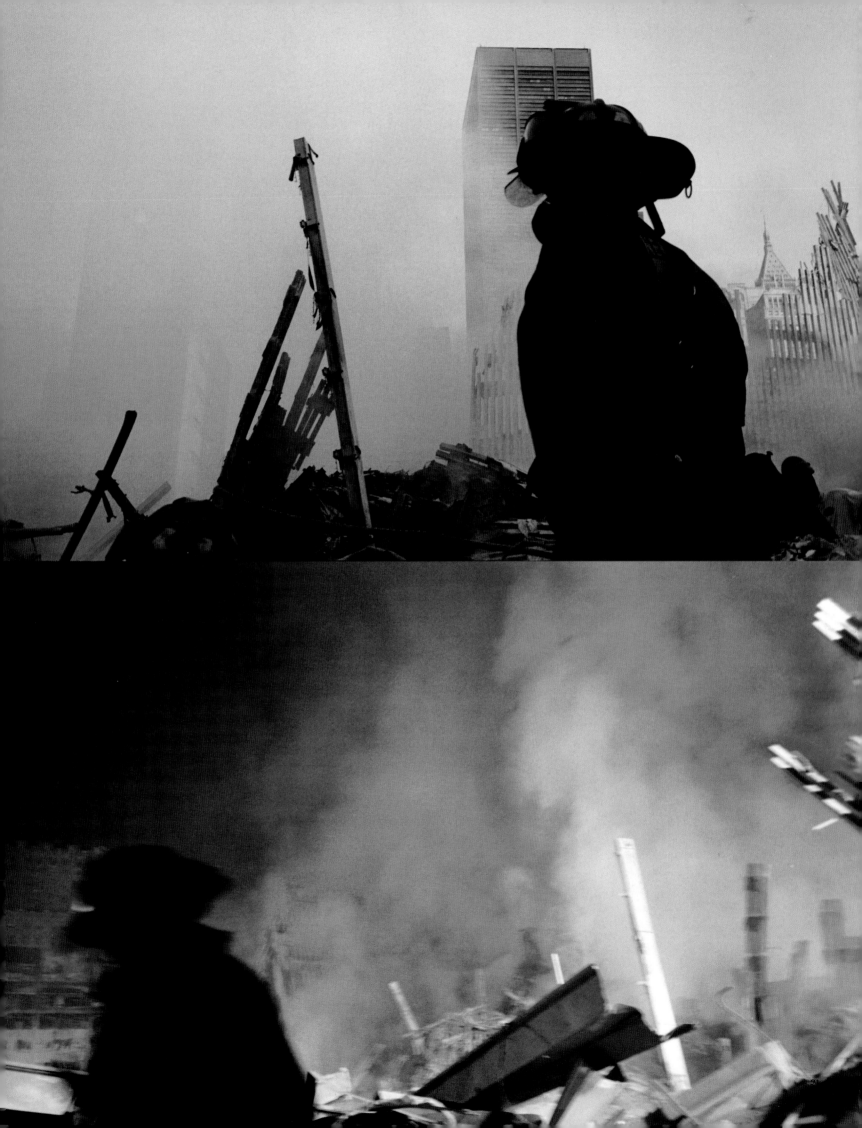

I took this photograph in SoHo on West Broadway shortly after the second tower collapsed. The thing that strikes me now is the very different, immediate reactions to the disaster: horror and disbelief, and panic.

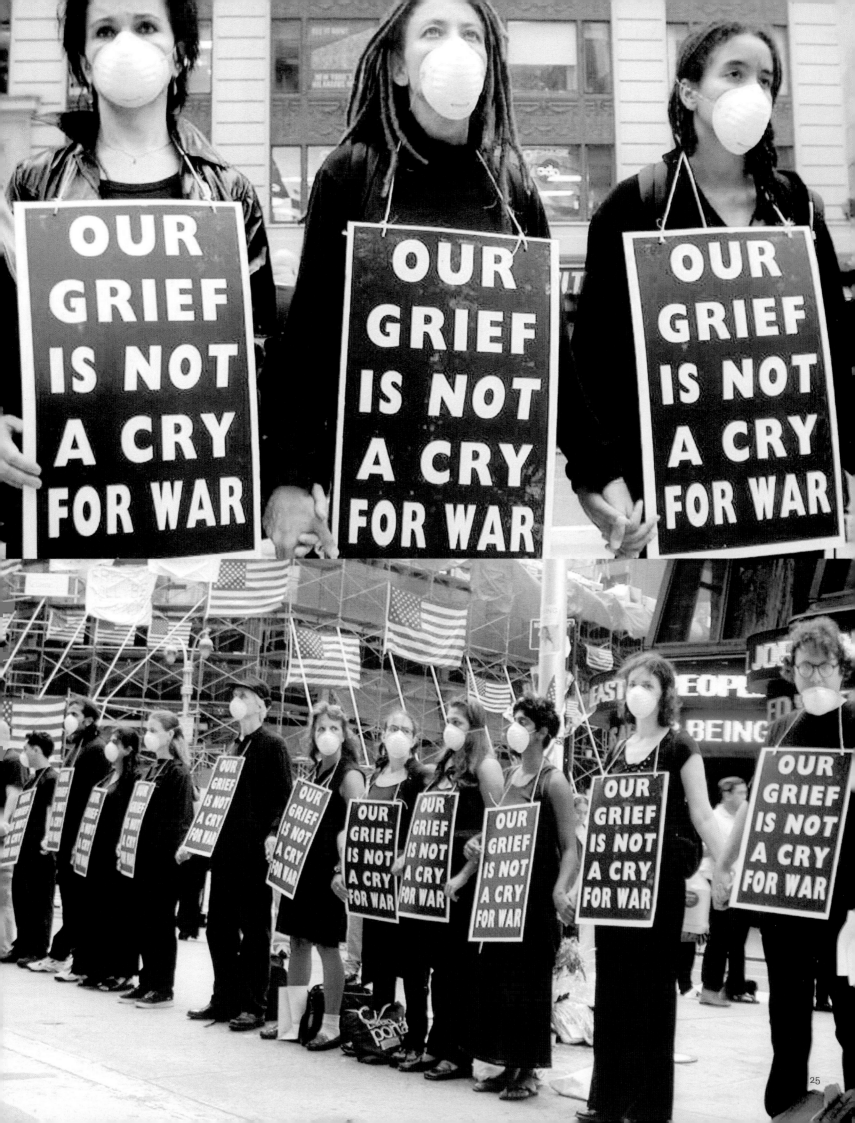

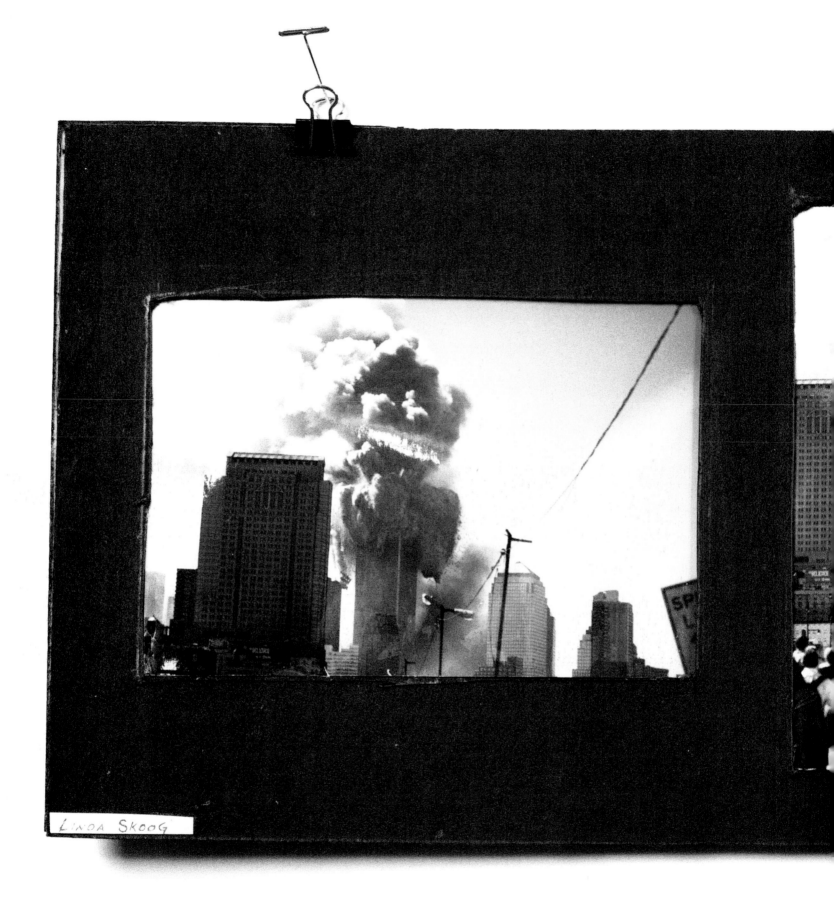

LINDA SKOOG

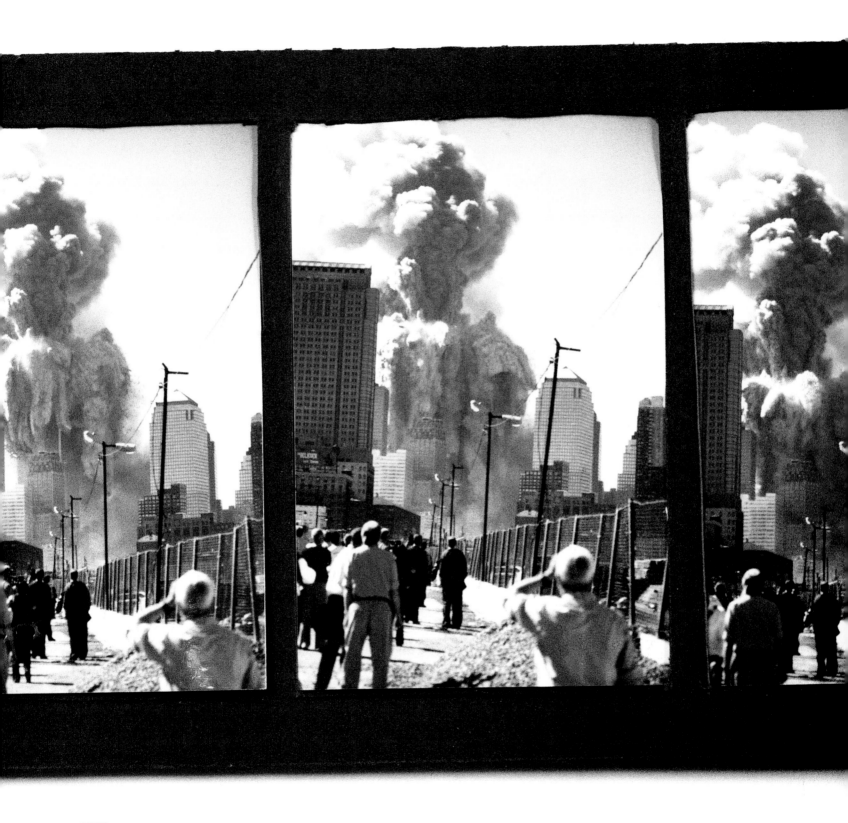

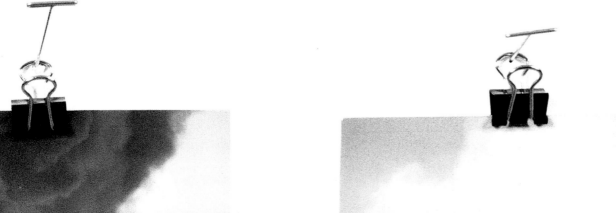

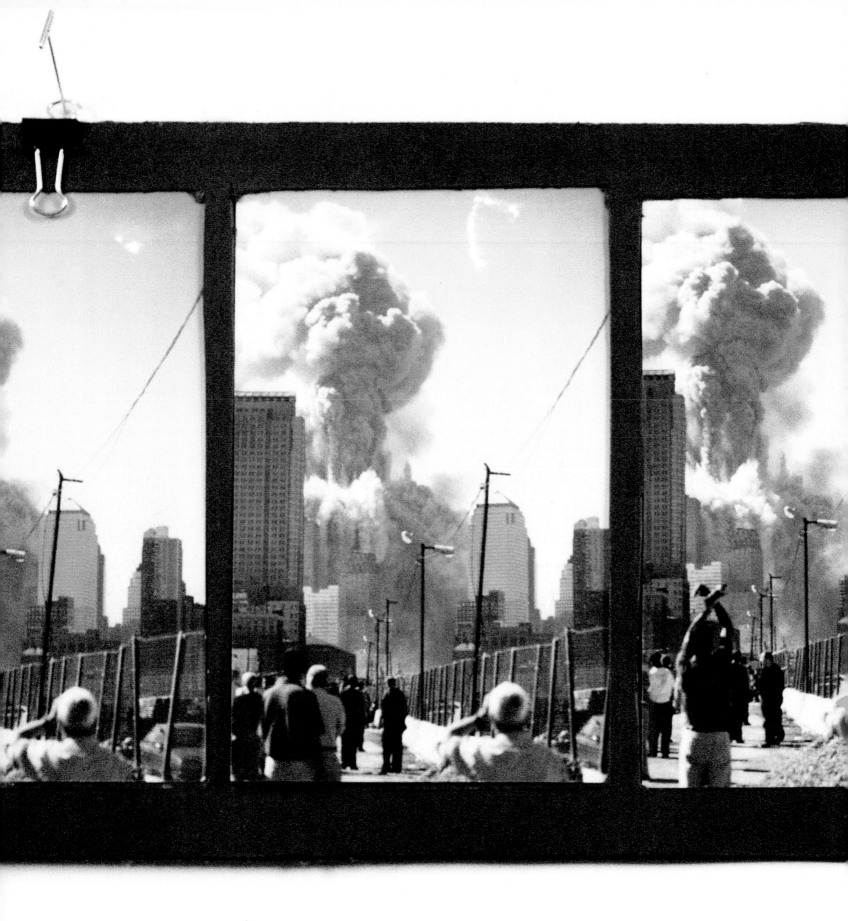

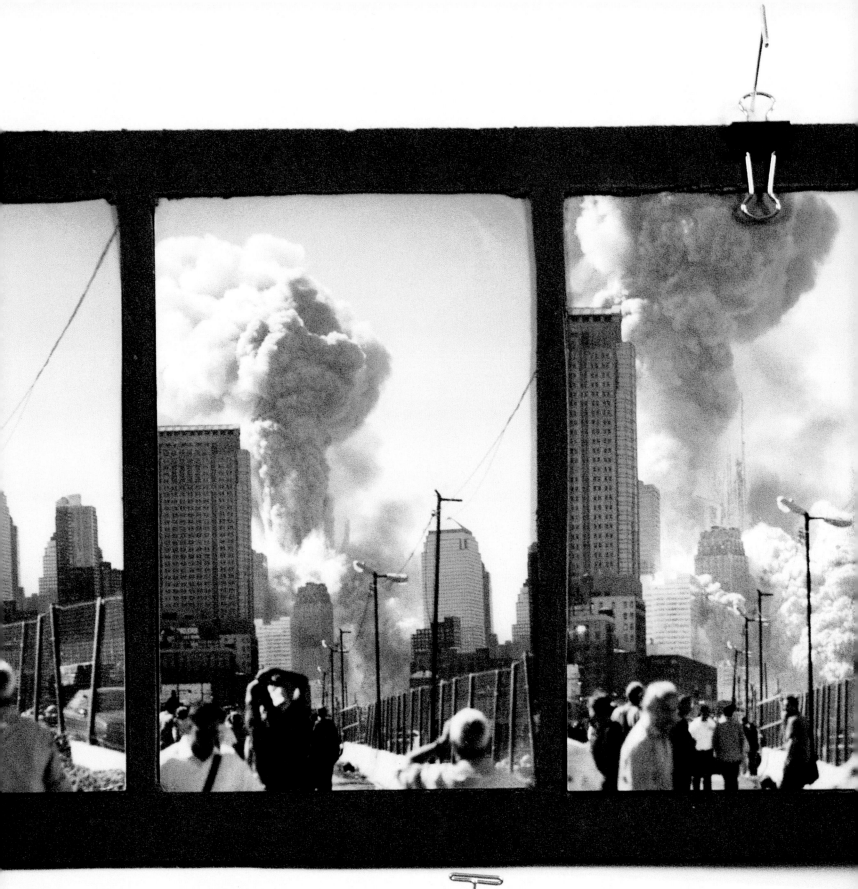

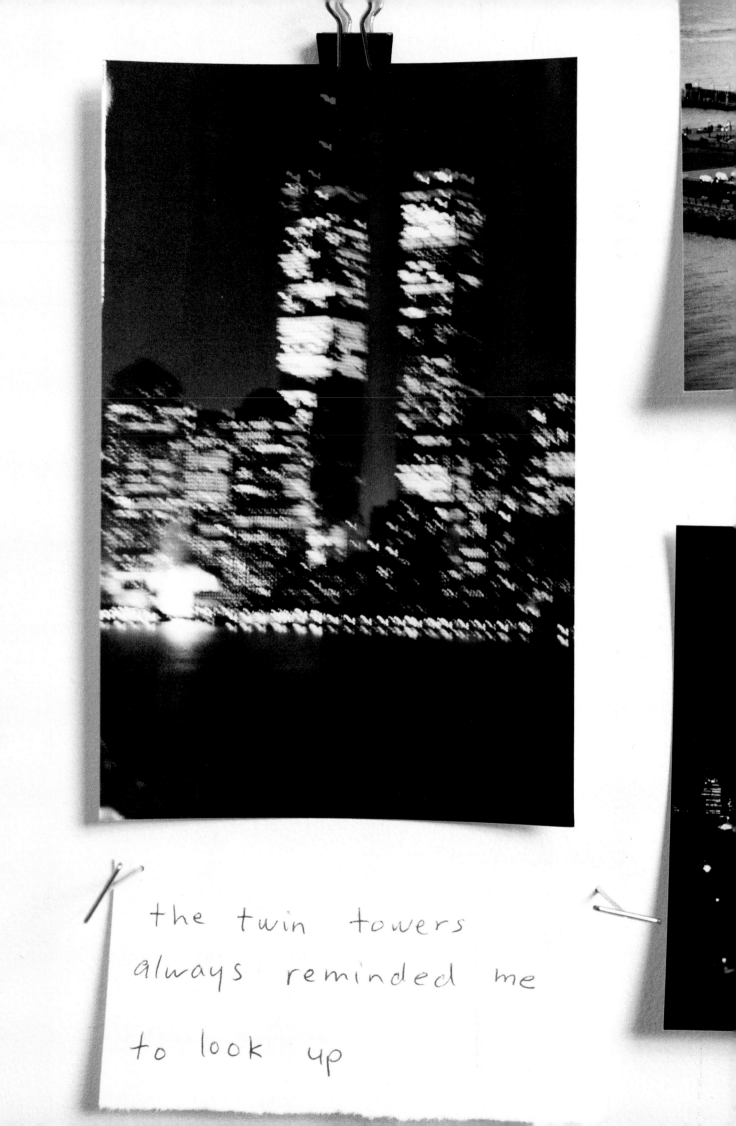

the twin towers
always reminded me

to look up

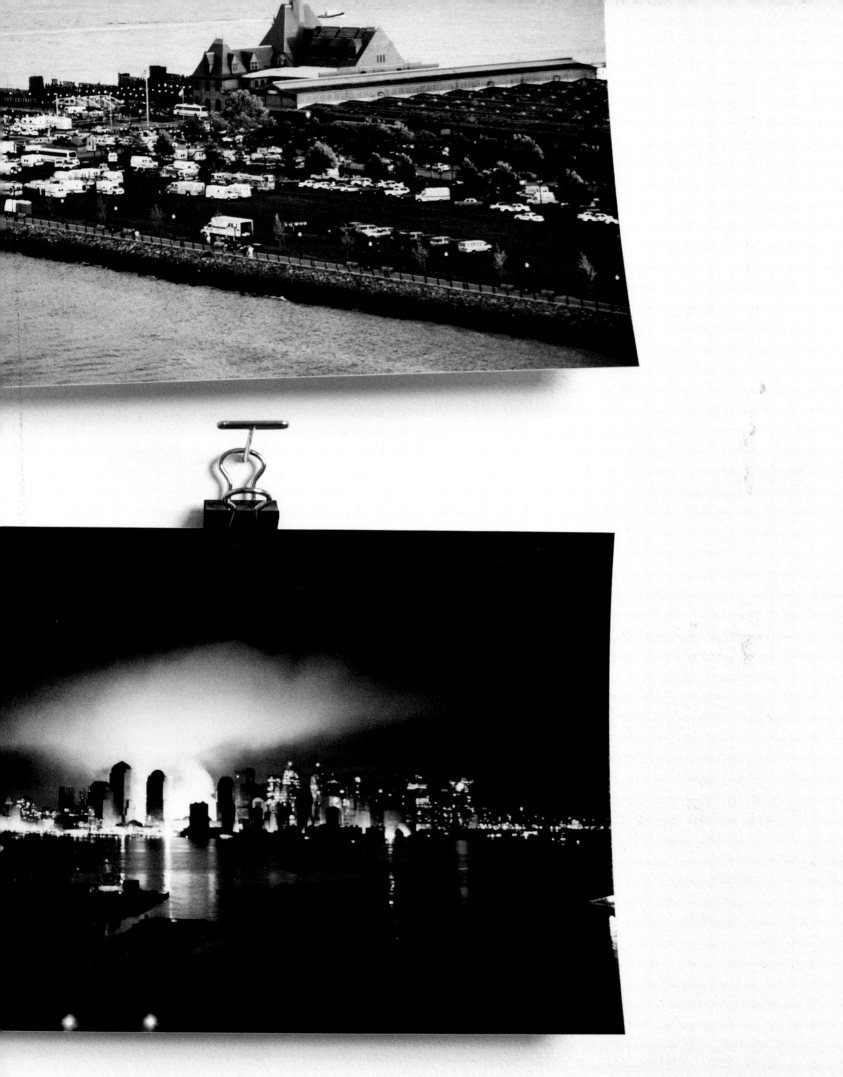

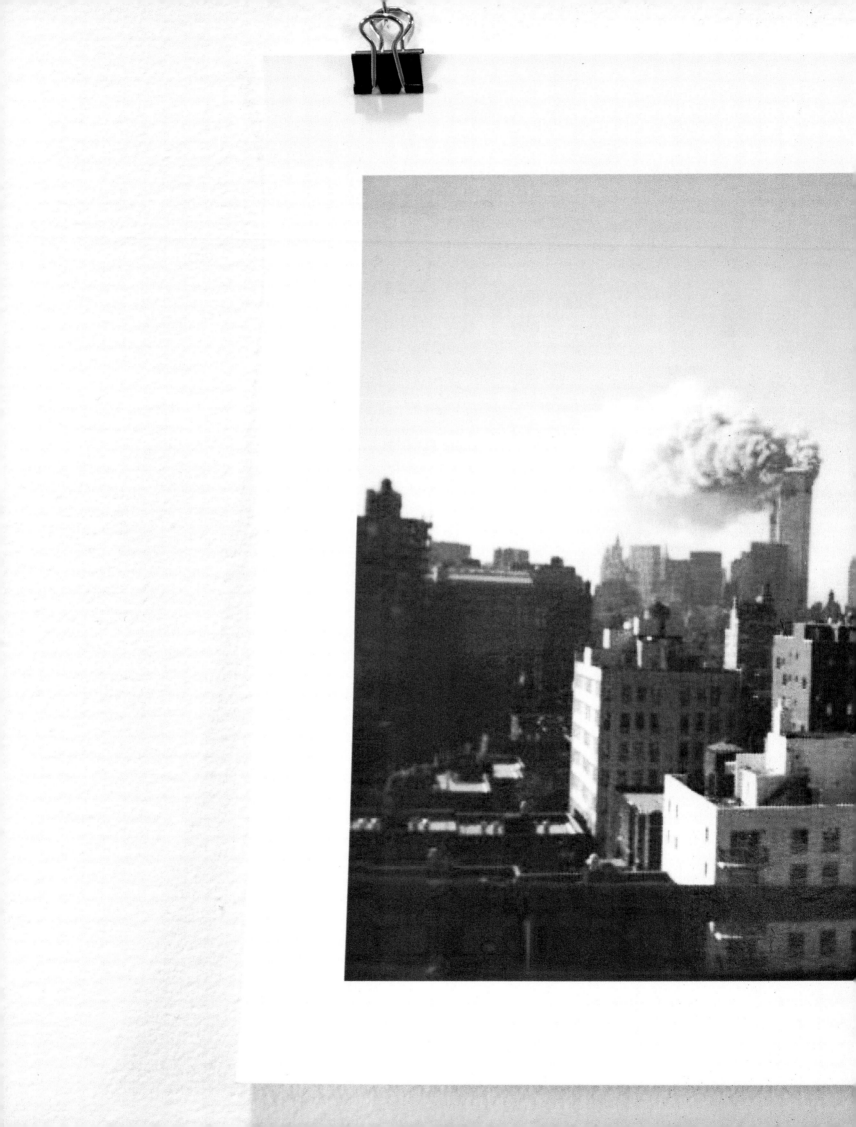

Mara Hershovitz 2001

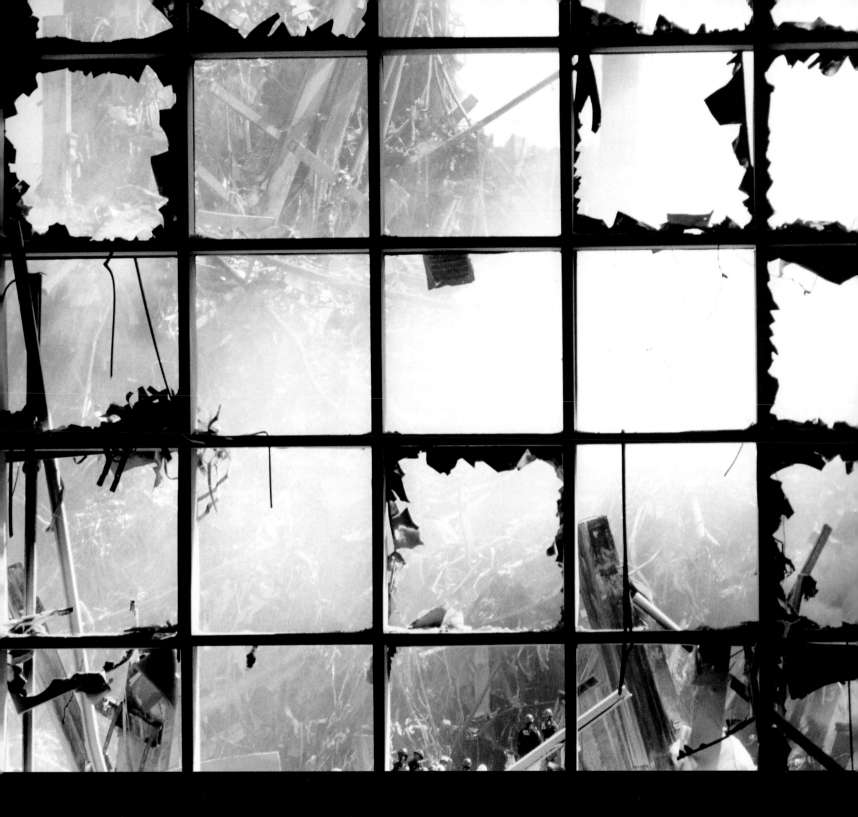

I worked on the 59th floor of World Trade Center One at Sidley Austin Brown & Wood, LLP. All but one of the 600 people we had working in the building got out alive. I didn't know that as I stood in horror on my way to work on 9/11 watching as the second plane crashed into tower two. It took less than 30 seconds for it to sink in that this was no accident and that something horrible was happening on the Island of Manhattan that day. I wanted no part of it, so I went right home to be with my wife and two children. I was one of the lucky ones in many ways. Thoughts of others weighed heavily upon my heart.

For that day and the next I felt helpless. My backyard was so quiet and peaceful. I just wanted to do something to help, anything. I was lucky to have a friend in the NYC Fire Department, who helped get me into Ground Zero to work on the bucket brigade. On September 13th and 15th I dug through rubble where the former WTC One building stood;

for all I knew one or more of my coworkers was trapped in an air pocket below. Unfortunately, no more survivors were found after the 12th.

I worked the main pit, amongst the real heroes, the firefighters and police who were working themselves till exhaustion looking for survivors and their fallen comrades. They would rest for short intervals only to be drawn back to the pit after thinking about the grieving family members who were counting on them. Everyone had a tremendous respect for the ironworkers without whom progress of any sort would not have been possible. These guys were the Clint Eastwoods of our generation, some real tough men.

It felt like war and smelled like death down there. I took a photo from inside the World Financial Center looking out the window at the rubble heap. The photo of the firefighter with the flag on his helmet still moves me close to tears every time I look at it.

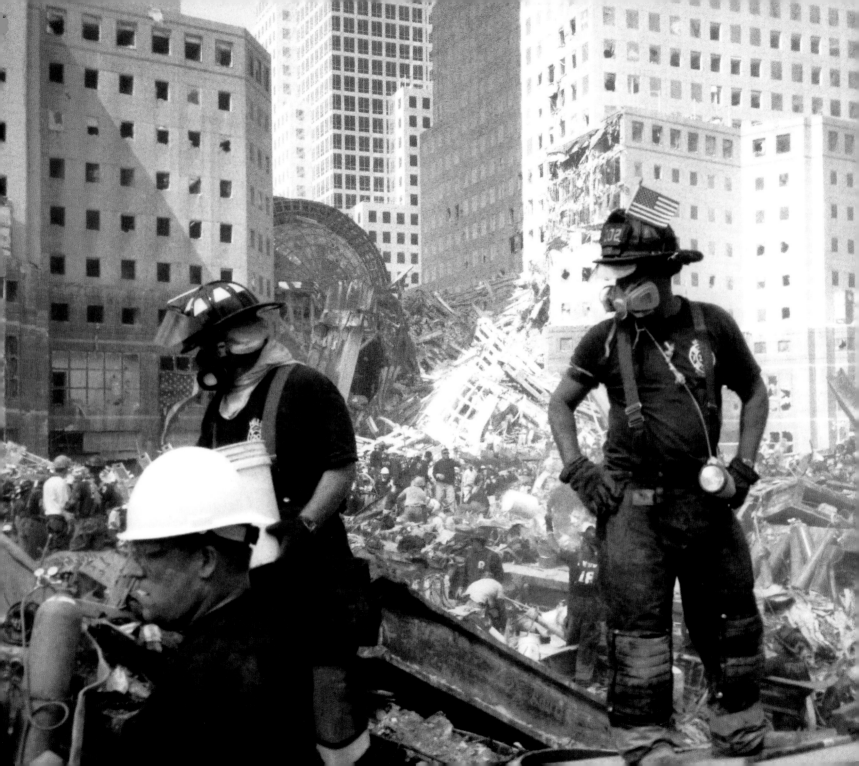

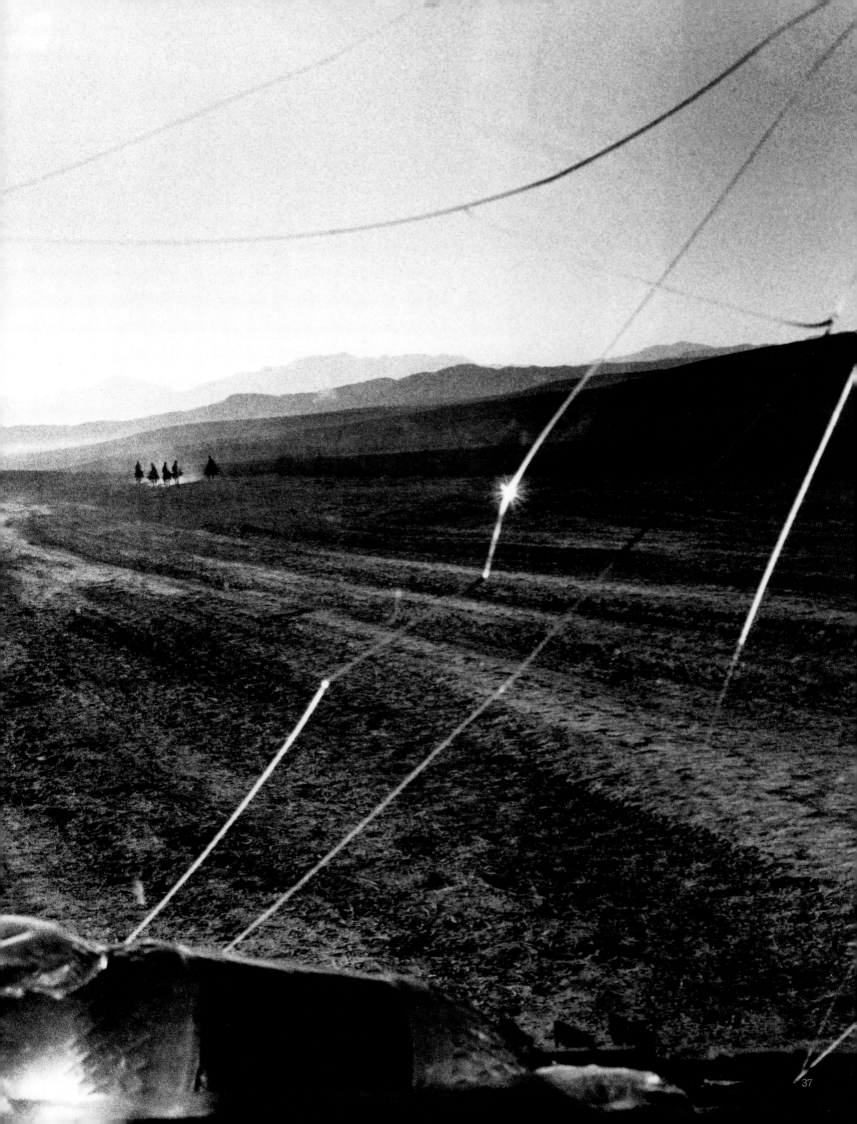

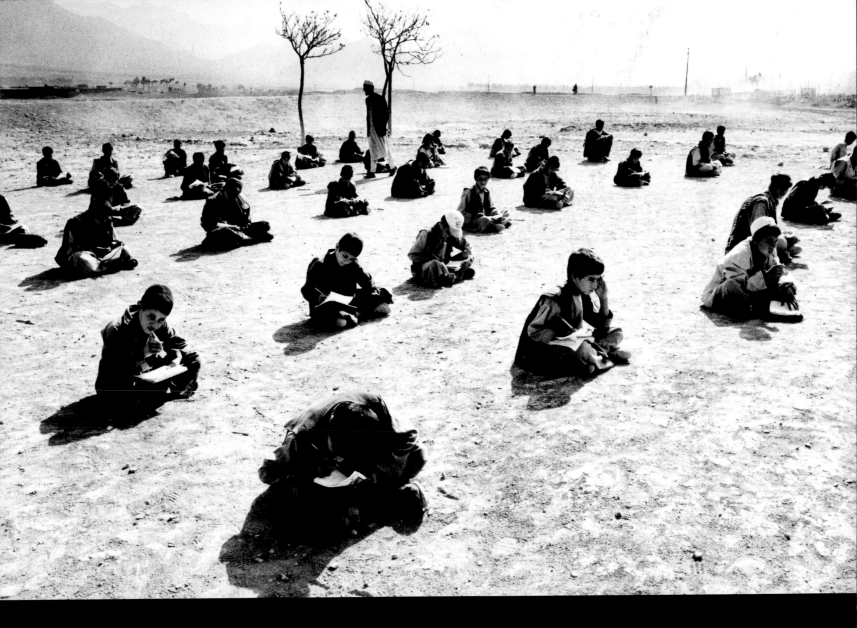

I was on my way to northern Kabul when I came across a peculiar
school in the middle of nowhere where students were taking an
exam outside. When I saw this scene, it made me very upset. I
questioned how we are going to rebuild this country when
Afghanistan has lost two generations from this war and the future
of the country depends on education.

Golbar, Afghanistan, October 2001

previous page:
On the first day on the humanitarian convoy in Dasht-e-Qaleh,
I looked at my country through the truck window and noticed
the symbolism before my eyes. I saw through this window a
magnificent country but every inch of it was broken.

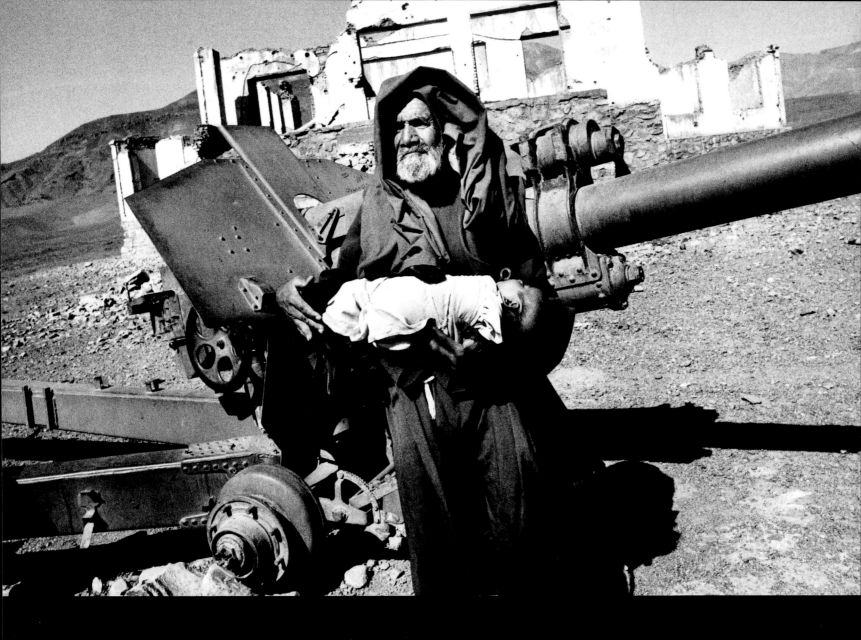

In the plain of Shamoli, north of Kabul, Baba Jan in the road carrying his grandson to the hospital 25 kilometers away. He told me he had to leave his village three times in four years because of Taliban advances. The third time, the Taliban destroyed his village and burned his food supply. Baba Jan asked me, "What do the Taliban want? They even destroyed the roots of my vines. Do they

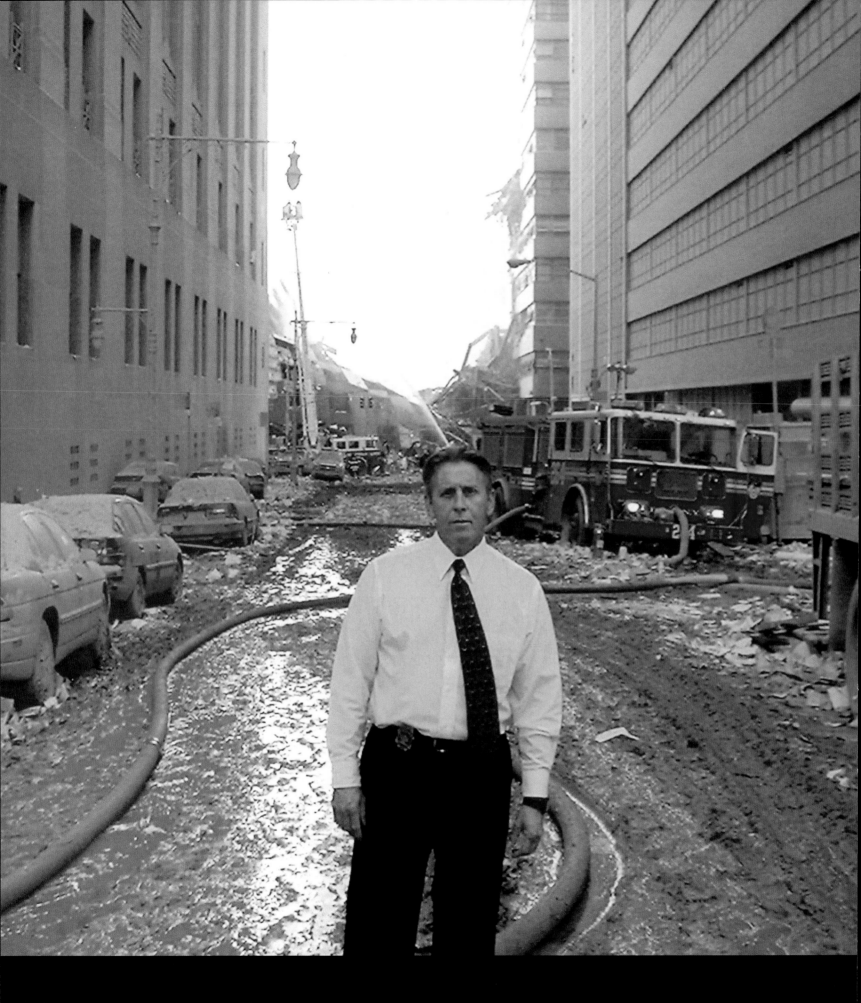

Subject: Stephen Shallash, Department of Sanitation
Photo by John Gray

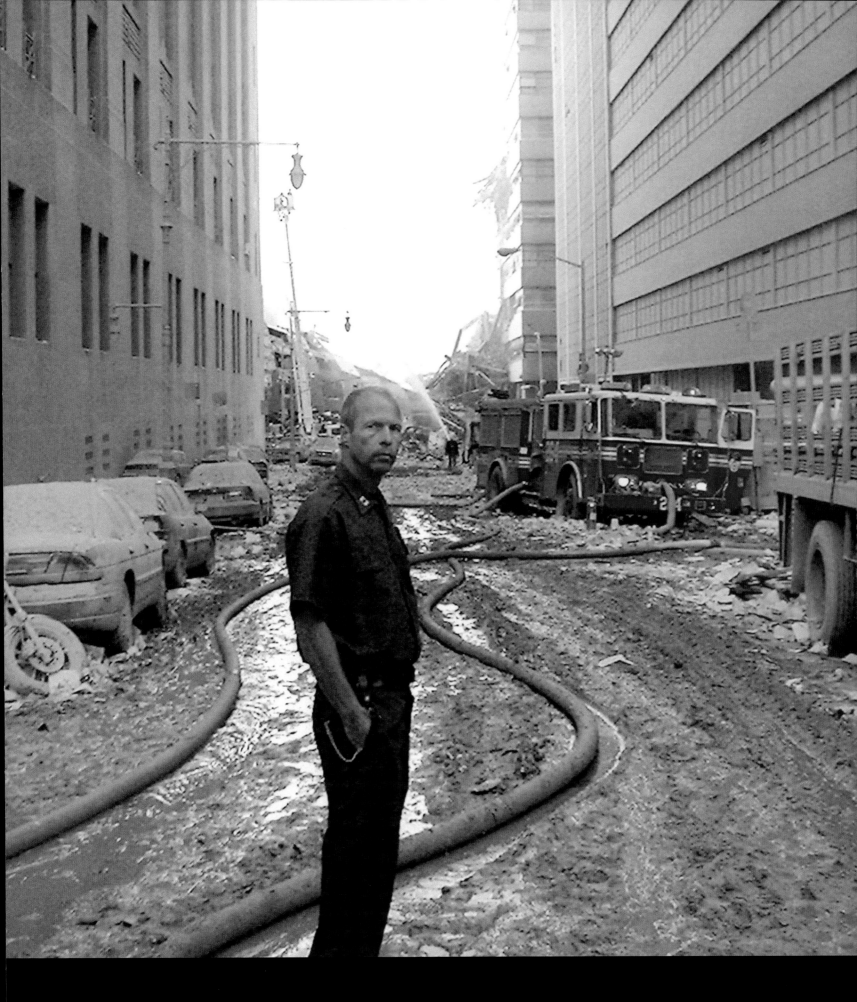

Subject: John Gray, Department of Sanitation
Photo by Stephen Shallash

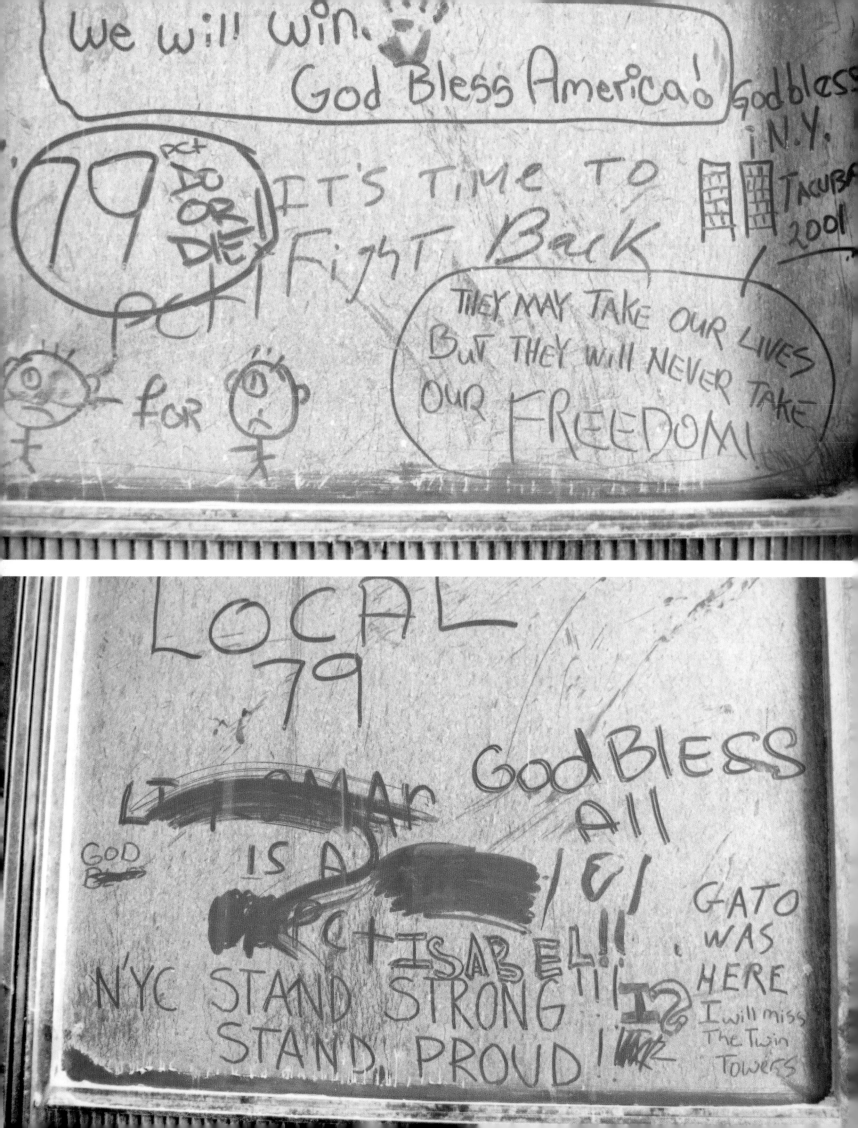

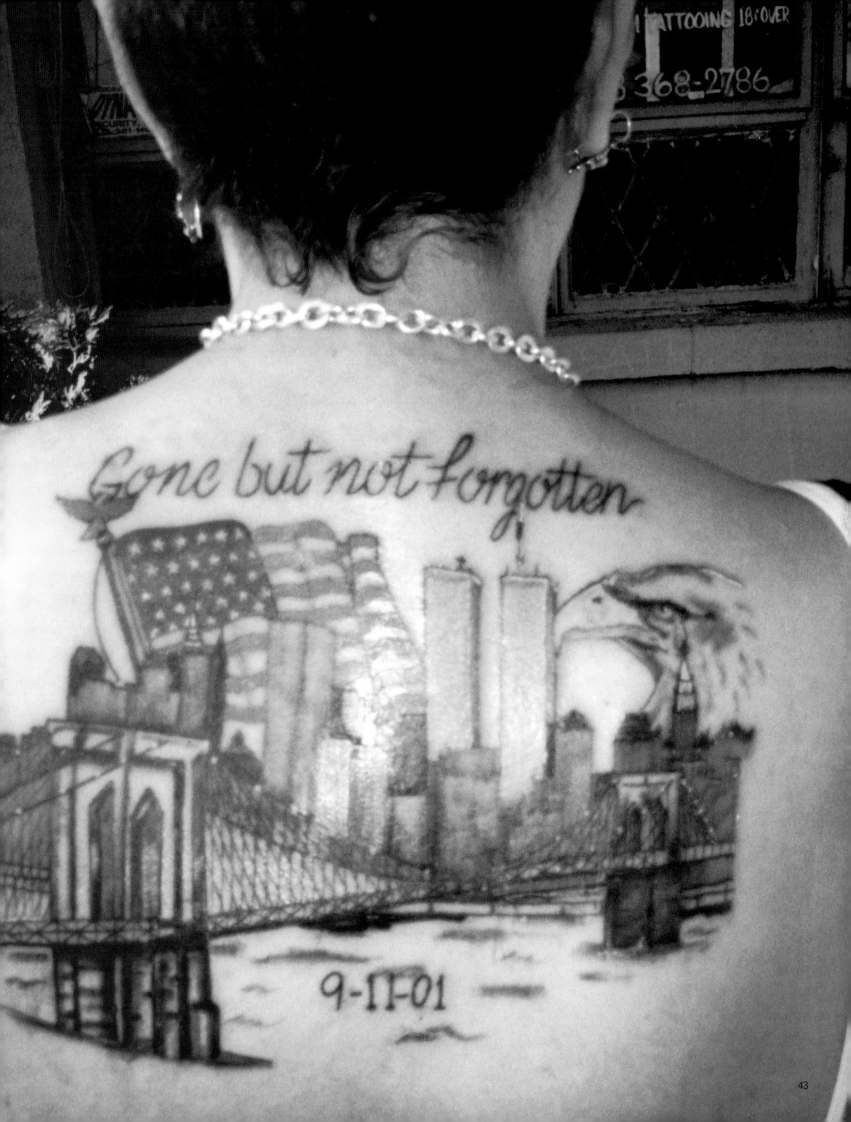

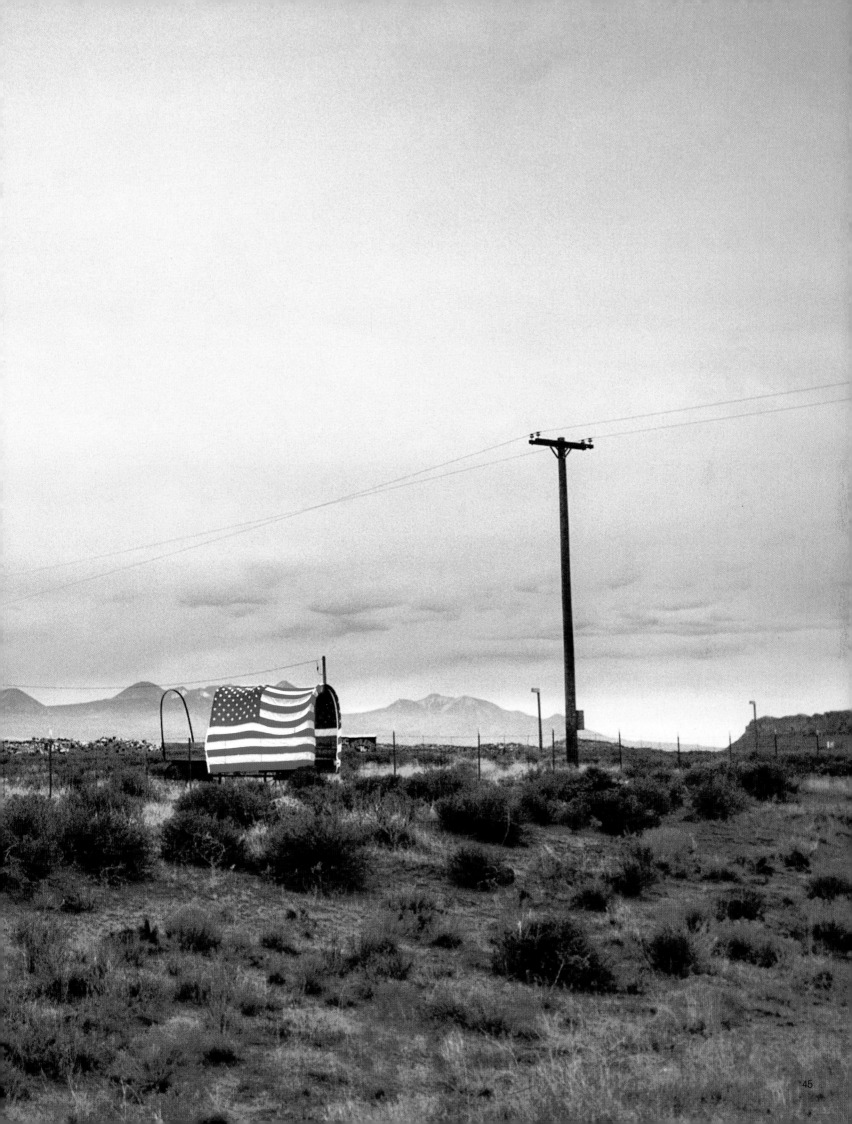

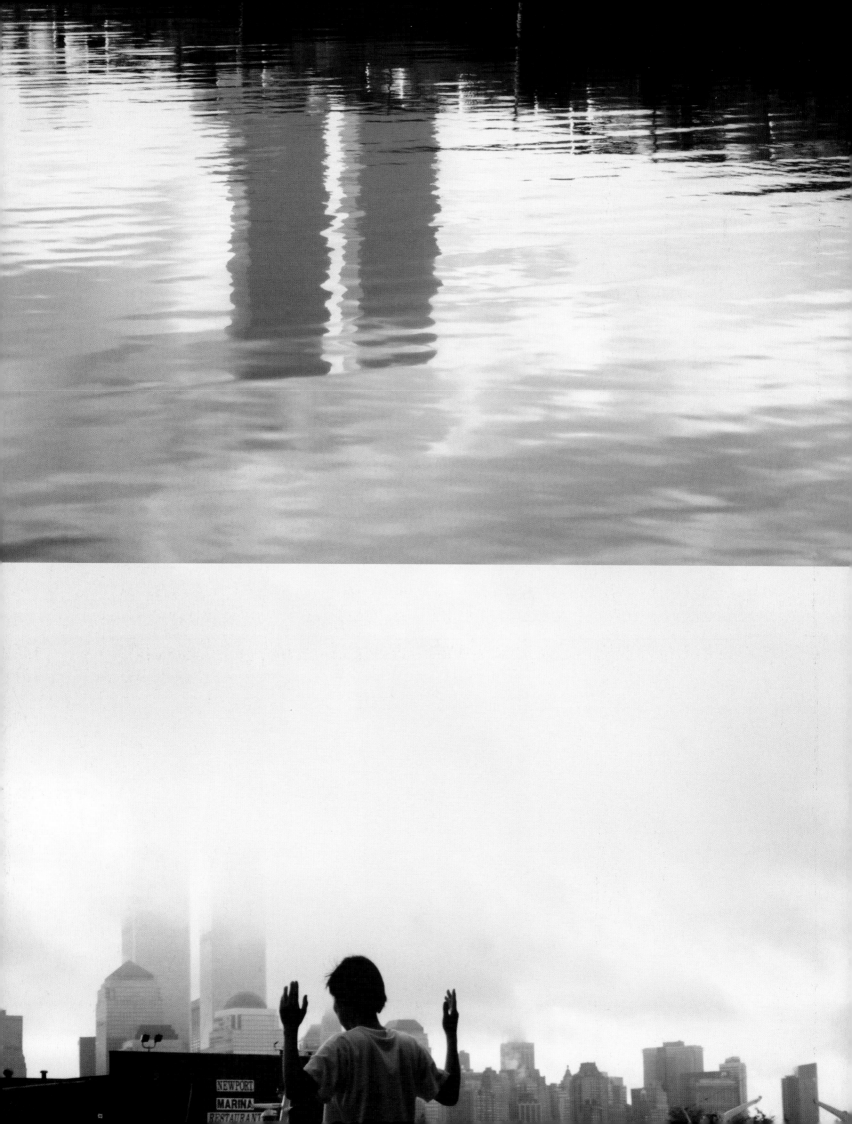

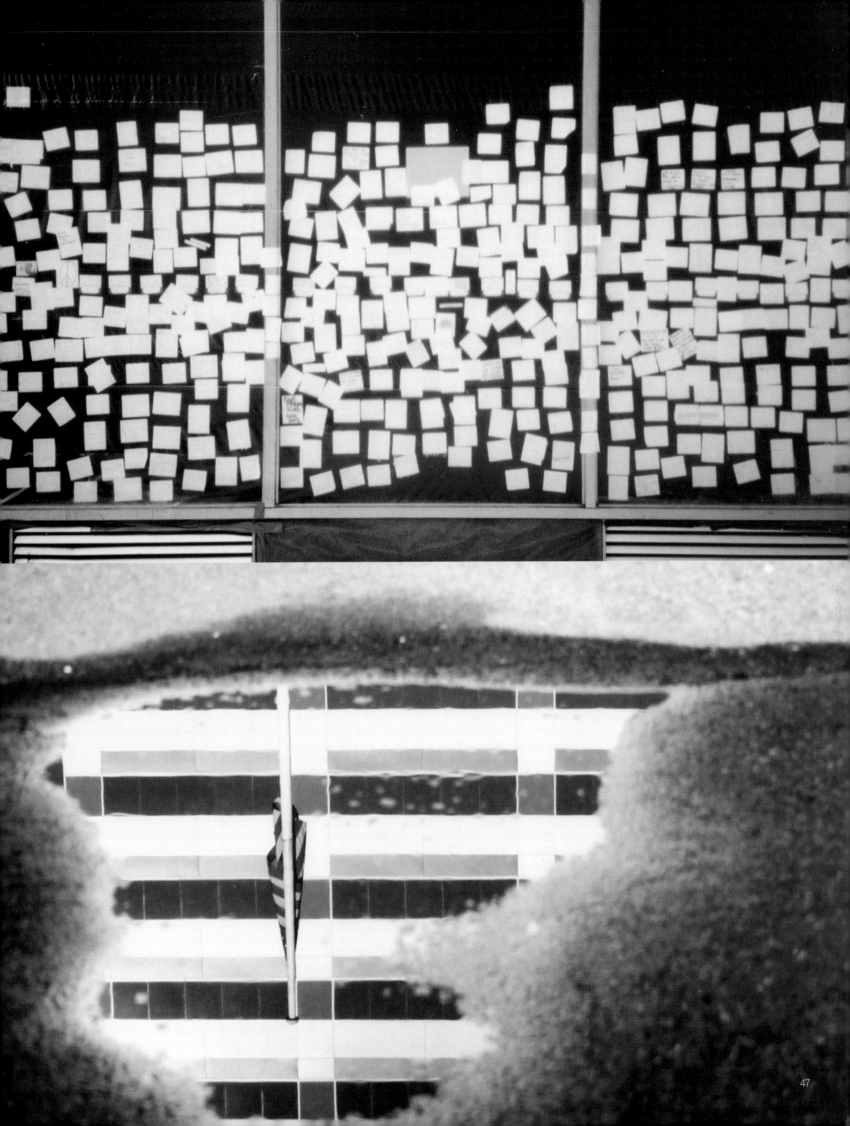

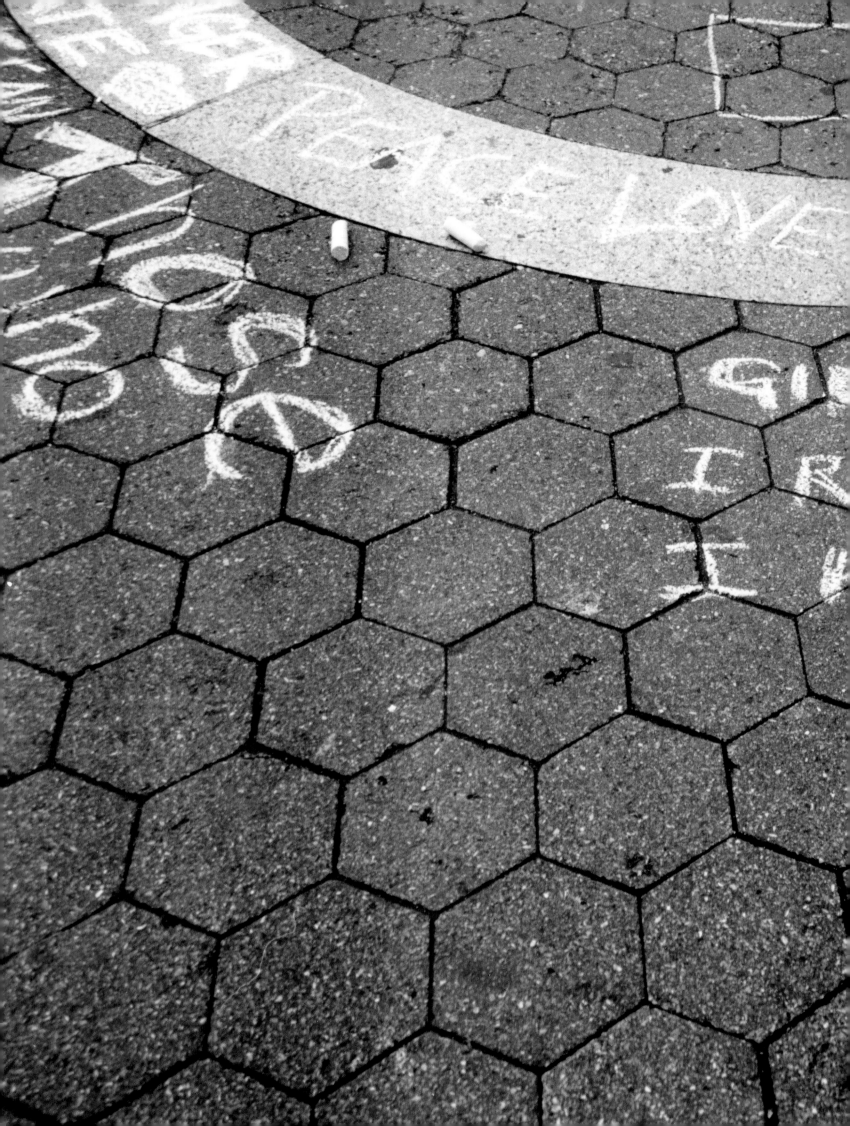

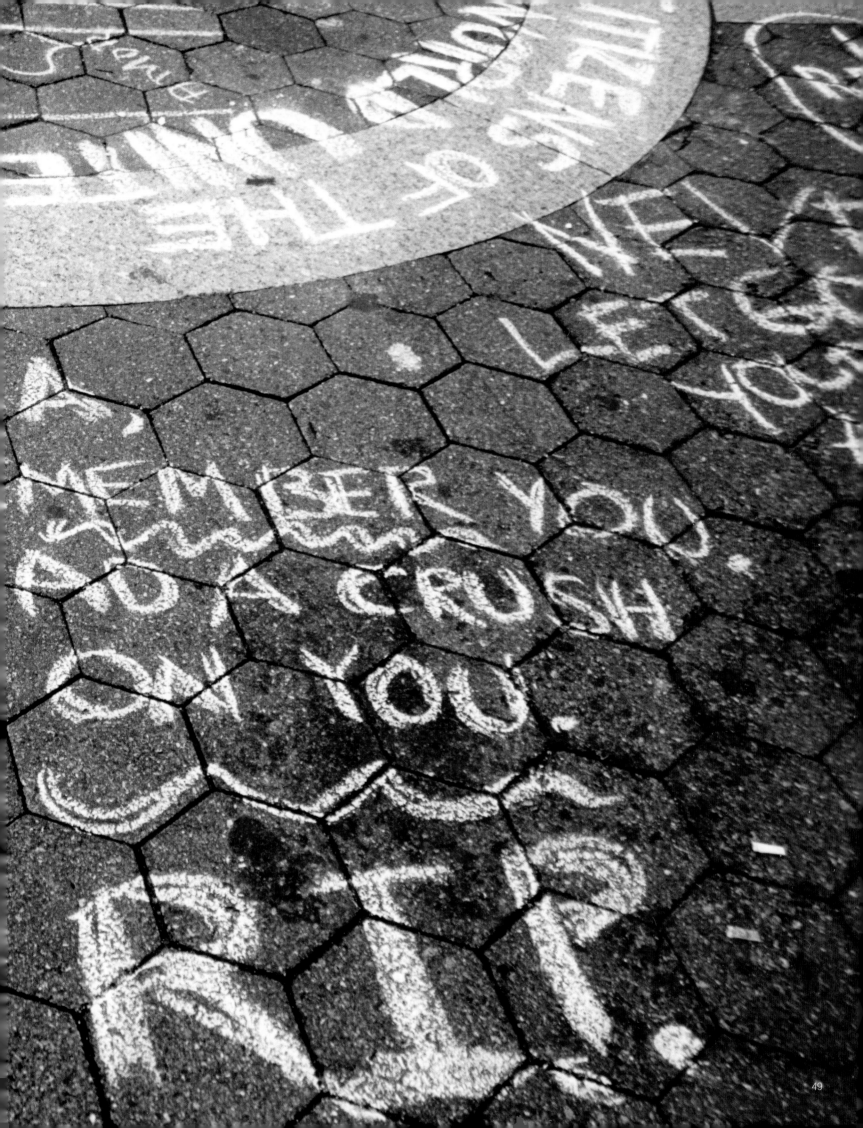

49

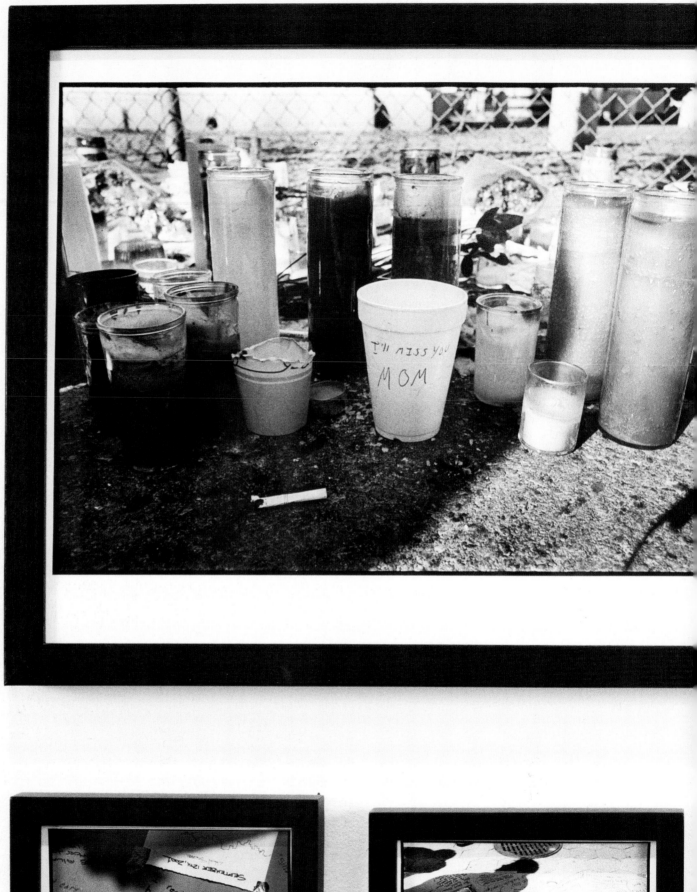

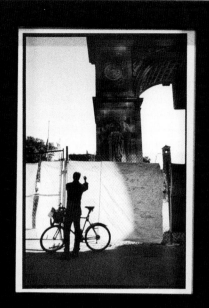

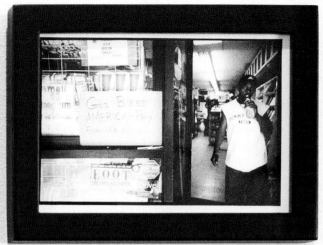

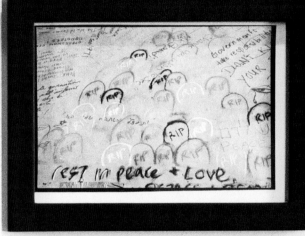

On September 11th + in the days that followed, I didn't know what to do with myself. I was filled with so much sorrow, so many mixed emotions. I started taking pictures because I felt the need to document what was going on. But a part of me also wanted to experience the events more, to feel things more deeply in order to reach a level of acceptance + understanding. I am hoping that the images will help me sort through it all in time.

Deborah Suchman Zeolla
New York City
November 2001

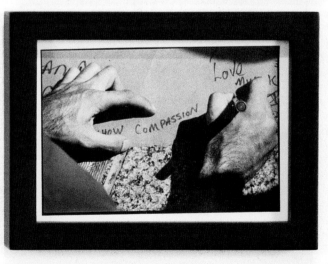

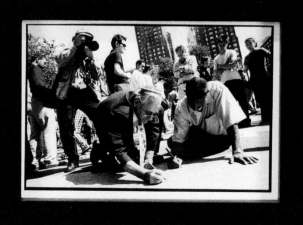

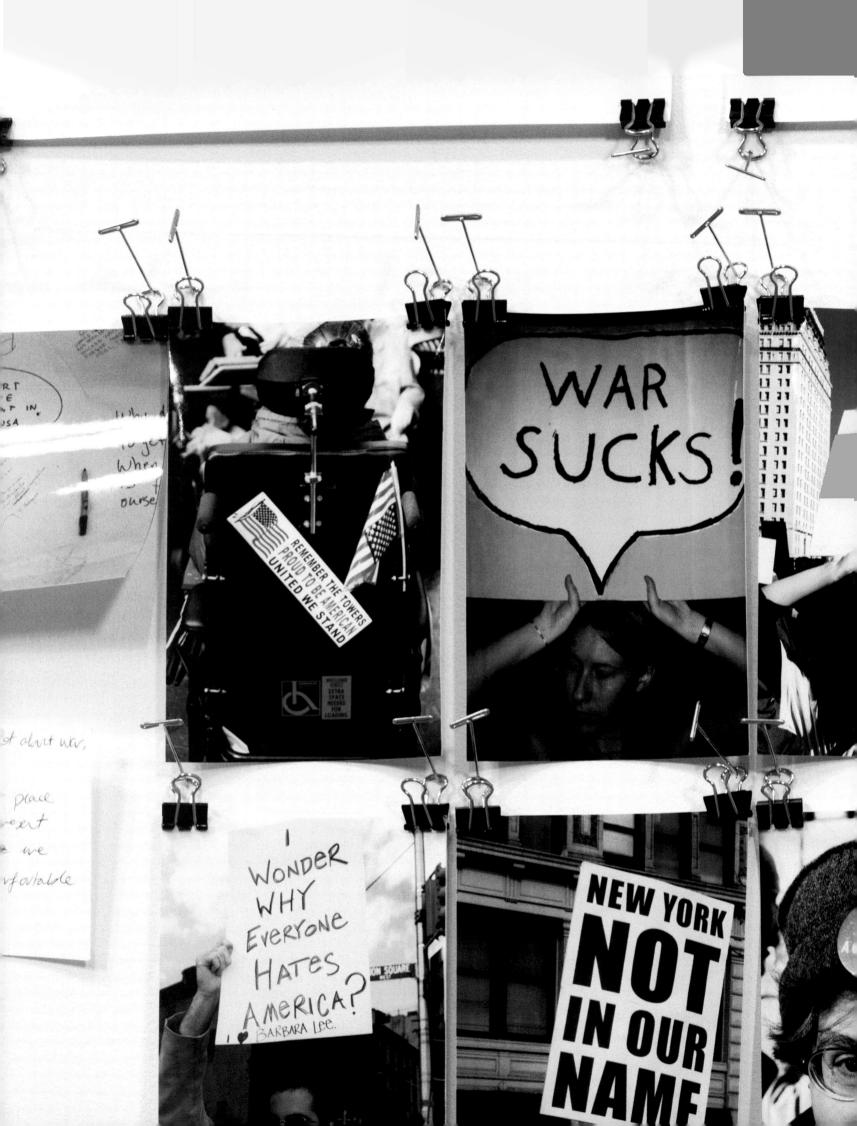

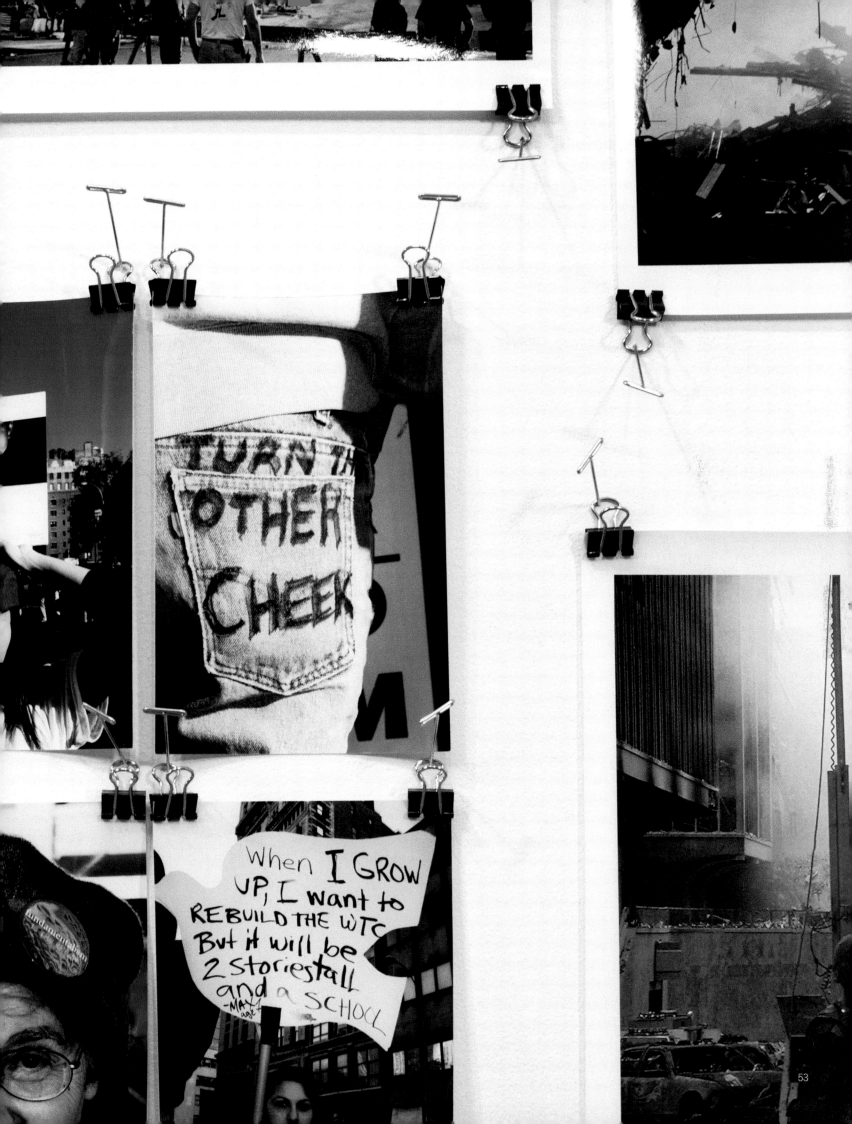

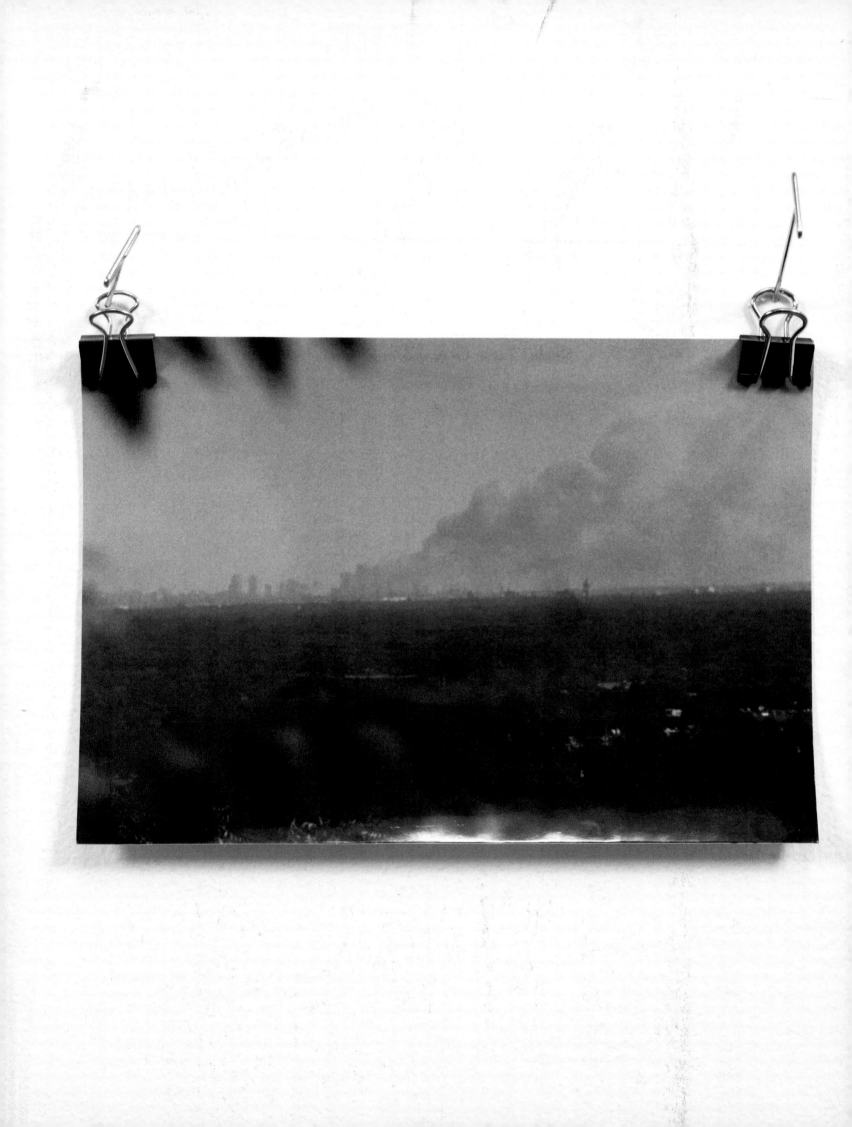

Empire State Building

Twin Towers were here

Air Traffic Control Tower Newark Airport

Elizabeth

Verrazano Narrows Bridge

September 11, 2001
about 11 AM

Taken from Washington Rock State Park
Green Brook, NJ

Kodak Pro 1000 film
photo has been darkened to
bring out smoke

Plainfield North Plainfield Dunellen Green Brook

the next day I was returning from a day at the NJ shore
September 12 - smoke on the left of my horizon near Seaside Heights
About 4pm, Garden State Parkway North

Kearny, near Cheesequake Rest Area and South Amboy
there's a bridge over a swamp
the free road has a bridge that goes up for boats at the Marina
I spied, through the gap out to the bay

So close I could touch it

Across the bay - 3 miles? to Lower Manhattan

A LIVING DEAD VILE THING

SEETHING LEERING

OCHRE, GREY BEIGE BLACK SMOKE
THE Hell, the fire that was the WTC
 My God, people were working in that horror to rescue, put out fires, the search dogs,
The smoke was so close I could almost touch it...

Karen E. Stober
509 Warrenville Road
Warren, NJ 07059-4617
kstober@skyweb.net, http://members.skyweb.net/~kstober/

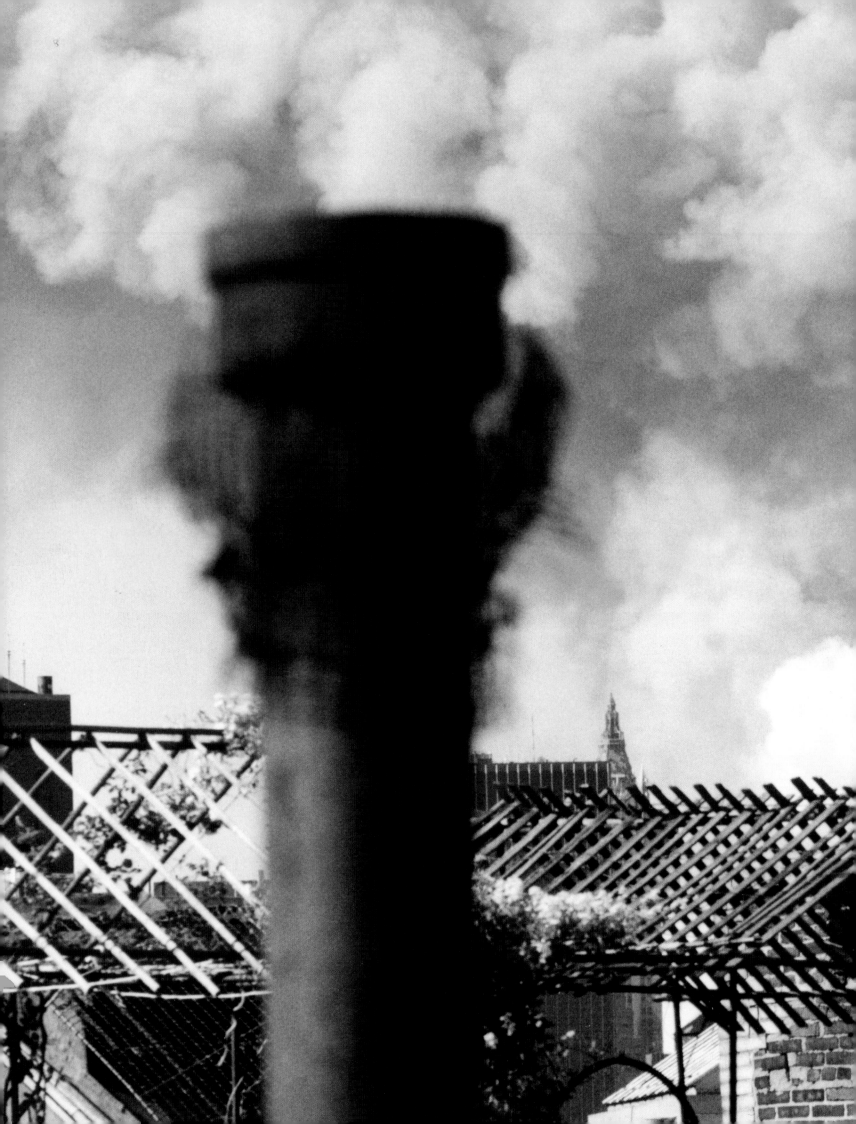

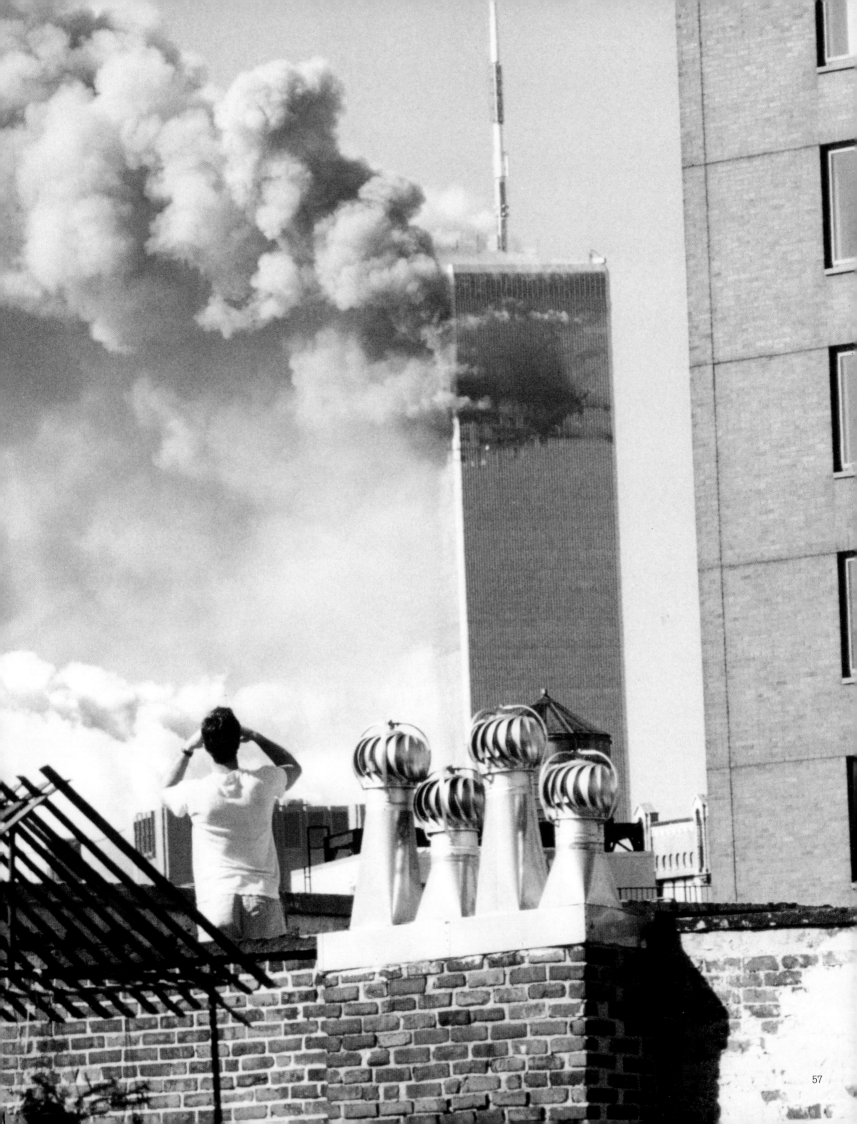

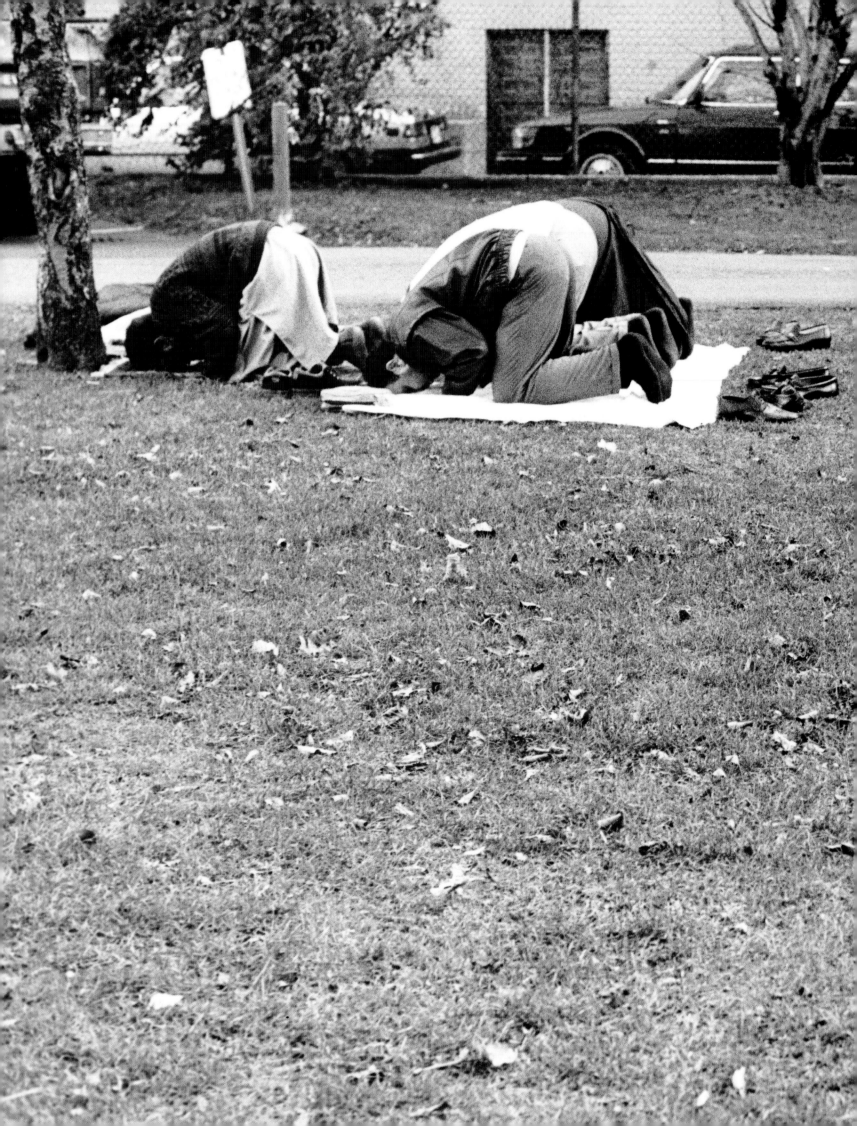

On September 11th I awoke to the news of the first tower being hit. I am a nurse and I knew that I had to go there. I Rollerbladed four miles downtown to the WTC with my medical kit and camera. We all helped people get to safety. Then I went back in with the first medical team and lived in the streets for five days and nights looking for bodies and nursing the rescue workers.

right:
Firemen and workers sing patriotic songs at Ground Zero by candlelight as they make a toast to all those who are gone. This was our M·A·S·H unit and the world outside had ceased to exist. No one had slept in days . . . no one wanted to stop looking. Just to find one person alive would have been enough.

following pages, clockwise from top left:
A little out of focus but clear to my mind. Firemen climbed through the holes of the WTC windows looking for survivors.

From day one, ironworkers worked around the clock to try and cut through the piles of steel to find someone alive. When the loose buildings around us were falling they stood firm. They were so brave. They never gave up. Here we could hear the tappings from someone deep underground. They dug for hours and climbed into dangerous holes, but it was hopeless; the steel was too deep.

Destruction . . . firemen climb into the unknown . . . looking for anyone.

We were there for the workers and we wouldn't leave. This picture was taken when FEMA finally ordered the shutdown of our M·A·S·H triage unit at St. Charlie's bar at Ground Zero on Day 5. Many officials came to move us out, but in the end they would cover their badges and say, "Just stay and do what you can. We need you." When it was time to leave we were exhausted. It was time for others to take over. We had tried our hardest.

After leaving Ground Zero I was traumatized in bed for a week. A worker from the American Red Cross gave me some cards from the schoolchildren. They said: "If you have a broken heart you can have mine," and "You are my best friend, I love you so much." These cards turned my life around; I joined the Red Cross and have been working back down at Ground Zero as a full-time volunteer for the past three months.

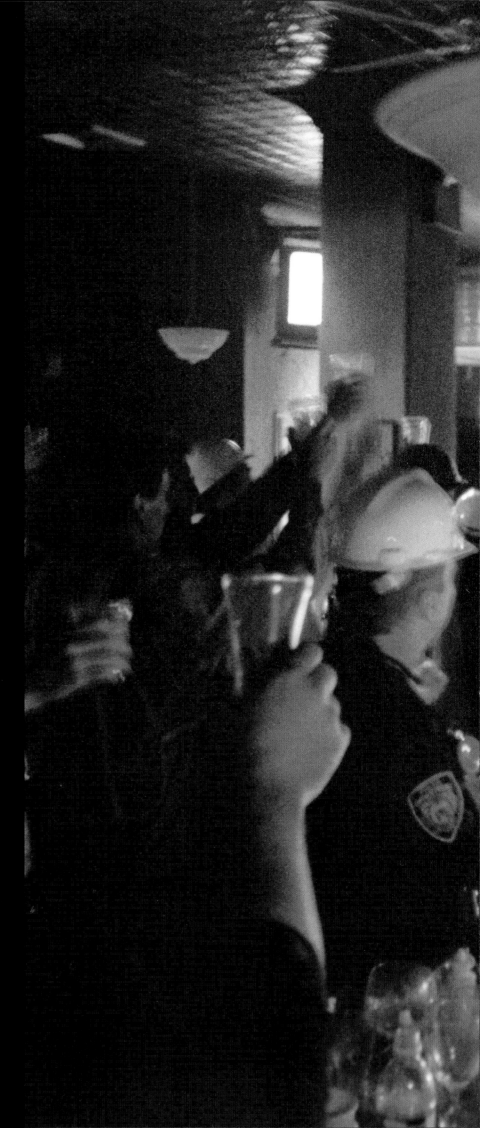

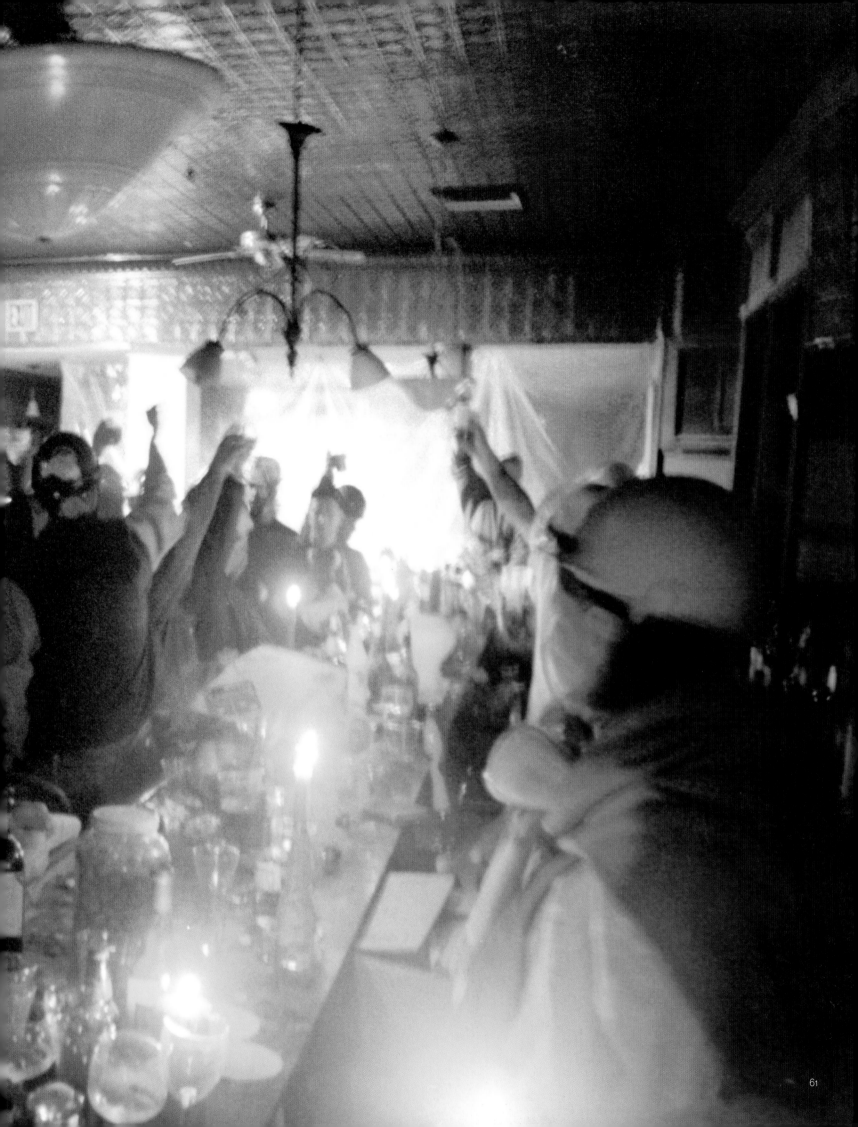

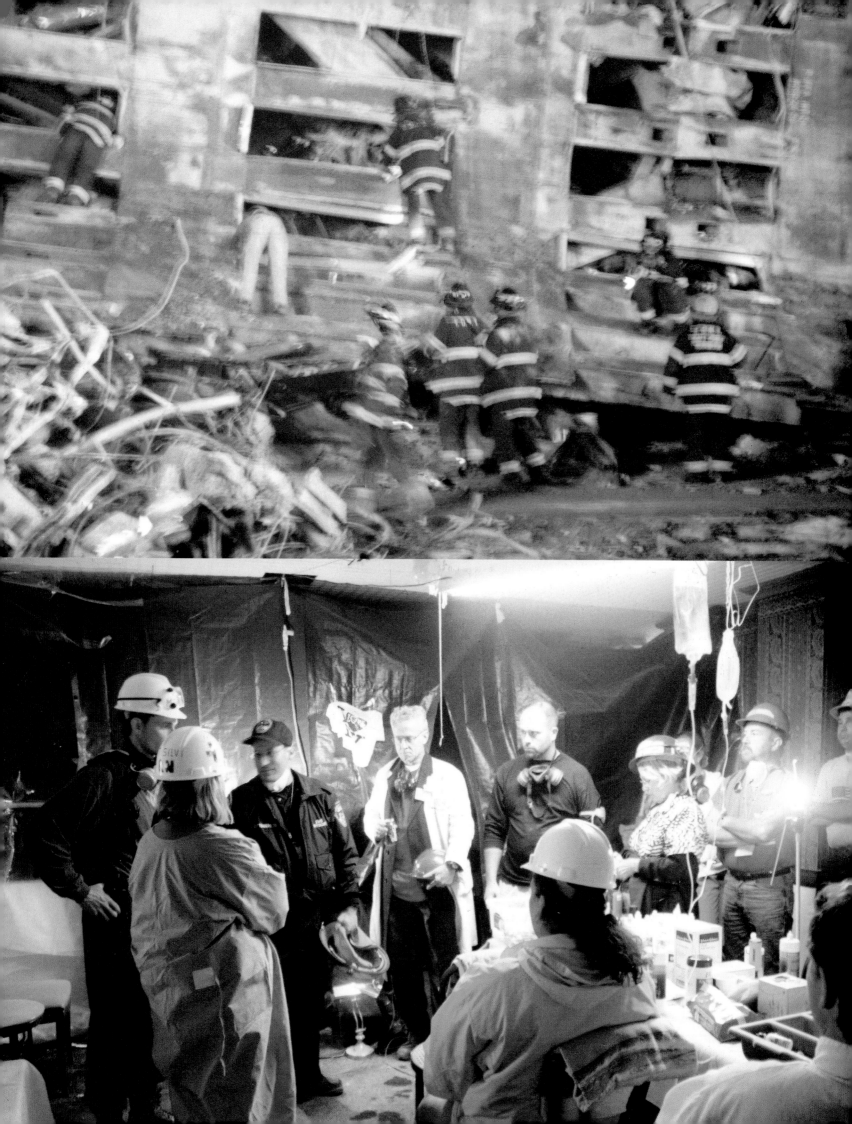

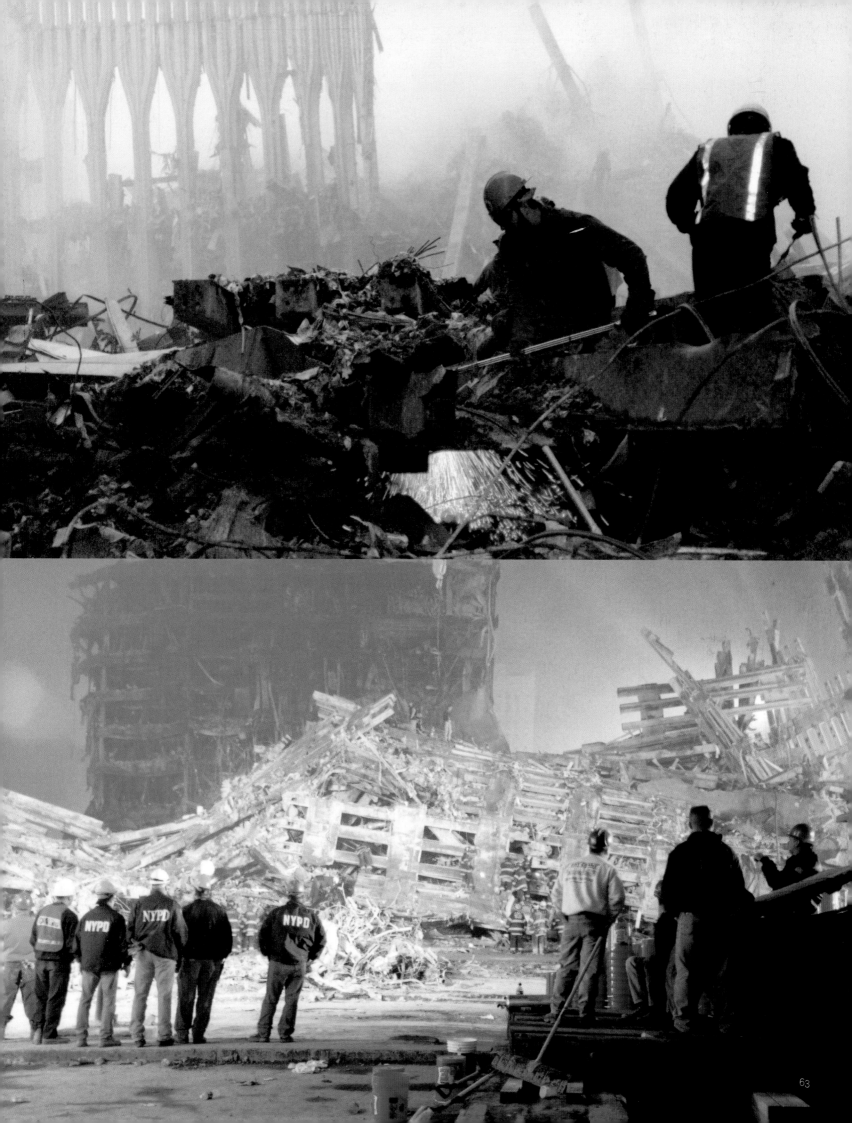

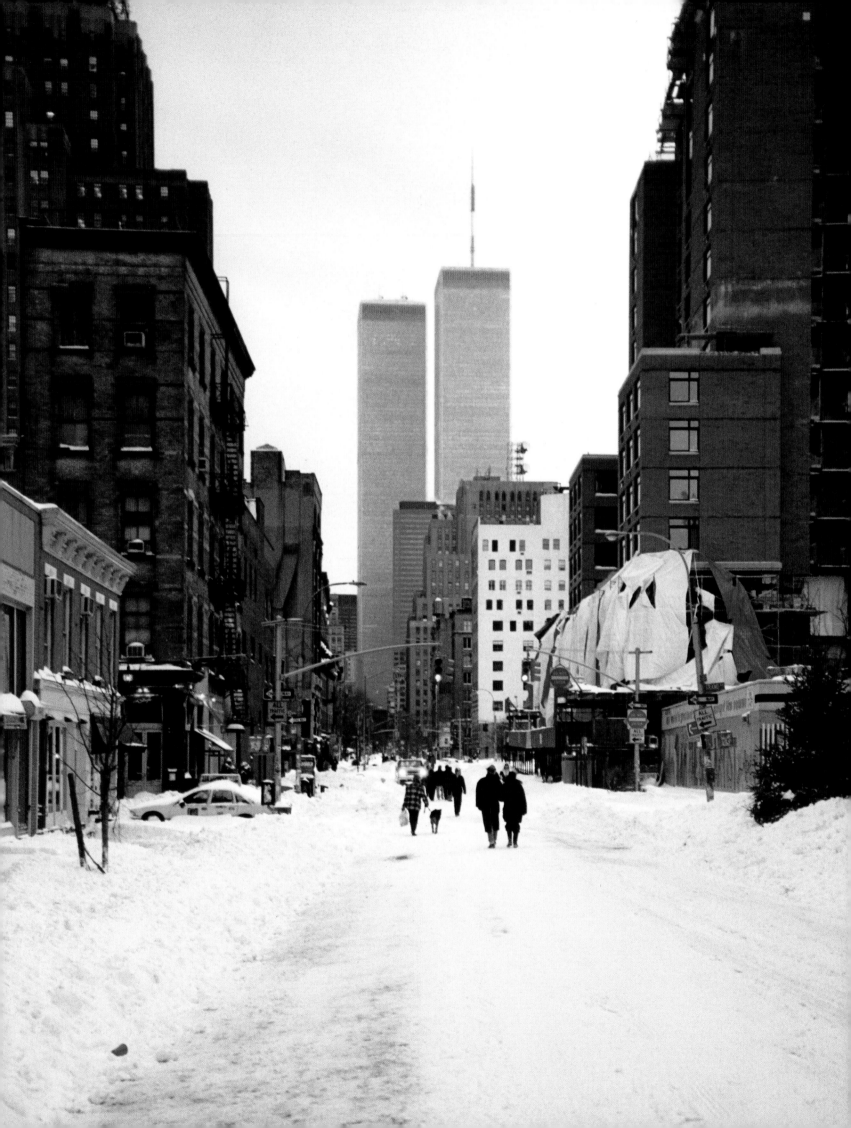

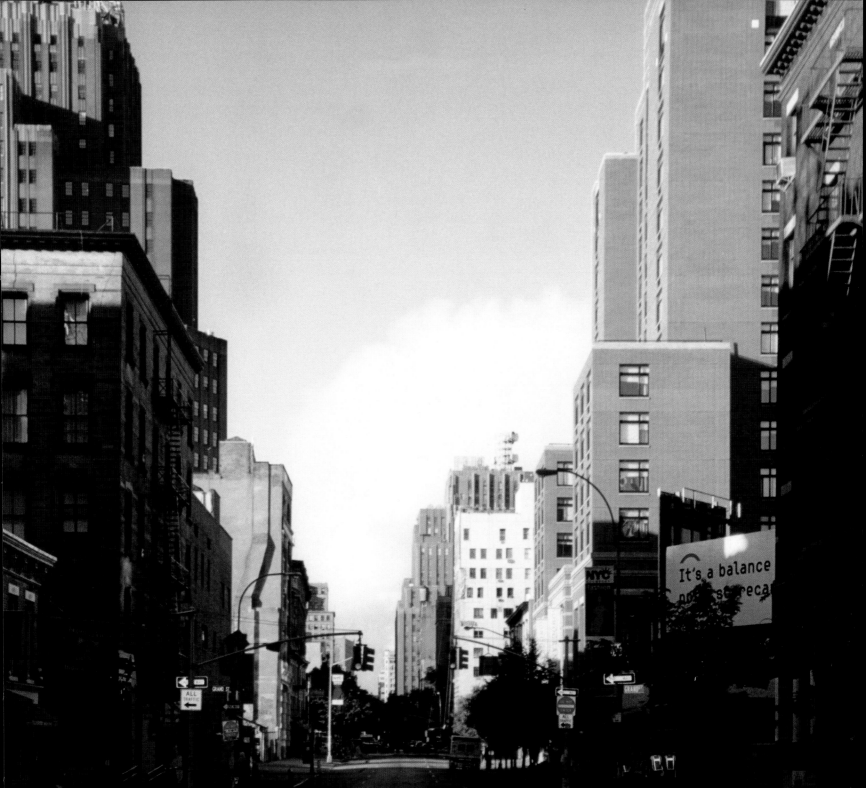

The Century 21 department store had seen better ad
campaigns. This one read:

MORGUE
3 blocks
Trinity Place FedEx Bldg.

There was still room beside the dripping, blood-red Krylon spray
paint for two visiting cops to add their tags to the dusty wall below
the blown-out display windows. It had poured rain the night before,
but there was enough dust-covered wall in lower Manhattan for
every New Yorker to sign in.

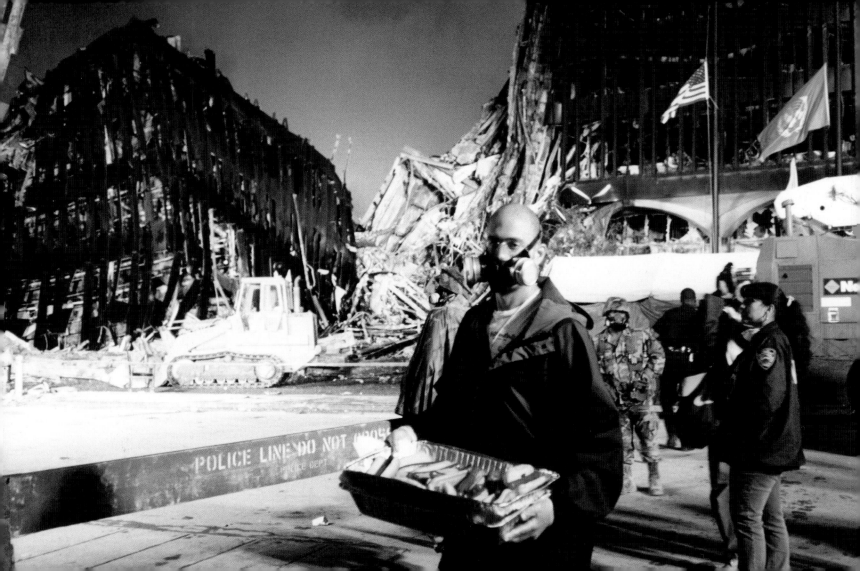

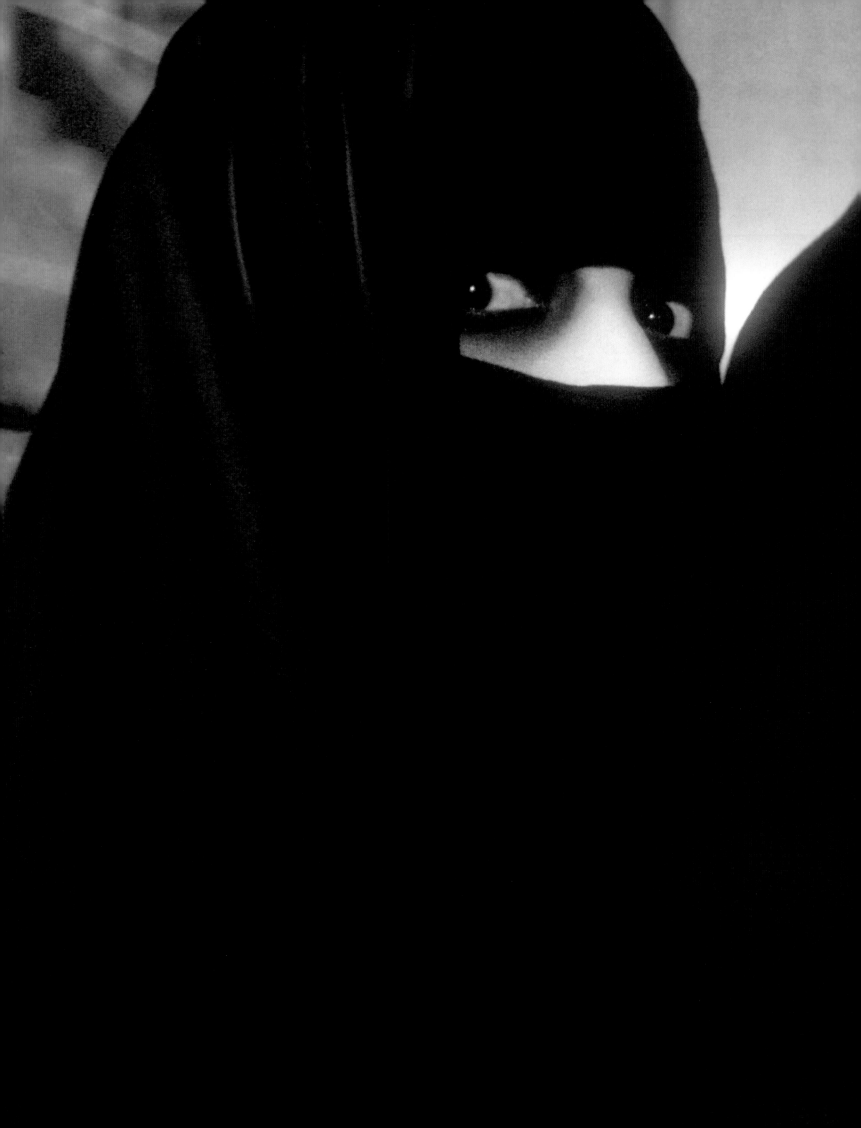

Dedicated to all women behind the Veil,
As they struggle,
For Equality, Freedom, and Peace,
In America, they fear for their safety.
In Afghanistan,
They are tortured by the Taliban,
Their struggle continues.

"Chador"

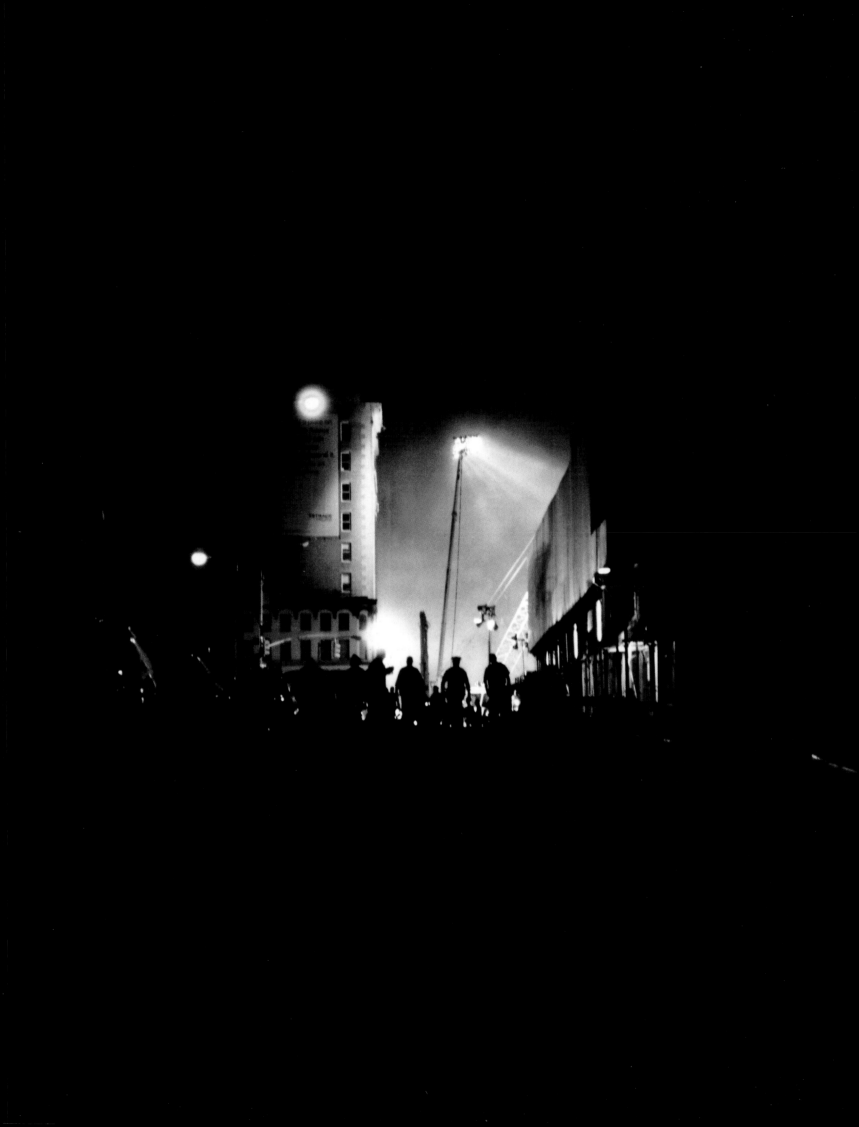

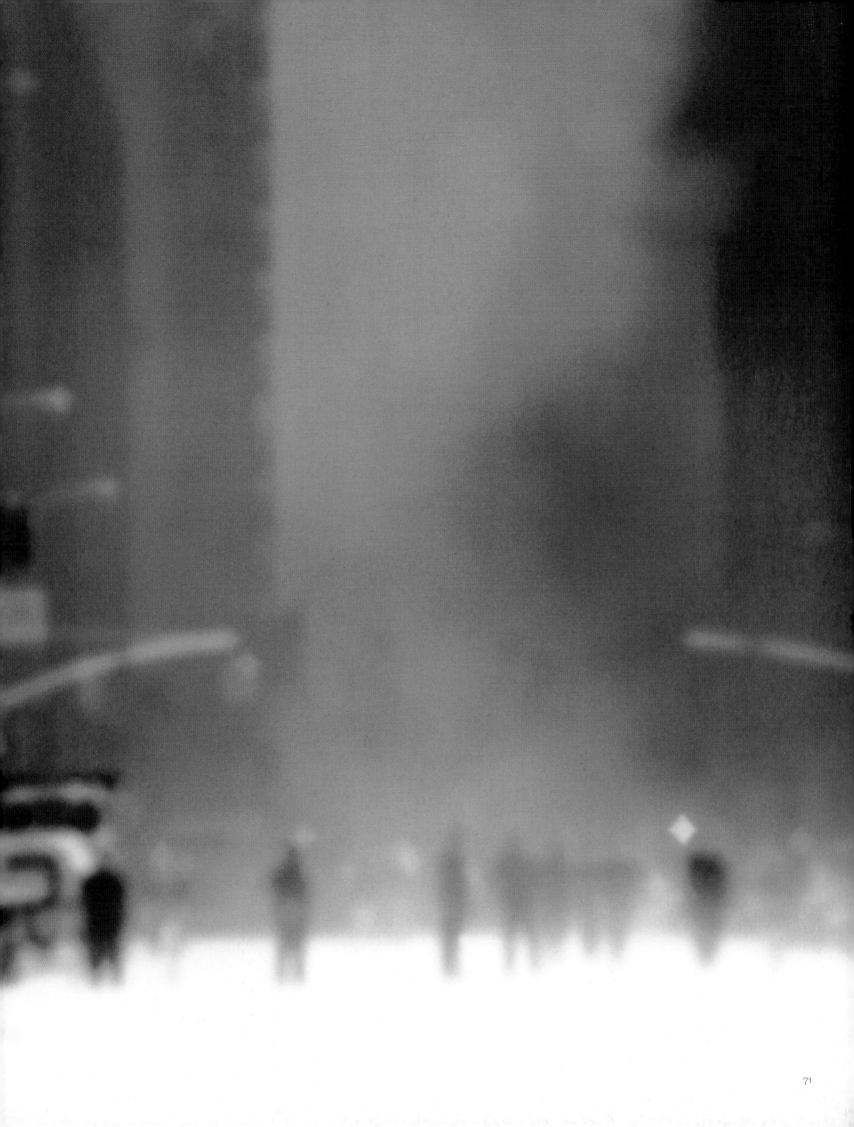

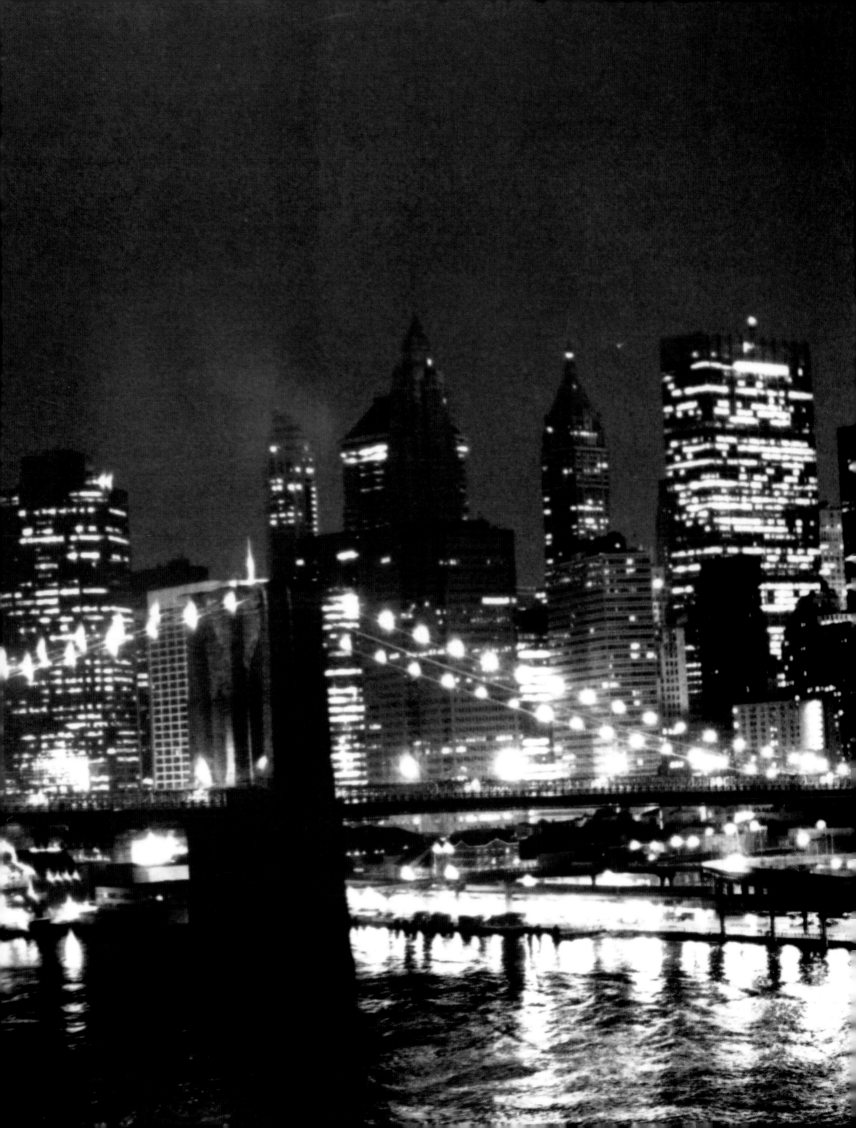

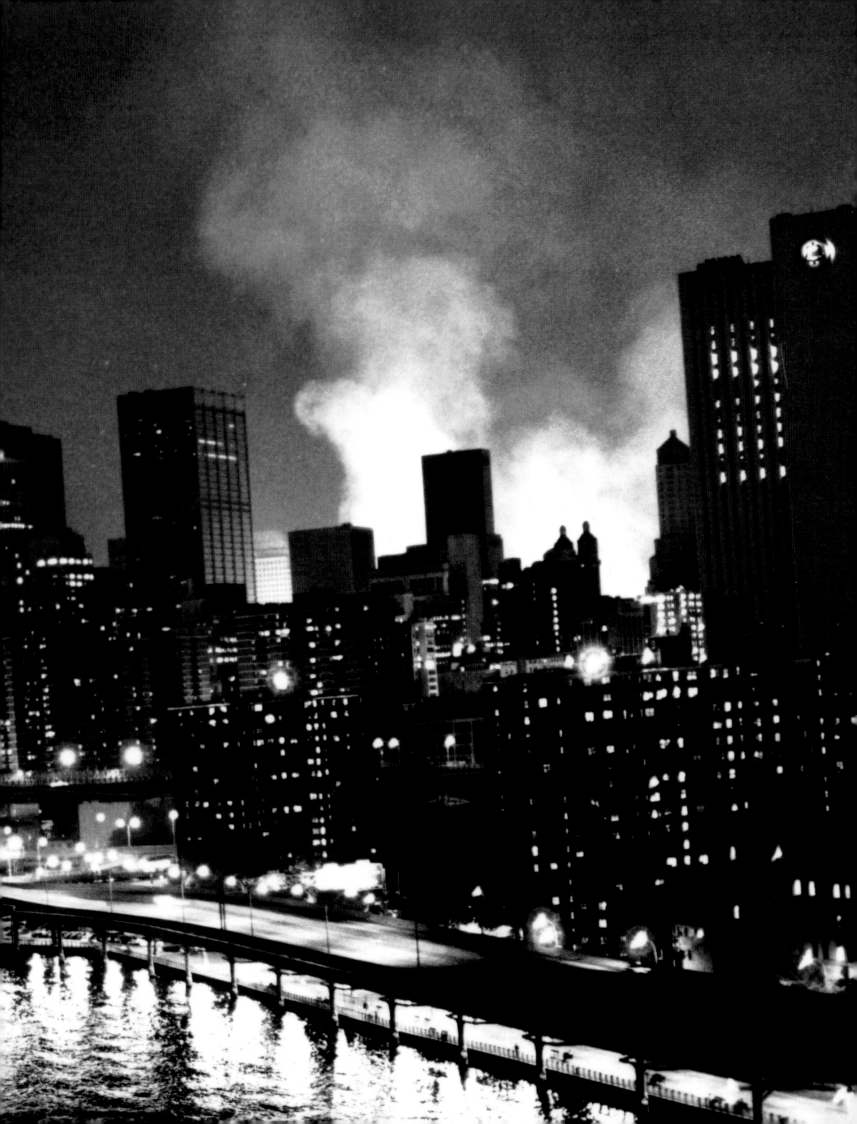

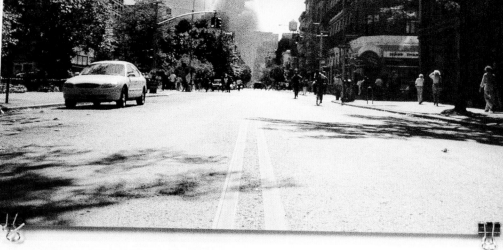

I've been taking photos since the DayOne of the Sept 11 attacks. This is a small collection of the photos I chose as place to represent the feeling that filled the air on that day. You might ask where is DayOne? DayOne to me & most of the people is about "missing" And that's why the photo of DayOne IS "missing" etc...

I have more photo in my web site if you are interested. → 911Vivo.com ... Thank you & be well.
CK.

911Vivo.com

Embolden.

Washington D.C. Police
December 2001

The September 11 Photo Project
25 Wooster Street
New York, NY 10013

Dear September 11 Photo Project:

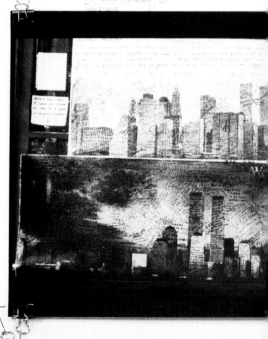

Battlefield.

Dear America

Vivo!

IronWill.

Lift.

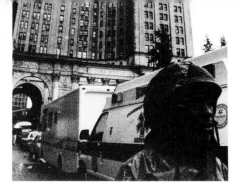

We pray for the victims...

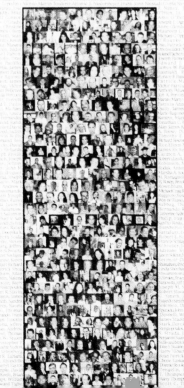

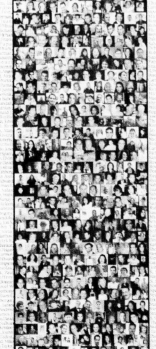

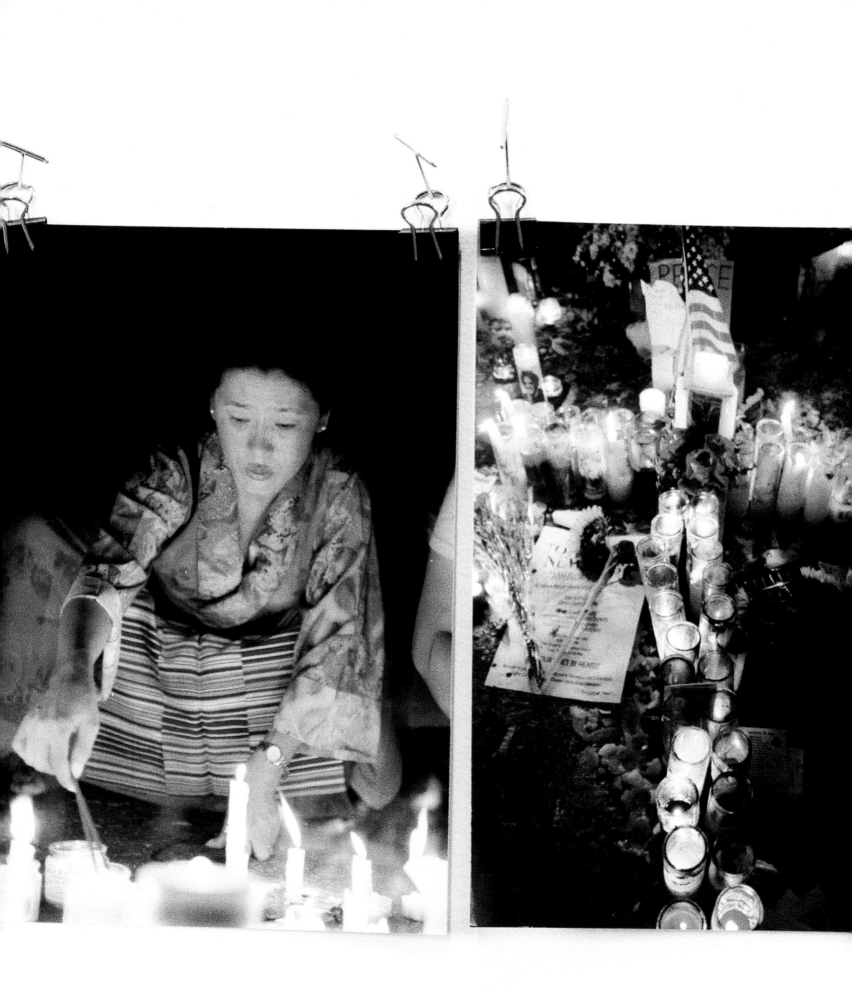

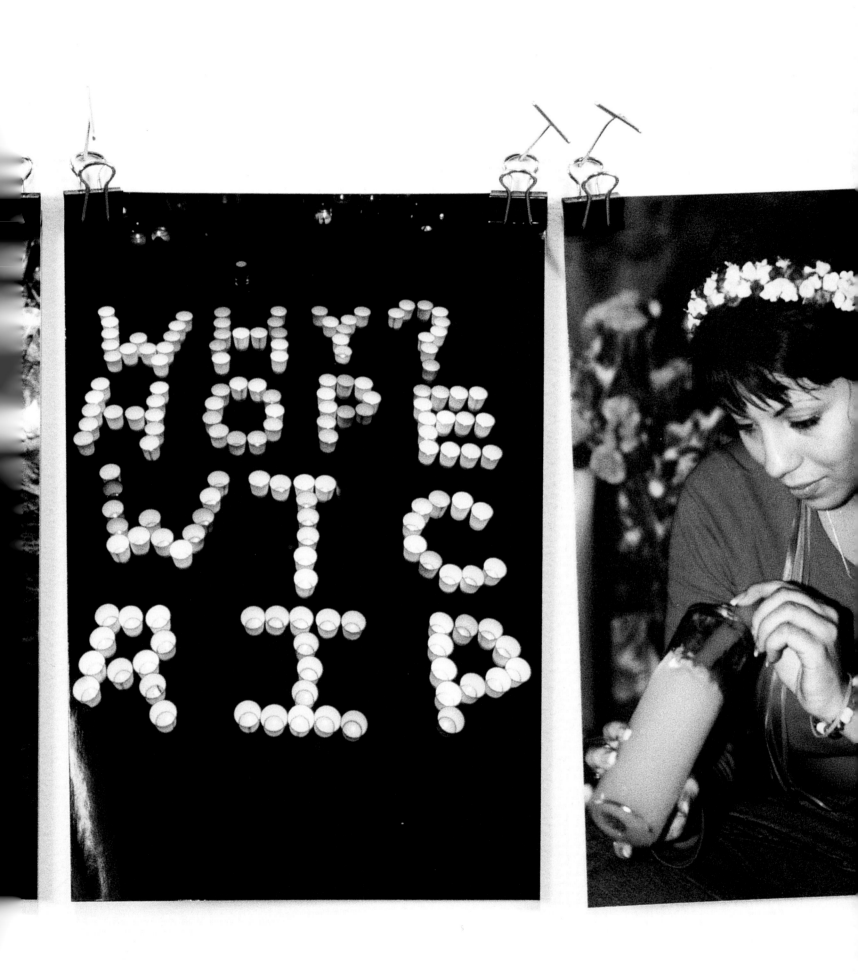

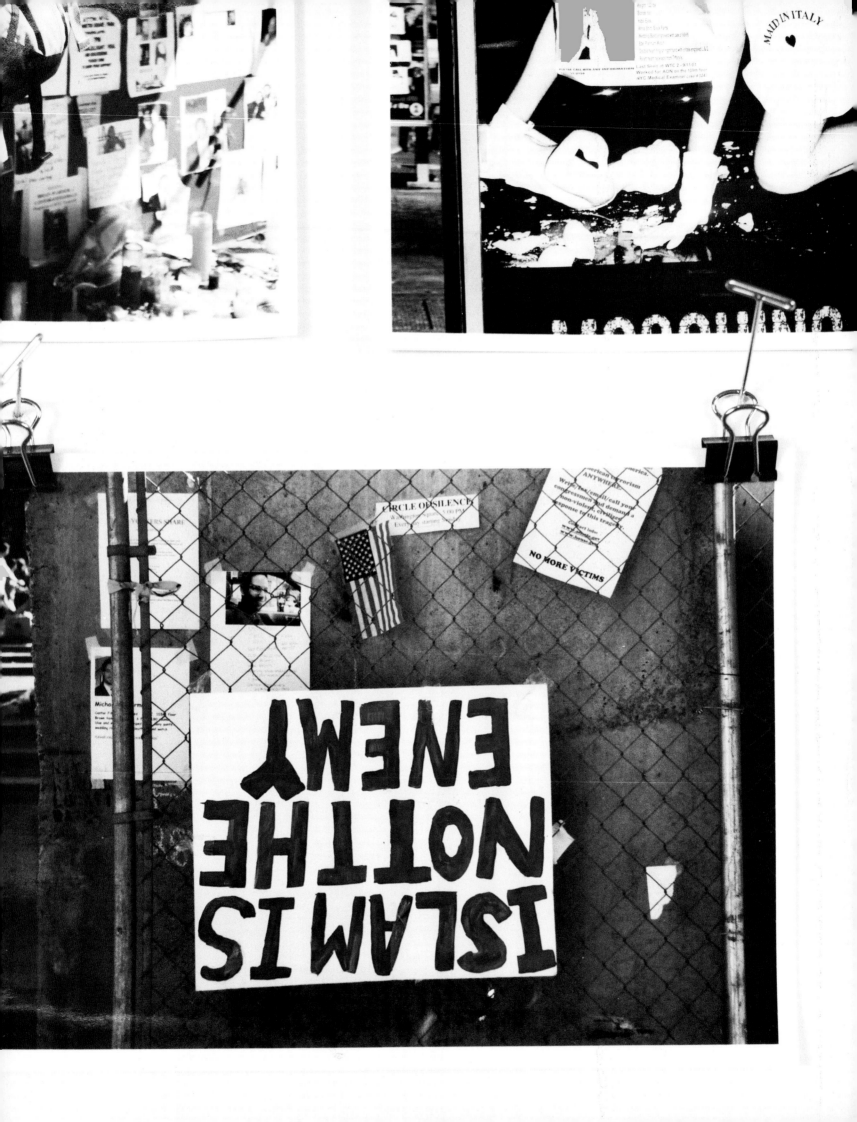

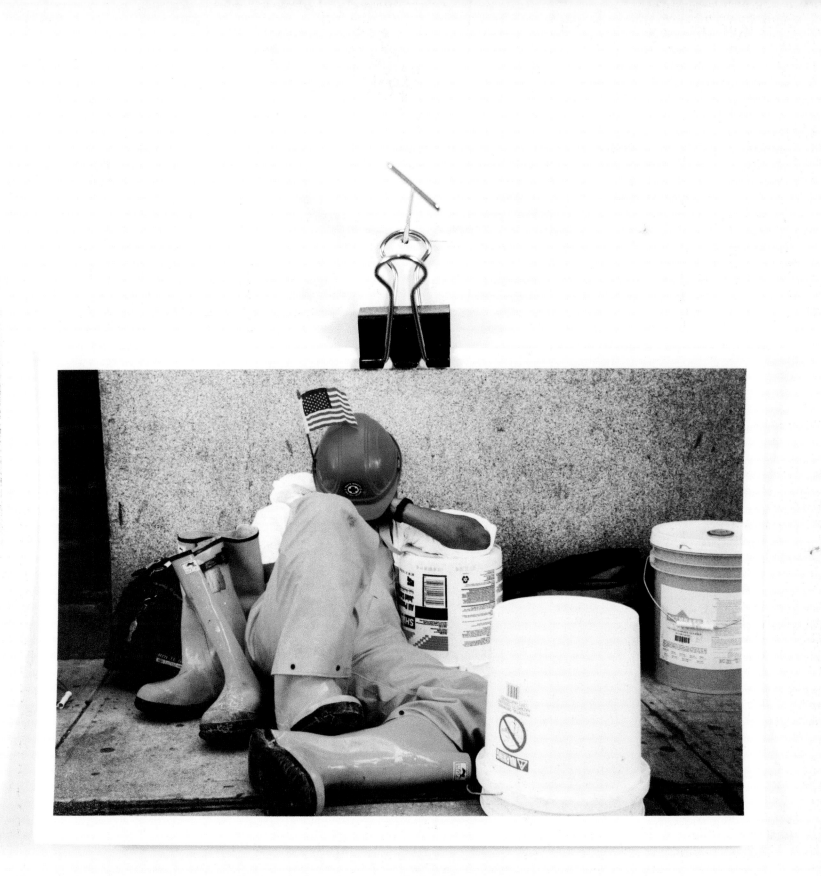

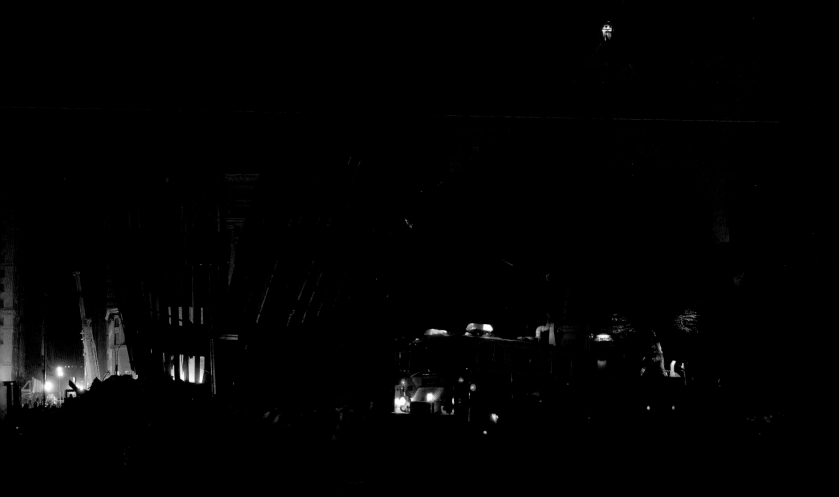

Intersection of Cortlandt and Church Streets on the night of
September 12th.

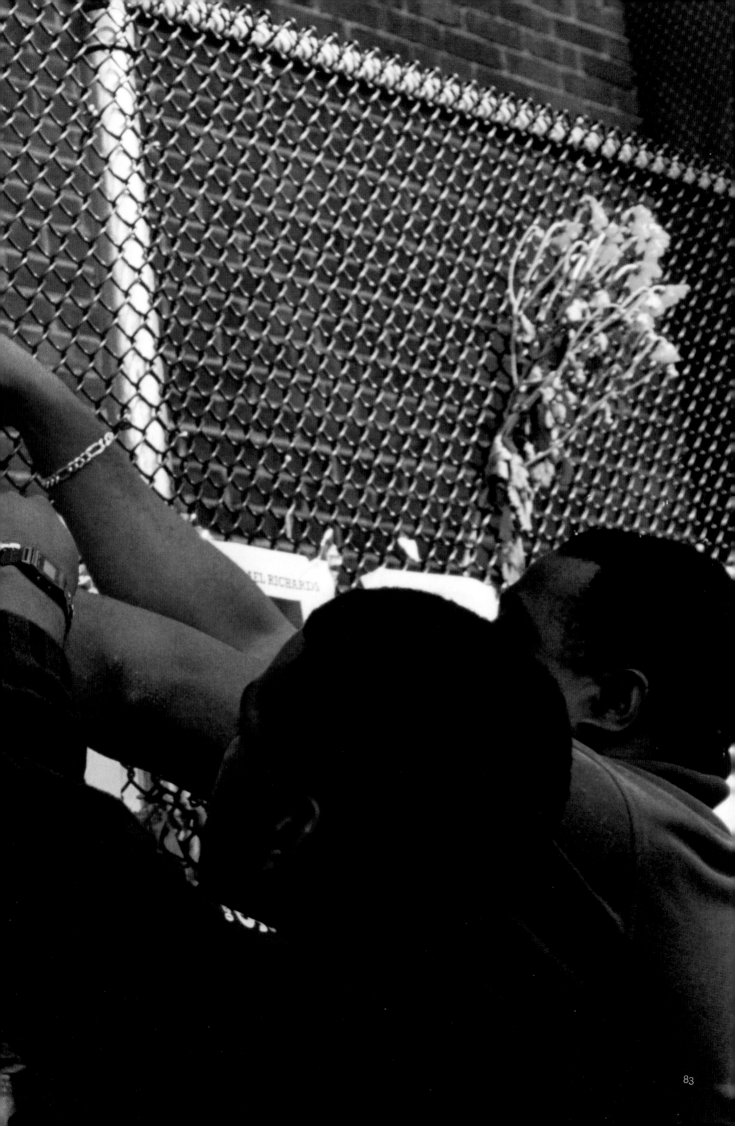

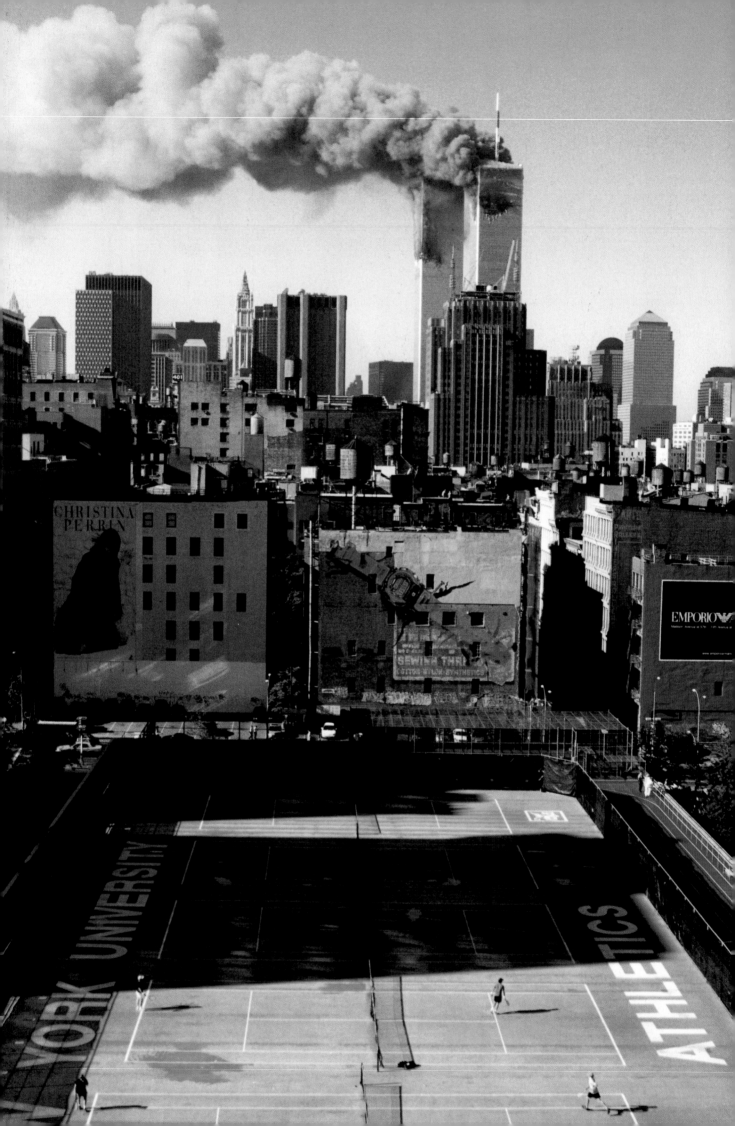

I am told that when President Kennedy was assassinated, everybody remembers where they were when they heard the news. The same is so of the terrorist attacks of 11 September 2001.

I had returned from a three-week trip late afternoon just the day before and awoke to meet my parents, who were visiting, for breakfast uptown. As I was about to leave my apartment, I heard a bang and turned to close my balcony door. I noticed one of the Twin Towers on fire and immediately turned on the TV. As I looked south from my balcony, the crumbling buildings reminded me of the film *Independence Day,* but this time it was not Hollywood. New York University tennis players continued playing, unaware that terrorists had struck. We have all been affected by this tragedy, some much more than others as I discovered at the nightly vigils and at the Lexington Armory, where "missing persons" posters seemed to go on forever. Tragedy has altered my "room with a view" and the NY skyline, but I realize that I am one of the luckier ones.

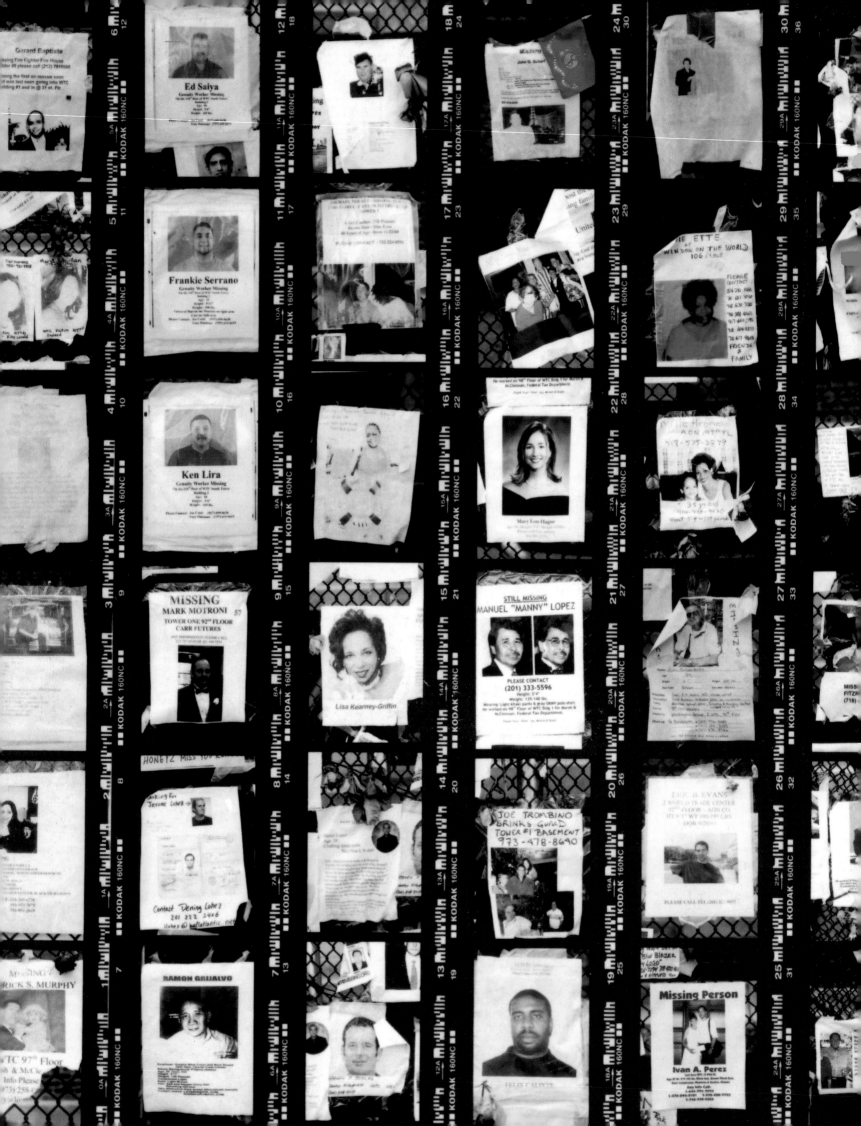

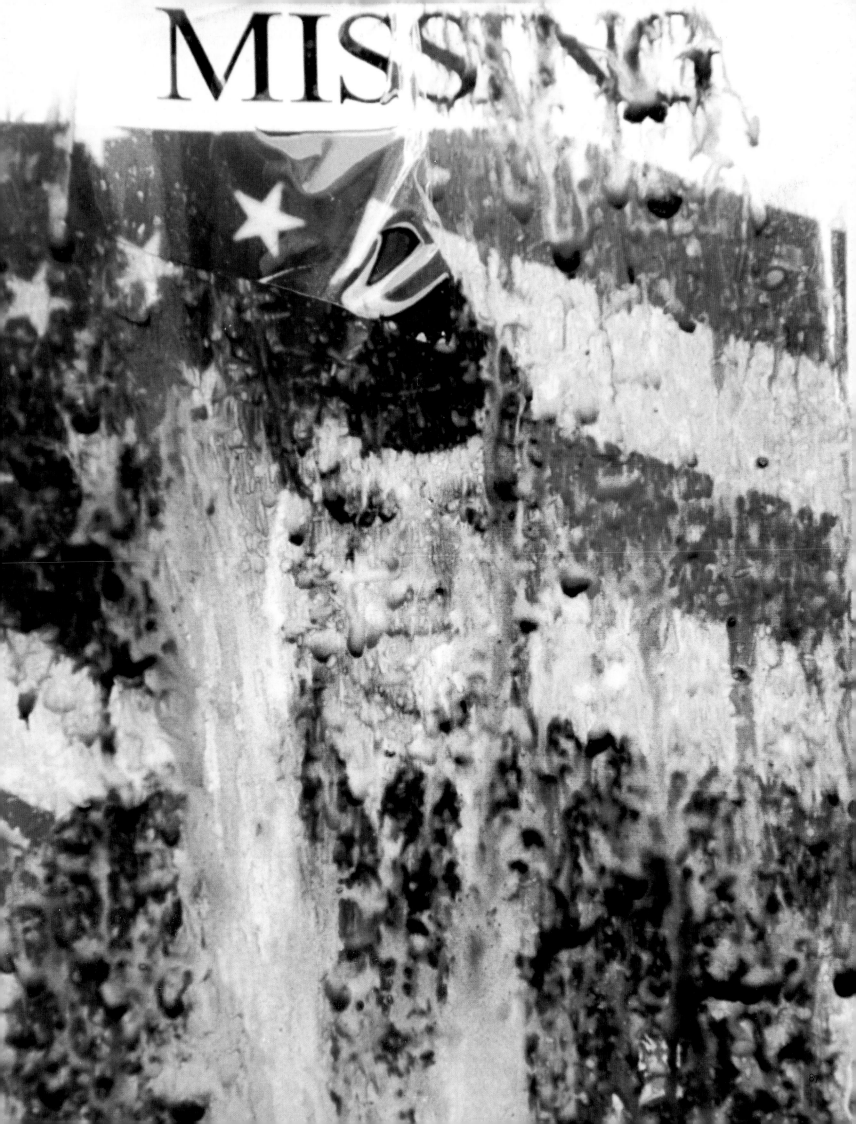

This picture was taken September 11th in Tanzania, before any of us knew. It seems oddly prophetic, in retrospect, how much a controlled burn resembled a terrible accident.

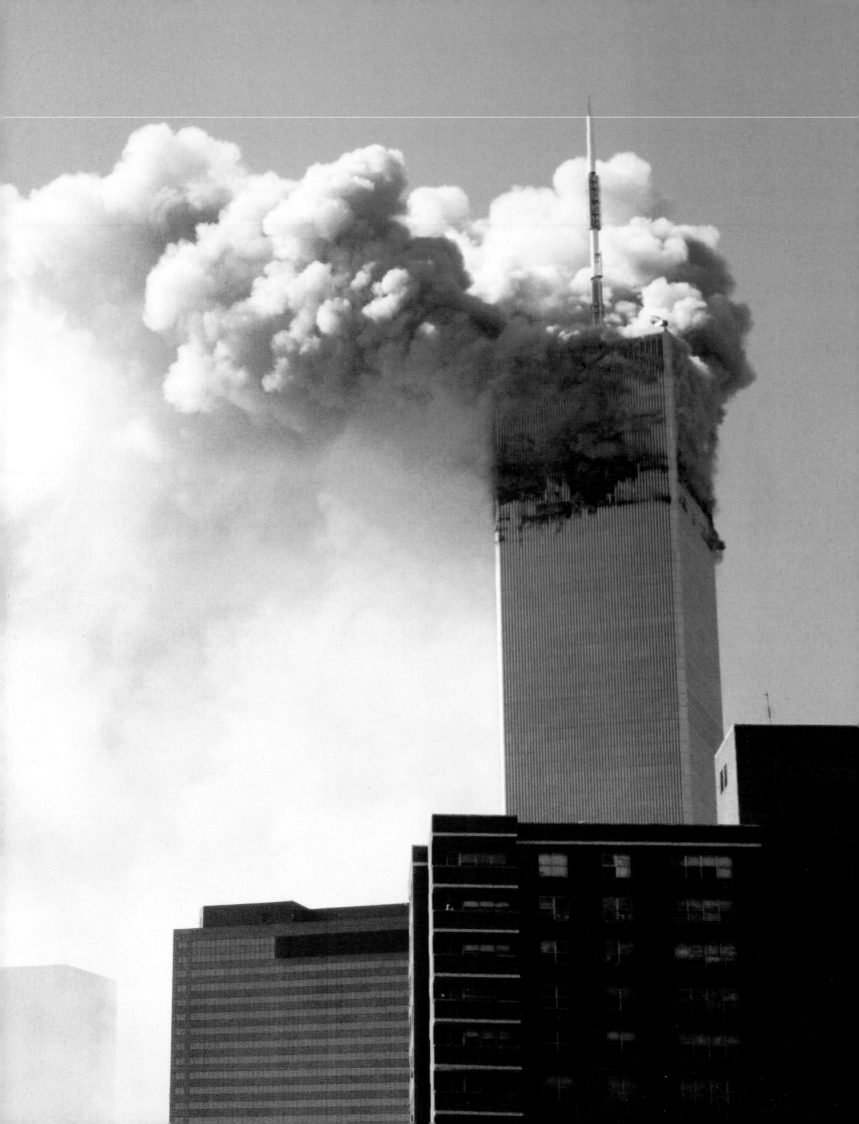

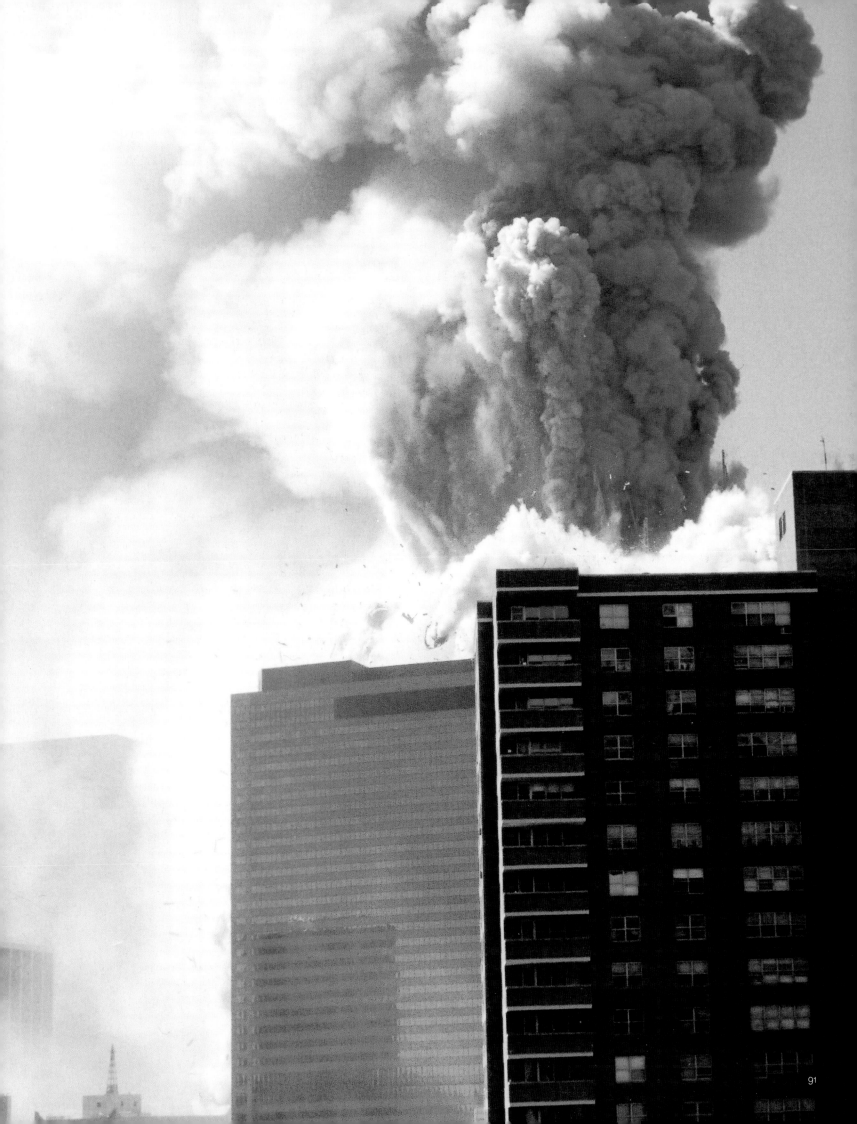

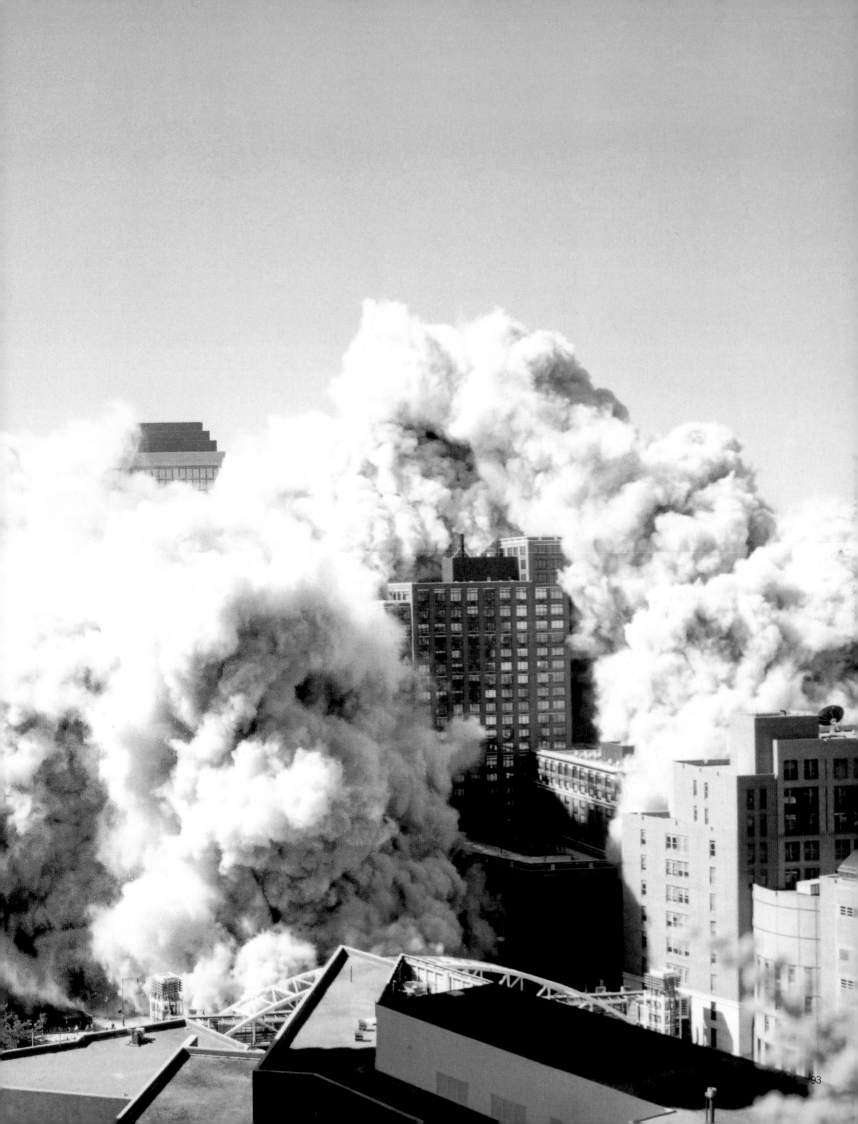

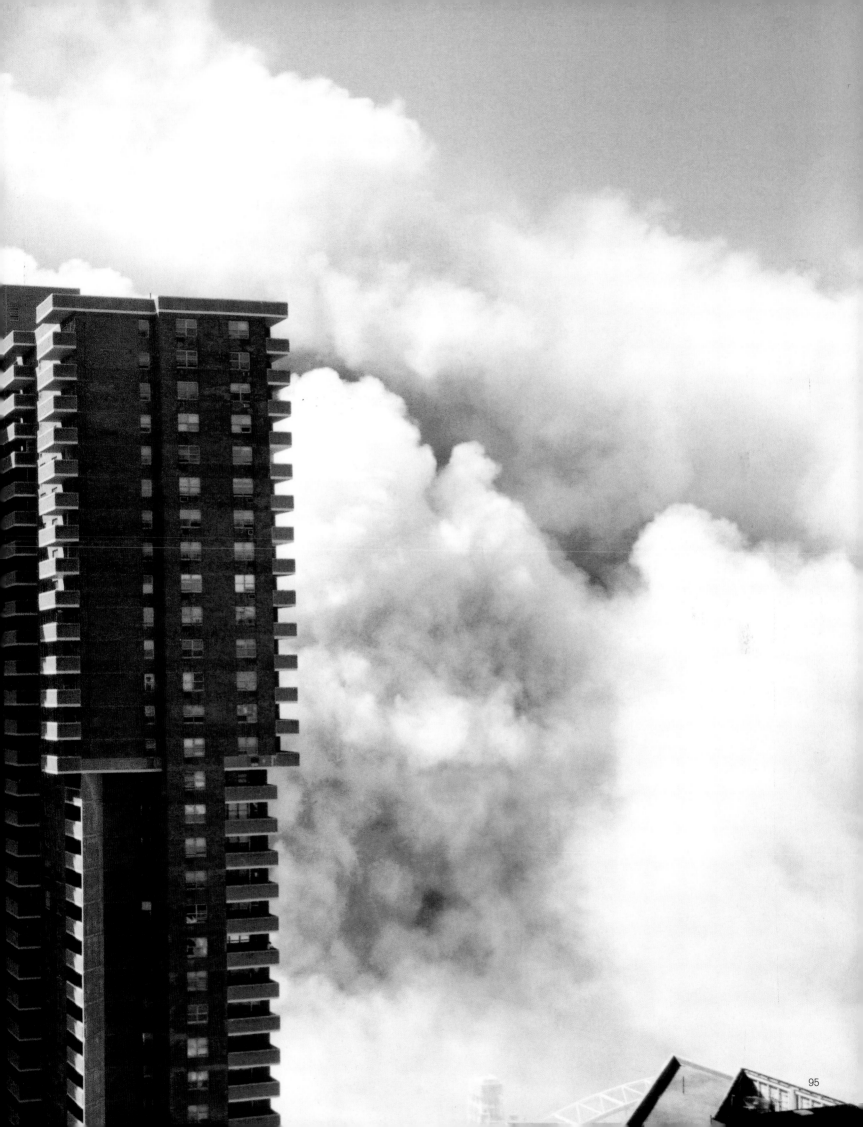

I am a photographer.

On September 11th my dear brother David Rice was on the 104th floor of the second tower at the World Trade Center. He perished in the attack. I remember walking in a haze of shock that terrible afternoon to register my brother as a missing person at St. Vincent's Hospital. It was the beginning of one of the hardest stretches of my life. As I was walking there I saw photograph after photograph in my mind depicting all the chaos, love, and strength surrounding me on the streets. I did not have my camera or any desire to pick it up and shoot.

Throughout the afternoon, I watched masses of people — covered in dust, shocked, and saddened — trudging their way home to their families. I kept thinking what a photograph, but that thought was overshadowed by my hope that my brother would walk up any moment. He never did.

My family was fortunate to have my brother's body within a few days. We had no need to post lost or missing signs. We took him home to Oklahoma to celebrate his life and to lay him to rest.

When I returned to New York City I still had no desire to pick up my camera, but I did gaze over at it once in a while. As I walked around the city, I found comfort in the various memorials around my neighborhood. Then I saw St. Vincent's Hospital for the first time since September 11th. I had a sudden pain in my heart. The memorial wall was beautiful. I looked at all the missing person posters, all of the touching memorials to the lost loved ones. My brother David was not up there, but I felt like he should be a part of the memorial.

I went home and made a sign for him with his photograph that read "loved and missed by all." The next morning, very early, my brother Andrew and I added the sign to the memorial. Andrew hung it and I quietly pulled out my camera for the first time.

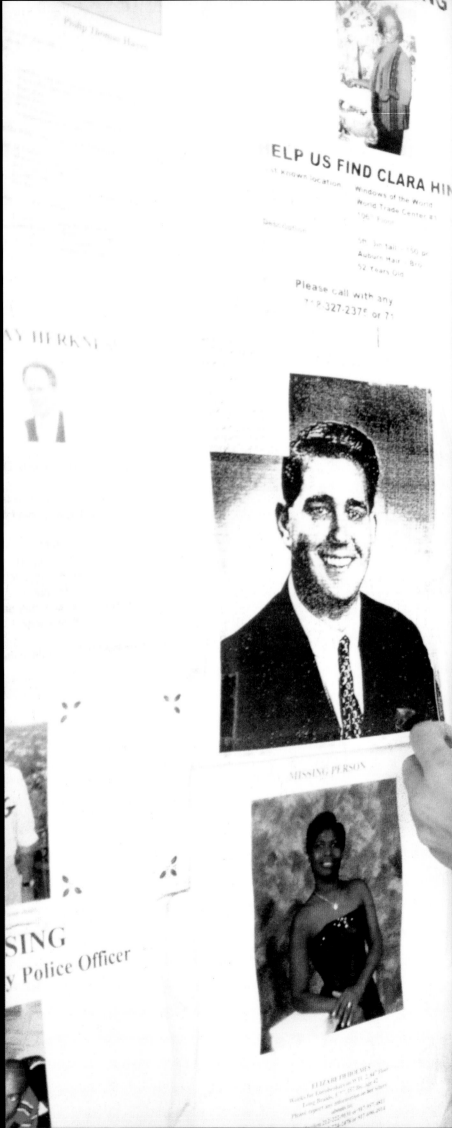

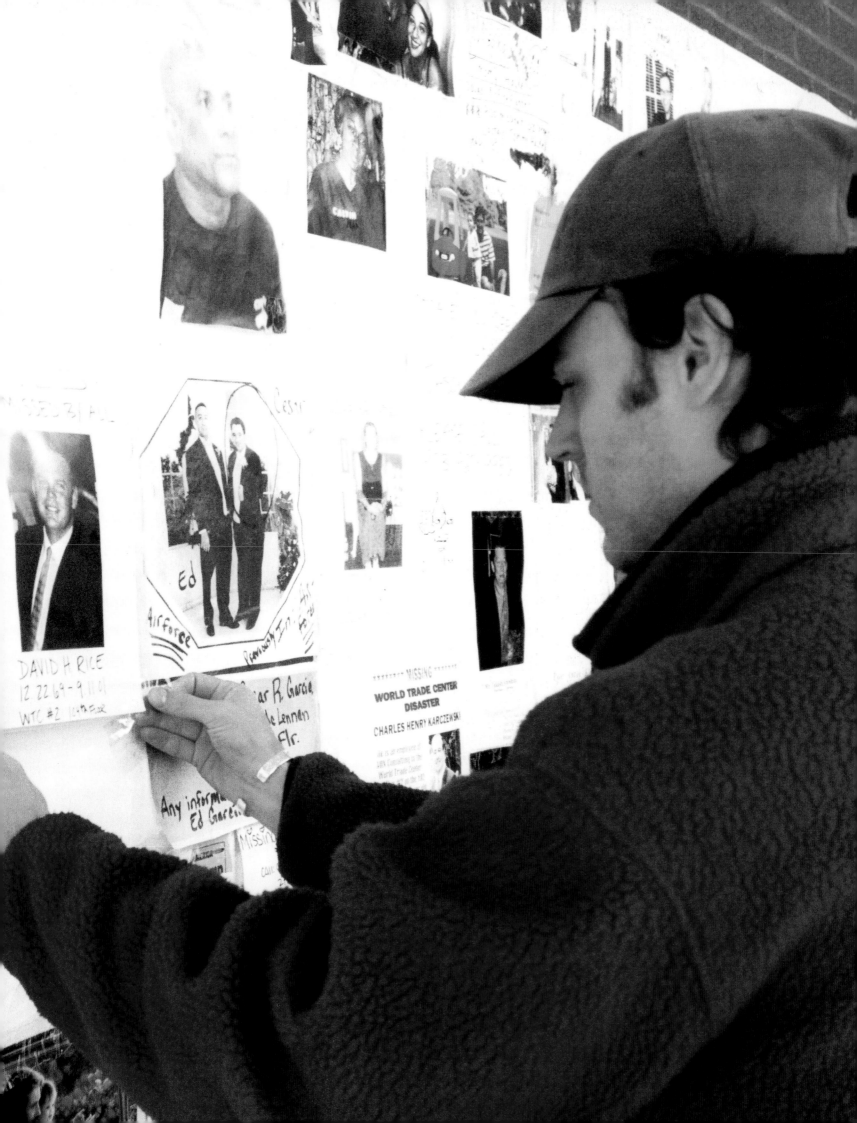

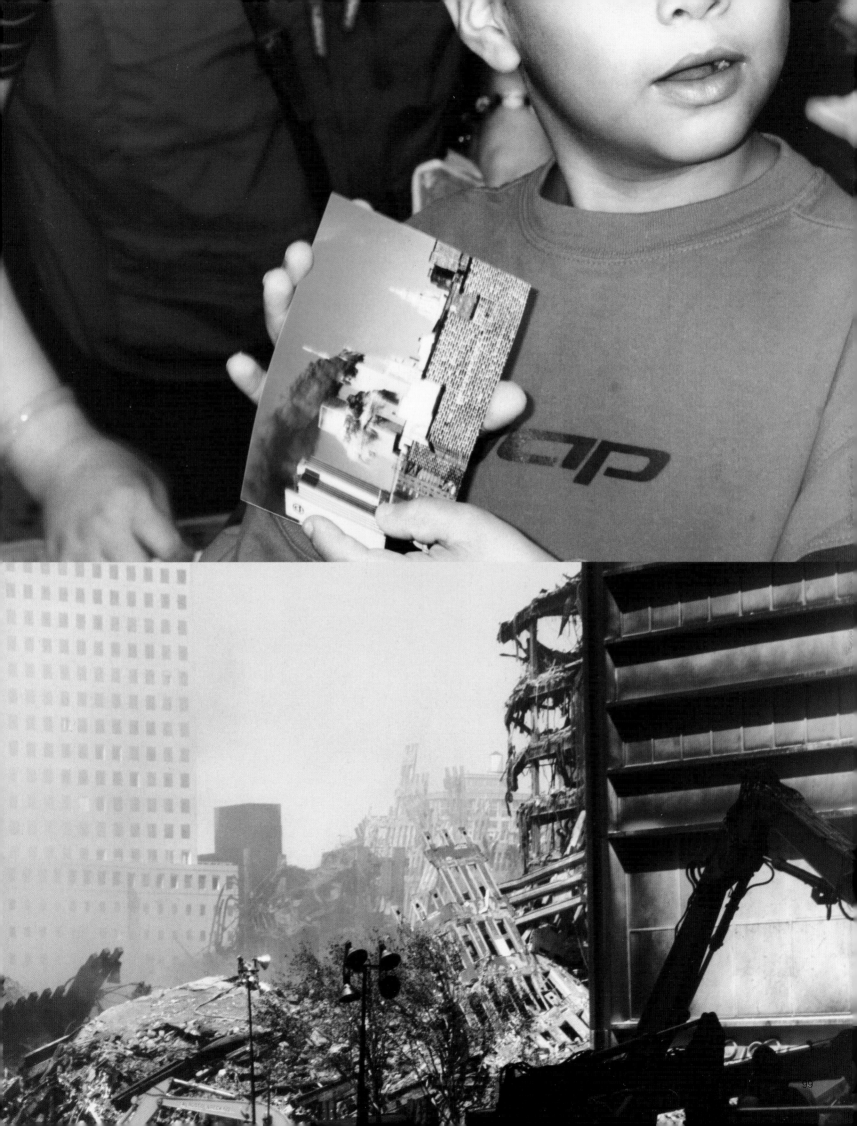

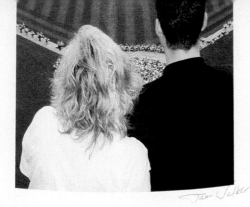

STADIUM, RE-VISITED
Couple stands for the national anthem at an interfaith
memorial service at Yankee Stadium on 9/23/01

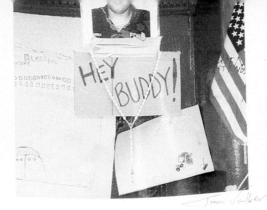

WISHING YOU WERE HERE
A missing firefighter from Engine #74 in Manhattan.
His body was later found.

THE W
Saint Vincent's Hospital's Wa.

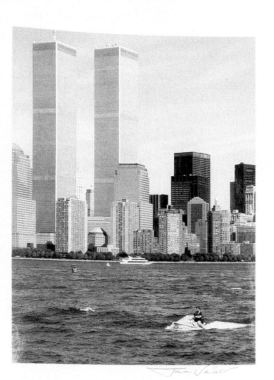

THE WAY WE WERE
The Twin Towers, just two days before their demise

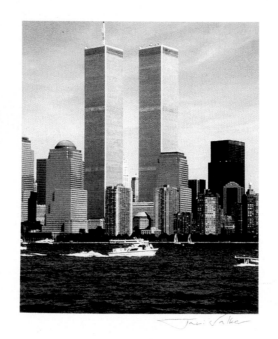

THE WAY WE WERE #2
Photo taken on 9/9/01

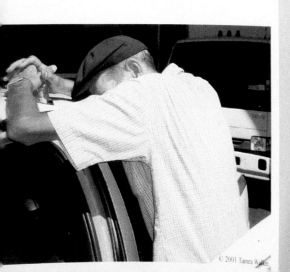

© 2001 Tamra Walker

ON HIS WAY TO HELP
The morning after, the Staten Island Ferry is only open to emergency

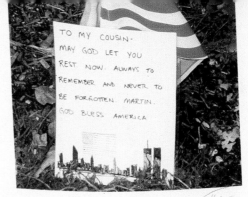

A NATION UNDIVIDED
Two women attending Yankee Stadium memorial service,
join hands in unity.

TO MY COUSIN -
MAY GOD LET YOU
REST NOW. ALWAYS TO
REMEMBER AND NEVER TO
BE FORGOTTEN. MARTIN.
GOD BLESS AMERICA

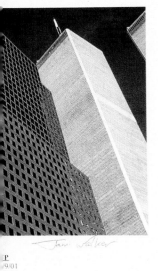

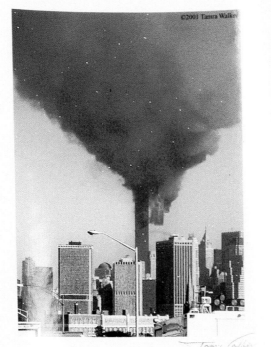

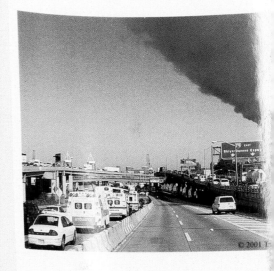

IN THE DISTANCE
View from the Gowanus Expressway in Brooklyn

MANHATTAN-BOUND VIEW
HOV lane is now reserved for emergency vehicles
rushing to the scene.

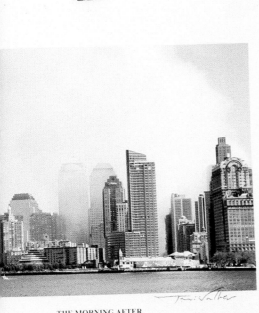

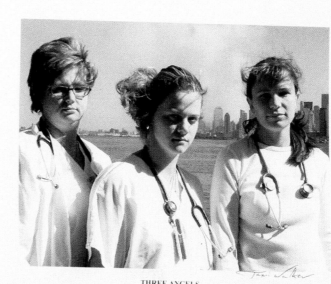

THE MORNING AFTER
is what we, on the ferry, were greeted with. Smoldering remains.

THREE ANGELS
Nurses, also on the Staten Island Ferry, approaching the scene.
Smokey view behind them. 9/12/01

SEEKING INFO ON NYC FIREFIGHTER:
CHRISTIAN REGENHARD

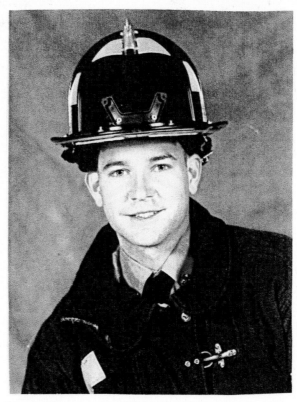

We are seeking information on **Christian Regenhard**, a NYC firefighter who responded to the World Trade Center with Engine Company 279 out of Red Hook, Brooklyn.

Christian is 28 years old, about 5 feet 8 inches with short brown hair and blue eyes. He has a large tattoo on his right arm of an eagle with a red, white and blue American flag with USMC for United States Marine Corps.

Another firefighter at the scene said he saw Christian helping an injured firefighter. He may be trapped in the first Tower to collapse.

We are hoping that he may be in a hospital somewhere or that he is still alive but trapped in the debris.

We ask that the search continues for him and others, and also ask that you pray for Christian Regenhard. Thank you.

Semper Fidelis,
Christian
From your sister,
Christina

Christian Regenhard on his graduation day
FDNY Fire Academy July 2001
Responded to The World Trade Center on sept 11.
Artist, writer, humanitarian, U.S. Marine and finally, firefighter
Our grief _is_ a call to action and a call
for war on those murderers who want
to take away our loved ones and our
way of life

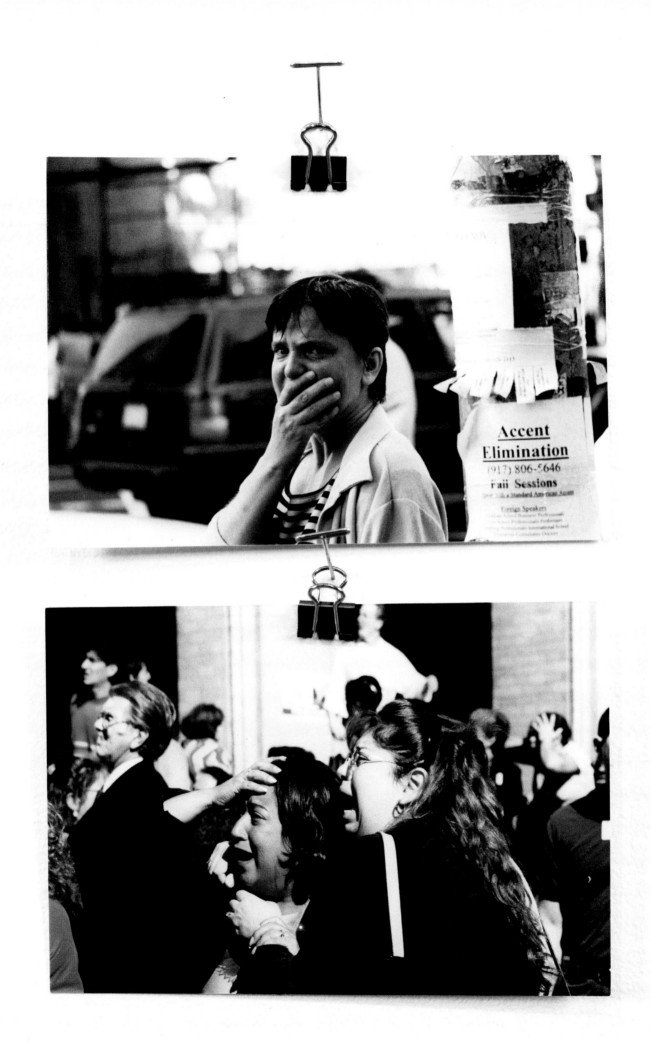

I stood in the street with thousands of others, aghast as the building burned. The air felt thick with the experience of communal shock. Then, to our shared horror, the remaining tower began collapsing . . .

Chris Anderson

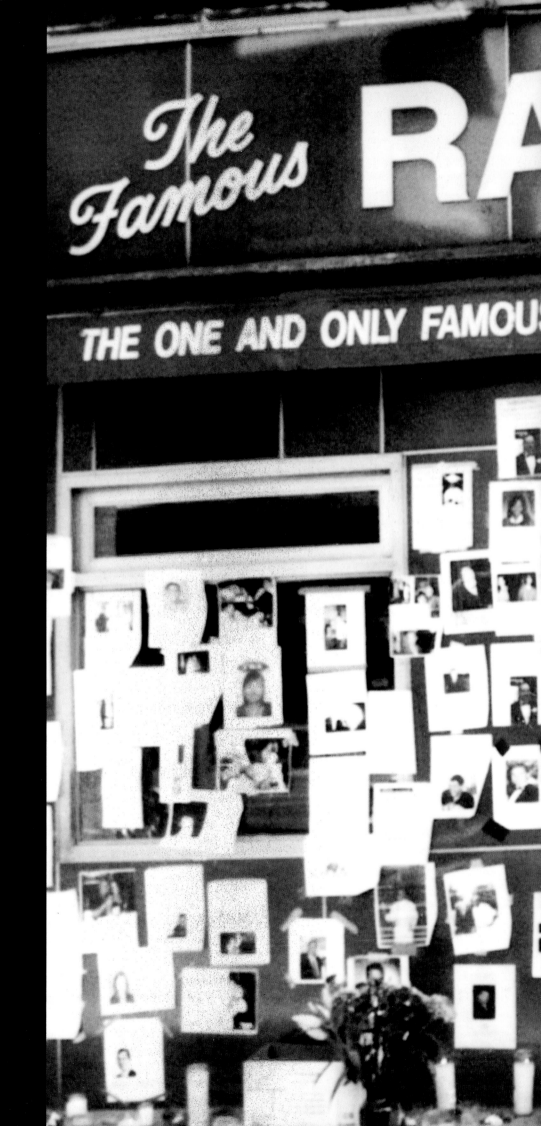

Famous Ray's Pizza, Sixth Avenue at 11th Street: "Hope is the Thing With Feathers That Perches In the Soul, That Sings the Tune Without the Words and Doesn't Stop At All." — Emily Dickinson

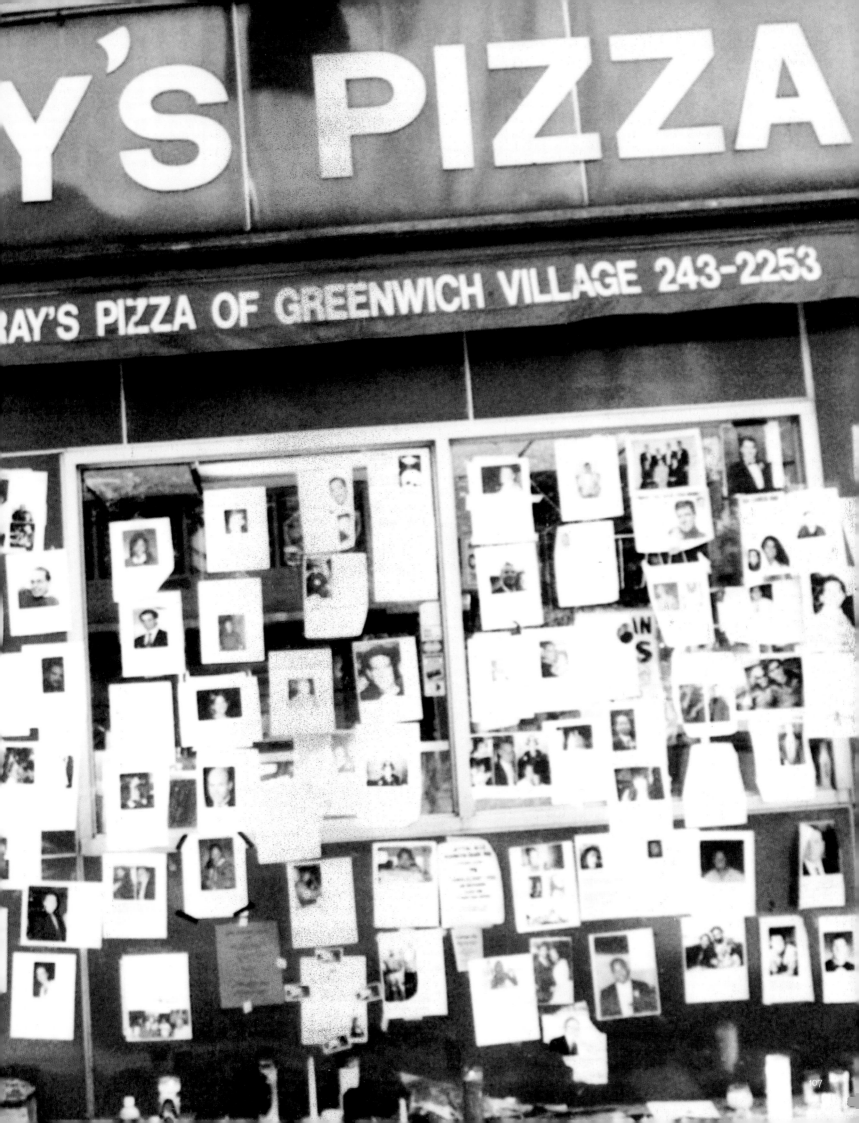

Myoung-(Woo) Lee
201-507-09□□

Myoung-(Woo) Lee, Father and Son Poster on a Tree:
"You Are My Son In Whom I Am Well Pleased." — The Bible

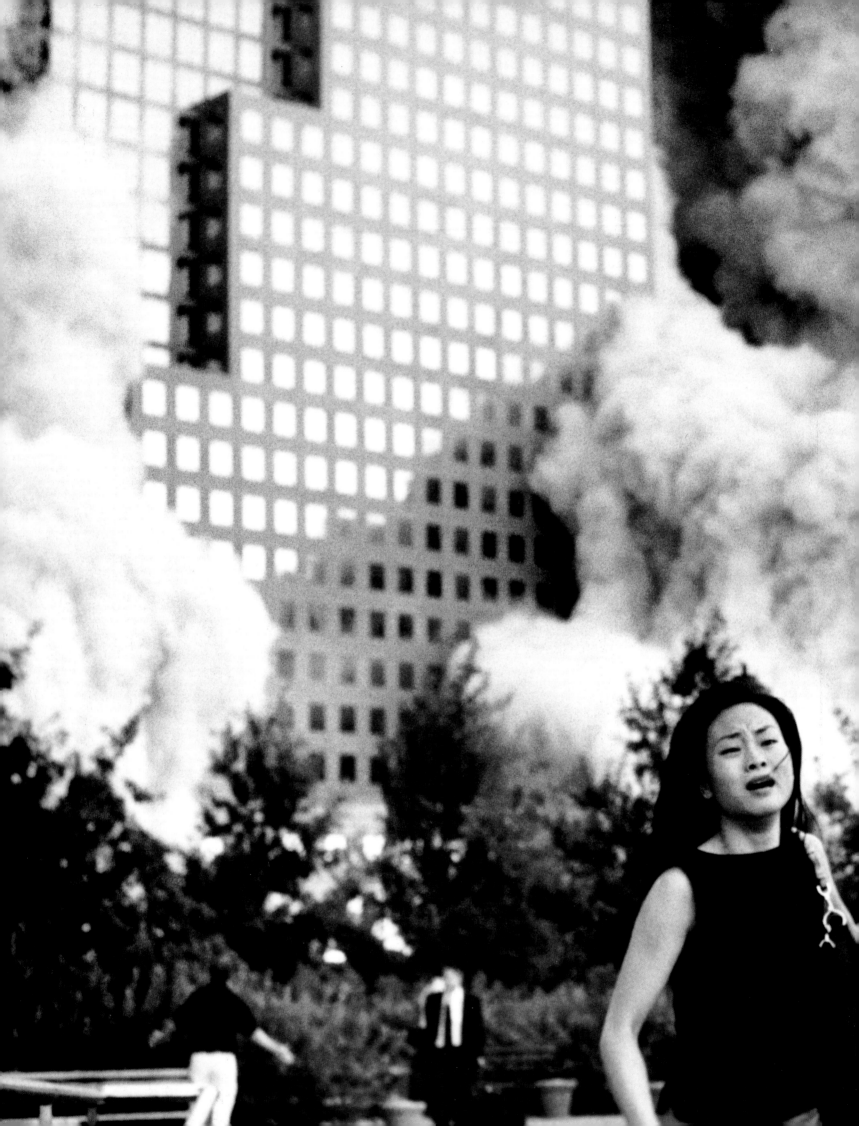

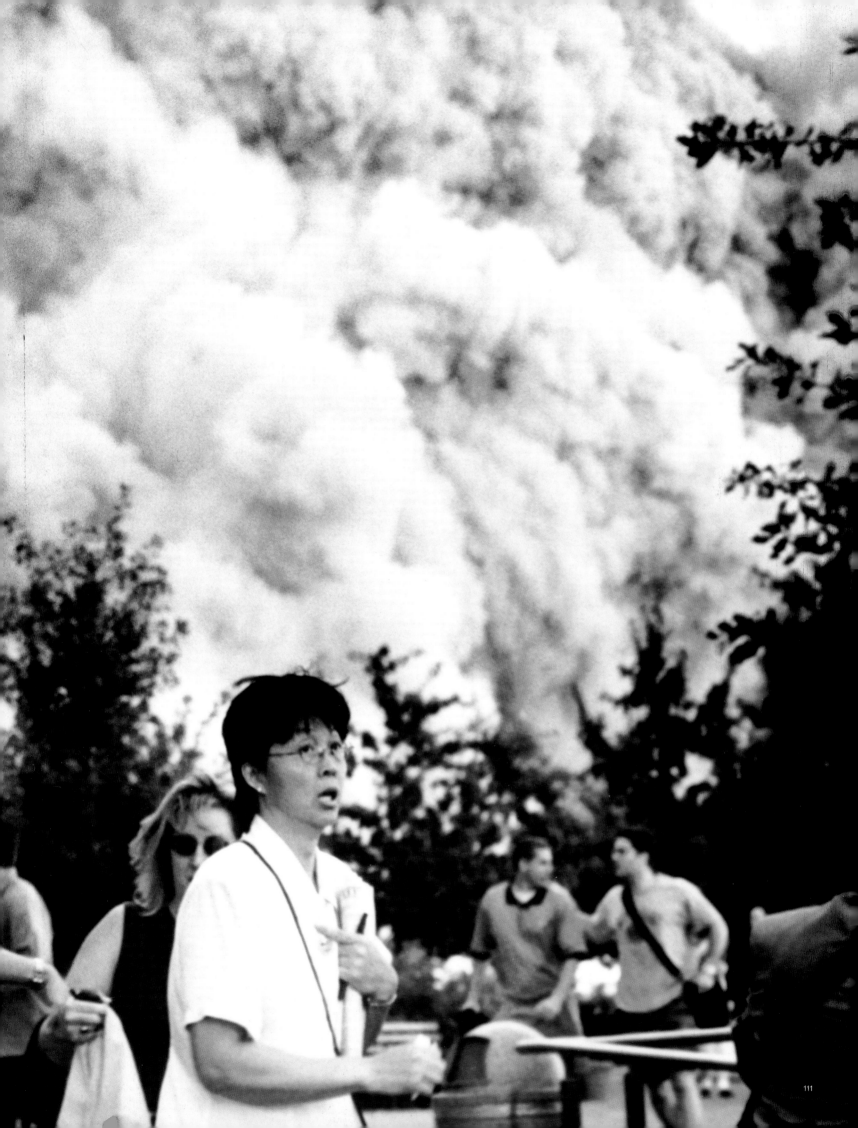

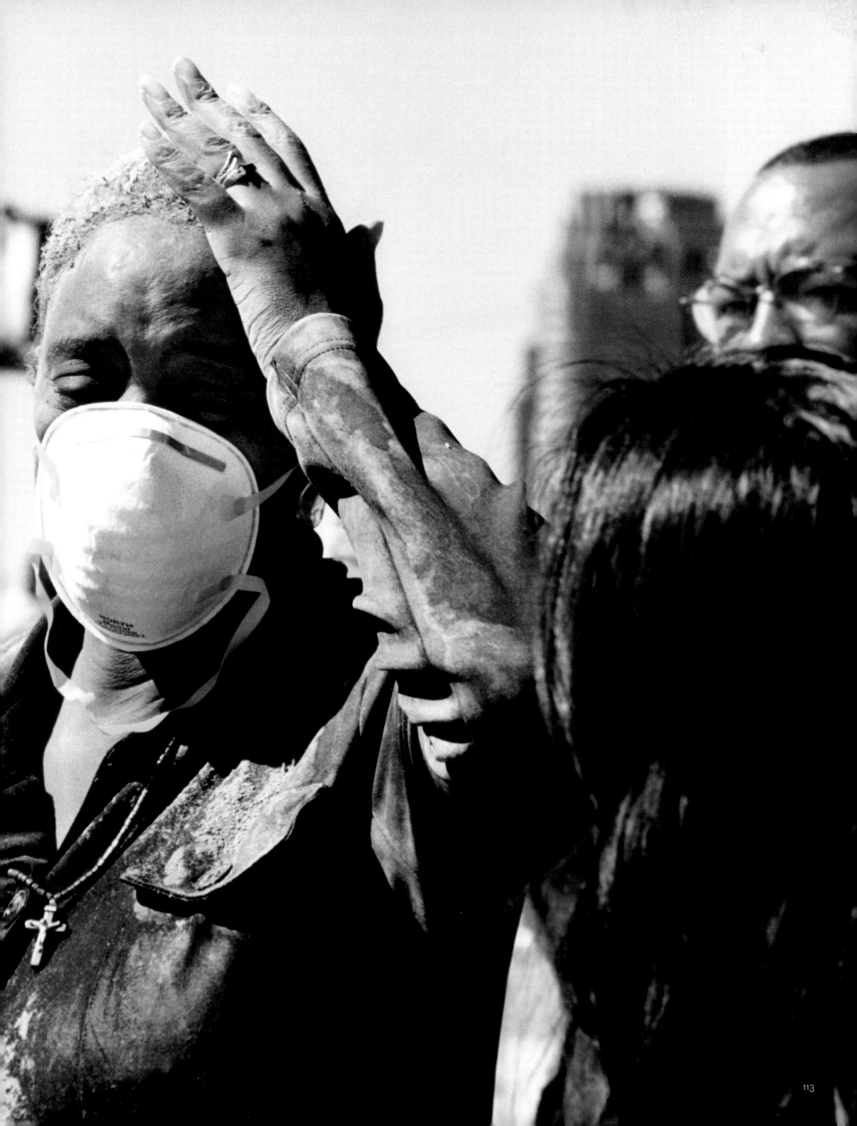

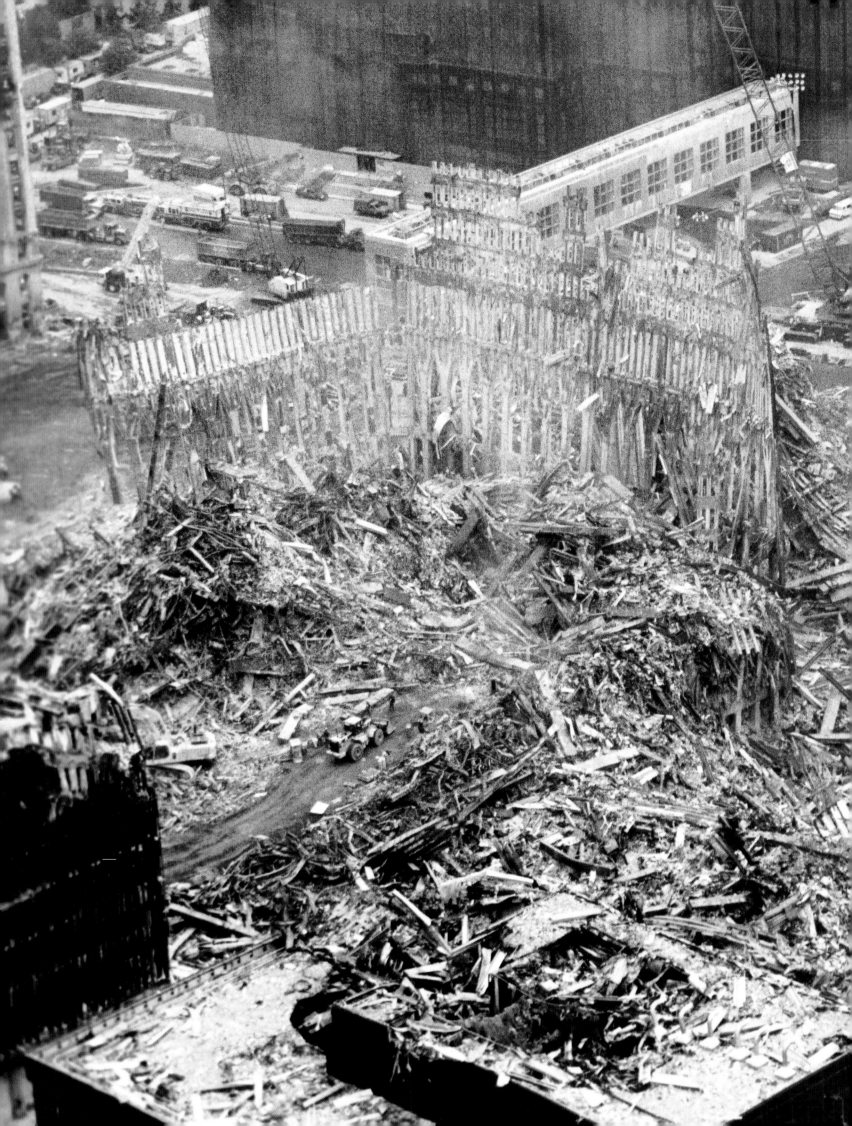

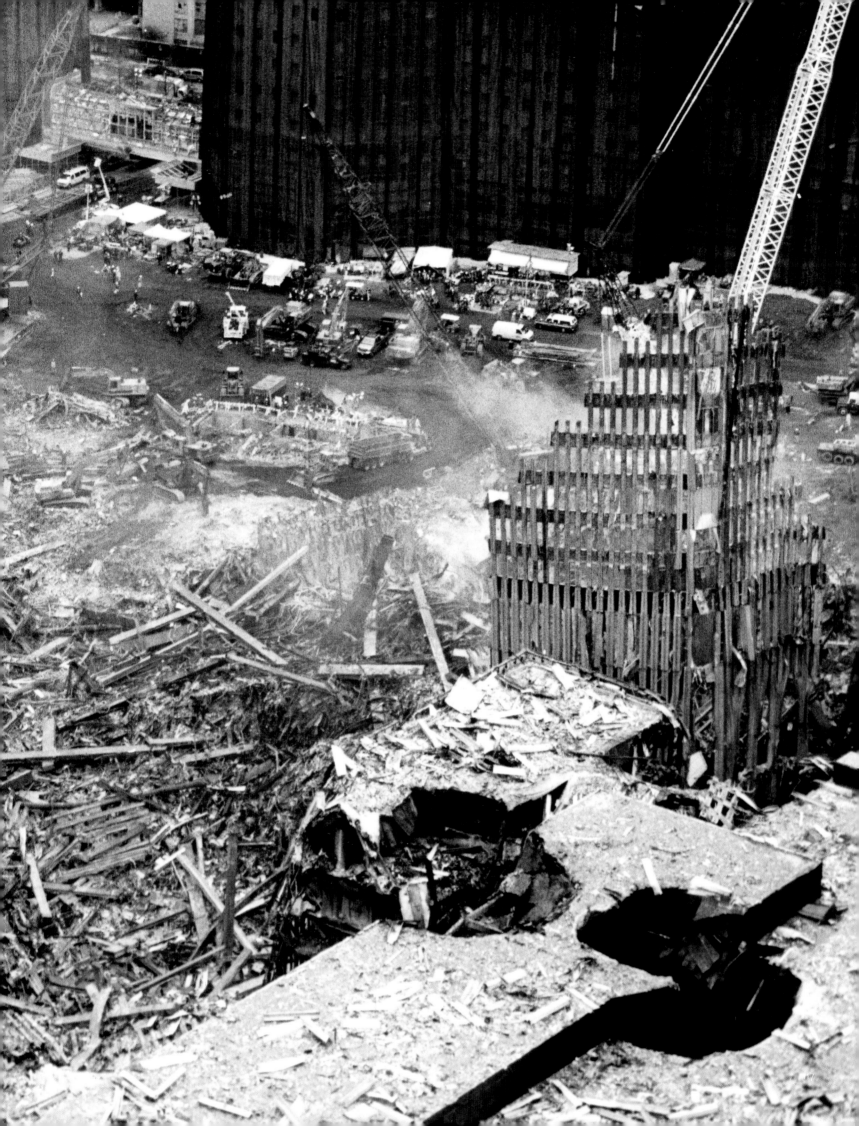

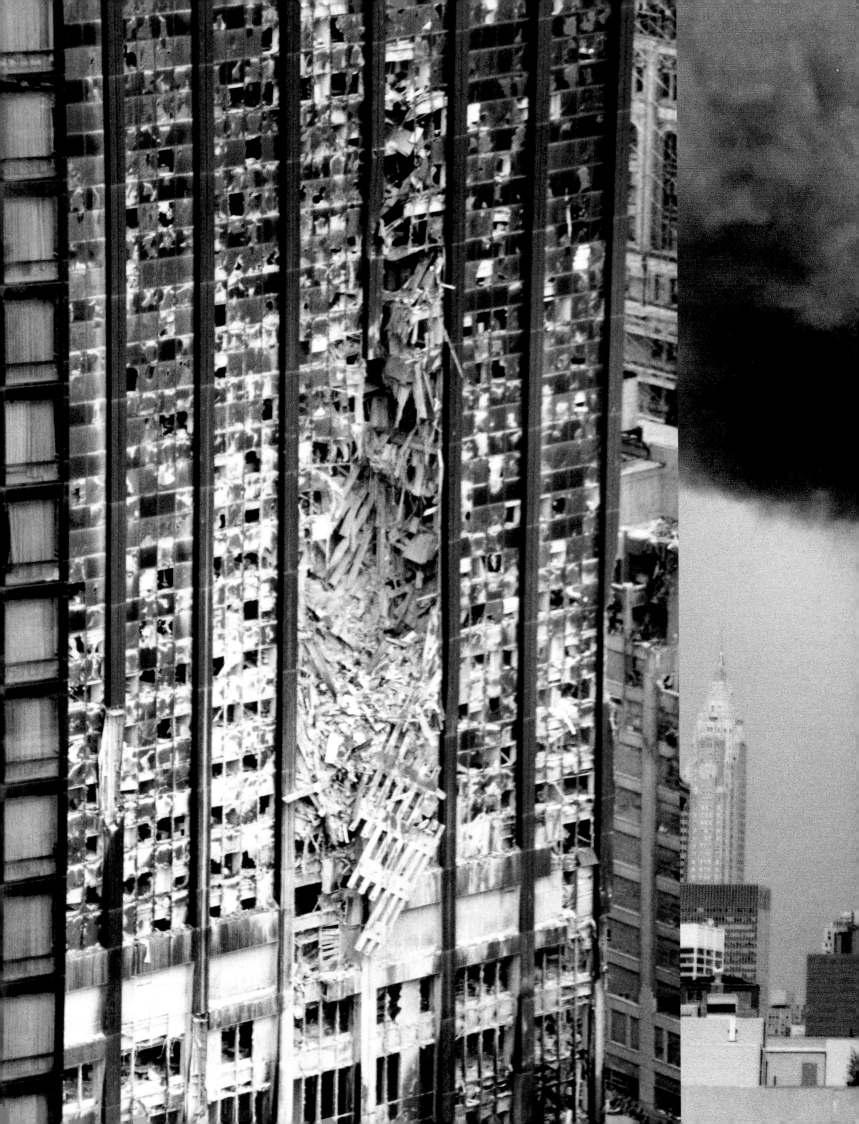

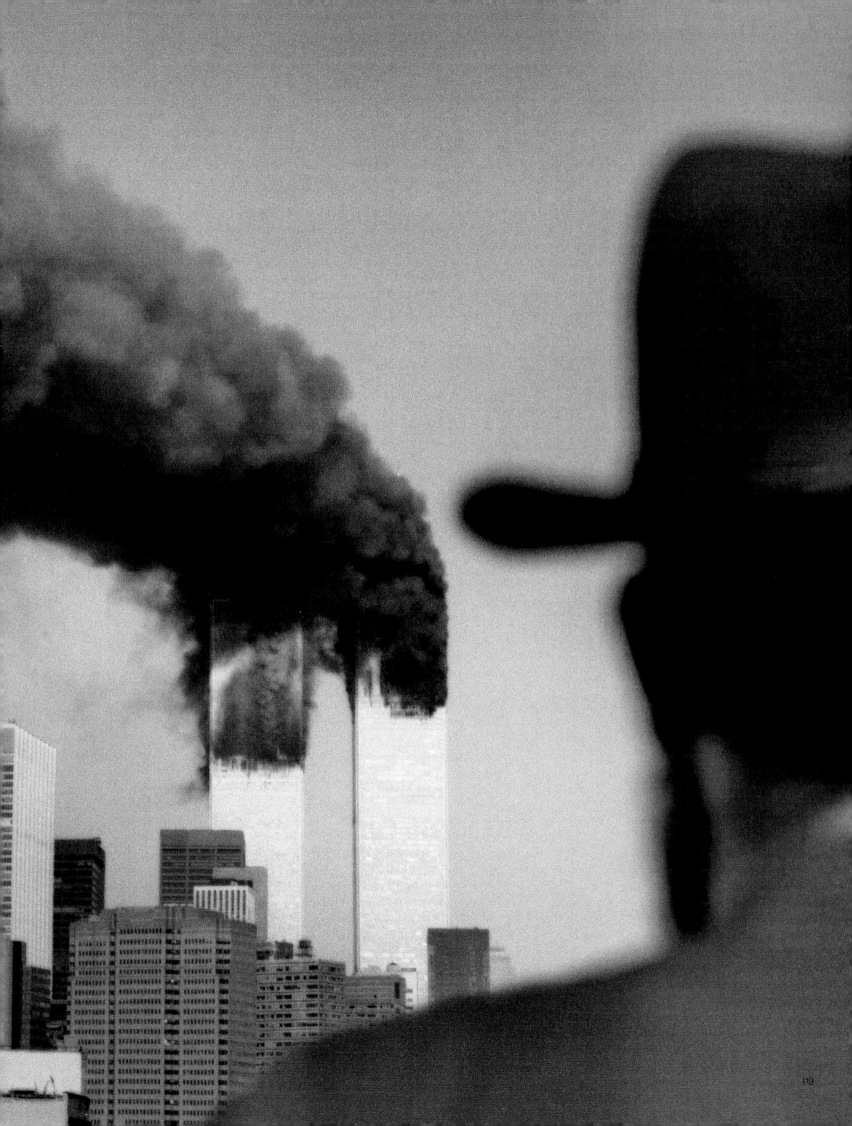

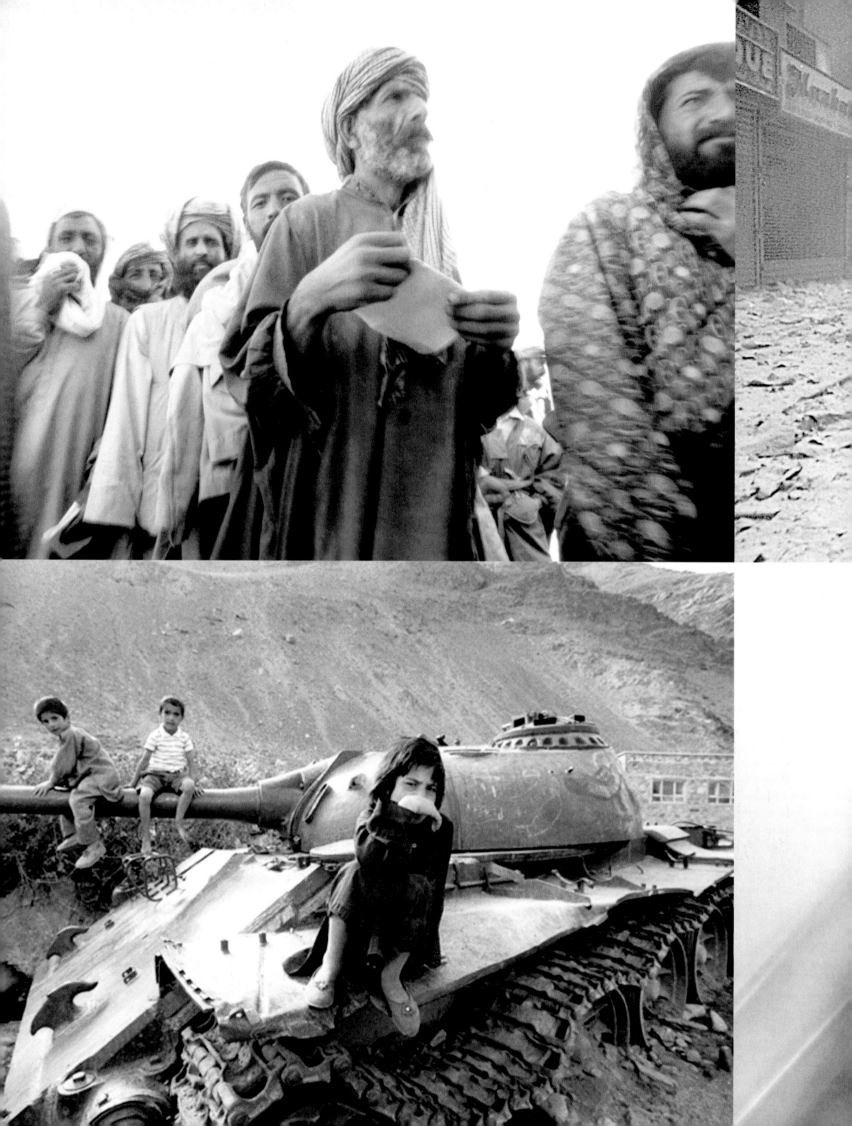

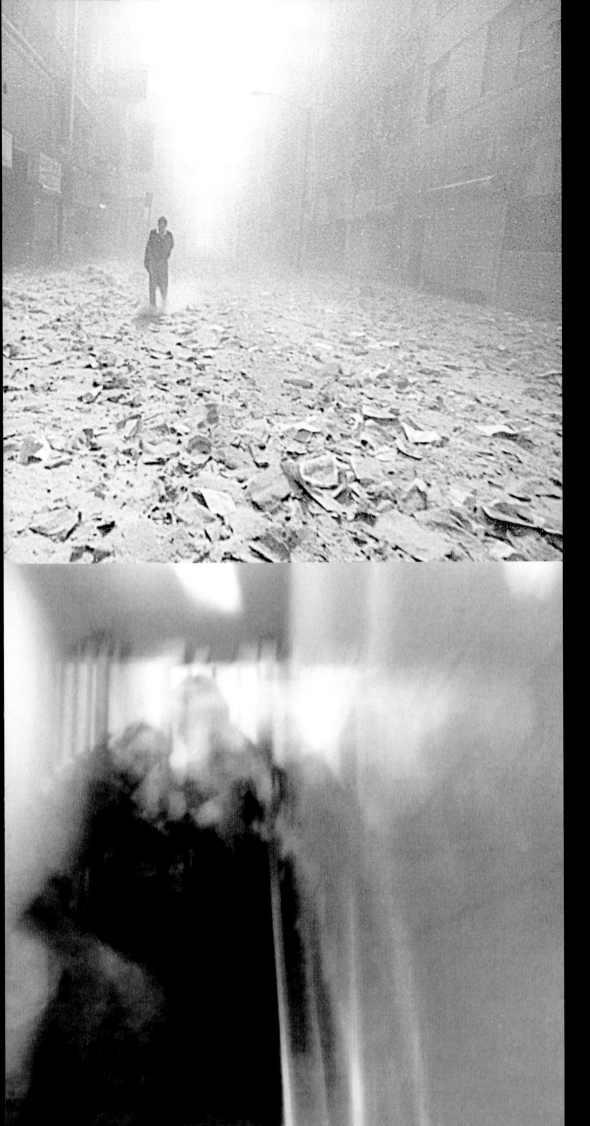

opposite top and bottom:
I went to Afghanistan in August to shoot a war. All was quiet. I returned to New York, and within five days the war was on my doorstep.

left top:
Vesey Street
9:59 a.m.

left bottom:
WTC/Church Street subway entrance
10:00 a.m.
(I was shocked to find this picture on my contact sheet. I have no recollection of shooting it. . . . If anyone knows who these police officers are I would really like to thank them personally for getting me out of there safely.)

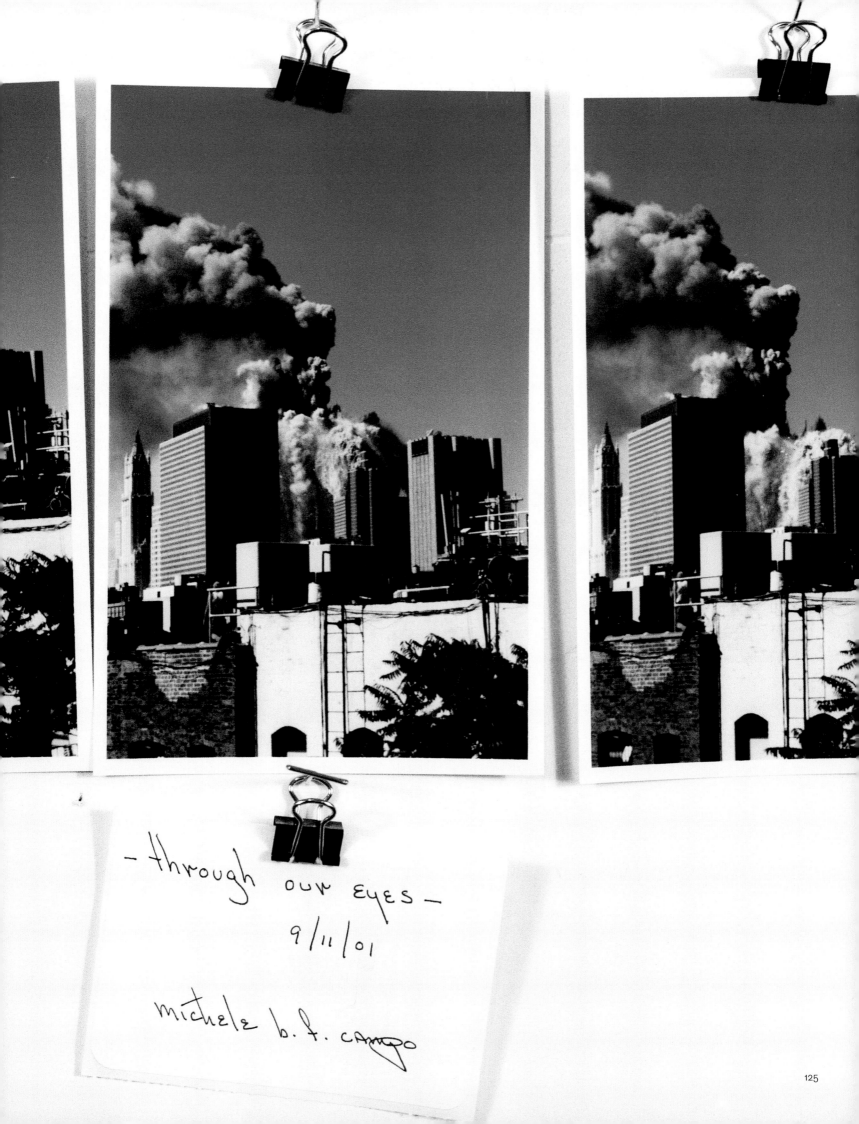

- through our eyes -
9/11/01

michele b.f. cam,o

September 11 Photo Project 12/7/01

I read about your project in my Time Out N.Y. magazine.
I would like to know if copies of the photos are for sale?
I am mostly interested in before photos. Being a native
new yorker from Staten Island / Brooklyn I took the skyline
for granted and never took any pictures of it. I guess my
attitude was why take pictures of something I can see everyday
Even when my Grandfather took me over to the city to watch
the towers being built. We never took any pictures. I also
read if we wanted to contribute any pictures to visit your
Web site. I don't have access to the Web. And the picture I
have enclosed is not part of the September 11 events directly.
But it is part of the aftermath. As you can see by my return
address that I am at a correctional Institution. I was really
surprised to see people here who never been to N.YC. show
compassion for the city and for those who lost their lives.
You may wonder why compassion was a surprise. Well compassion
is not something that goes with prison. The picture is of a Banner
that was made for a Lift-a-Thon to raise money for the
Firemans Fund. $3,200 was raise from just the inmates. Which
may not seem like a lot. But considering the average pay earned
here is about $28.00 a month it is a lot. I never seen inmates willing
to give as they did before this. The Fund raiser was a first
we ever had. The Banner which has a list of all the companies
who gave the ultimate sacrifice was sent along with a check
for the money that was raised. To a place in Tacoma WA
that has set up a collection office. I guess I am sending this
picture because I think people need to know that just because
a person is lock up does not mean we care any less for
our country or the people in it. So many times people
in prison are wrote off. Well good can come out of prison
Maybe not always but it does happen if given a chance.

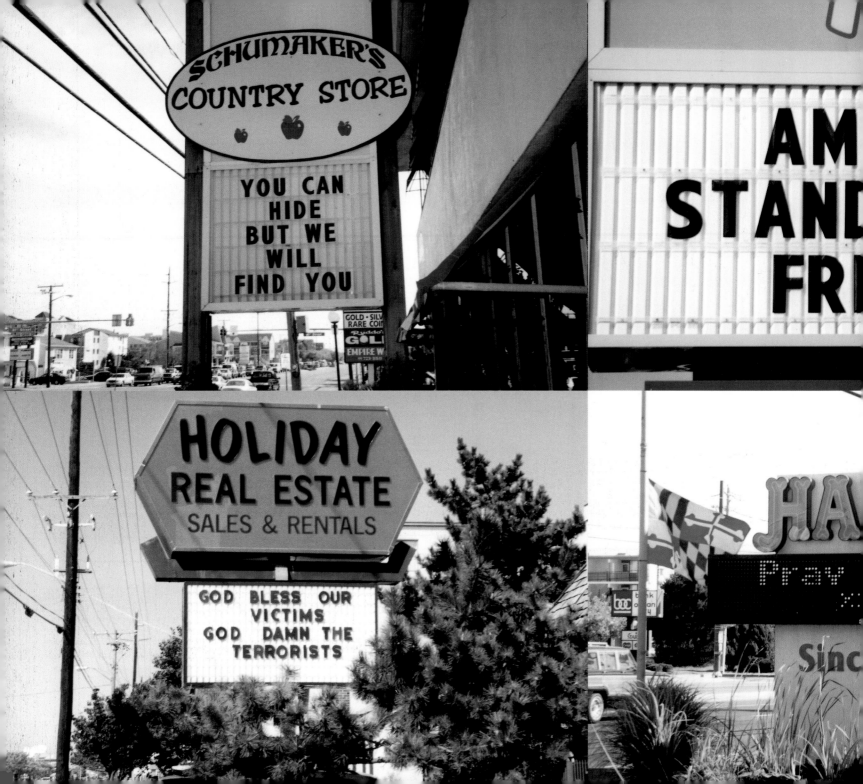

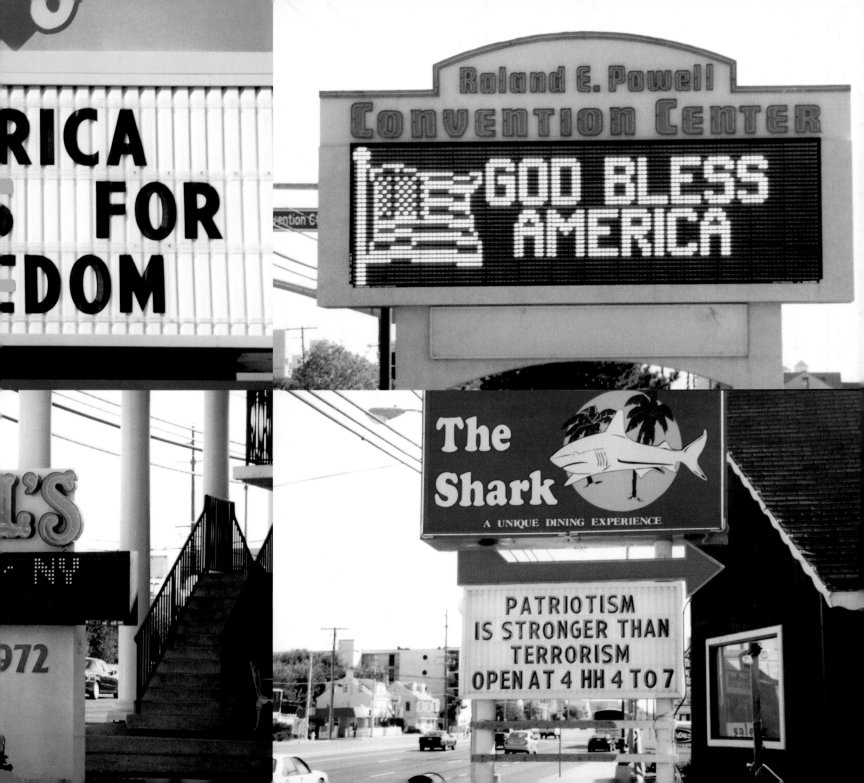

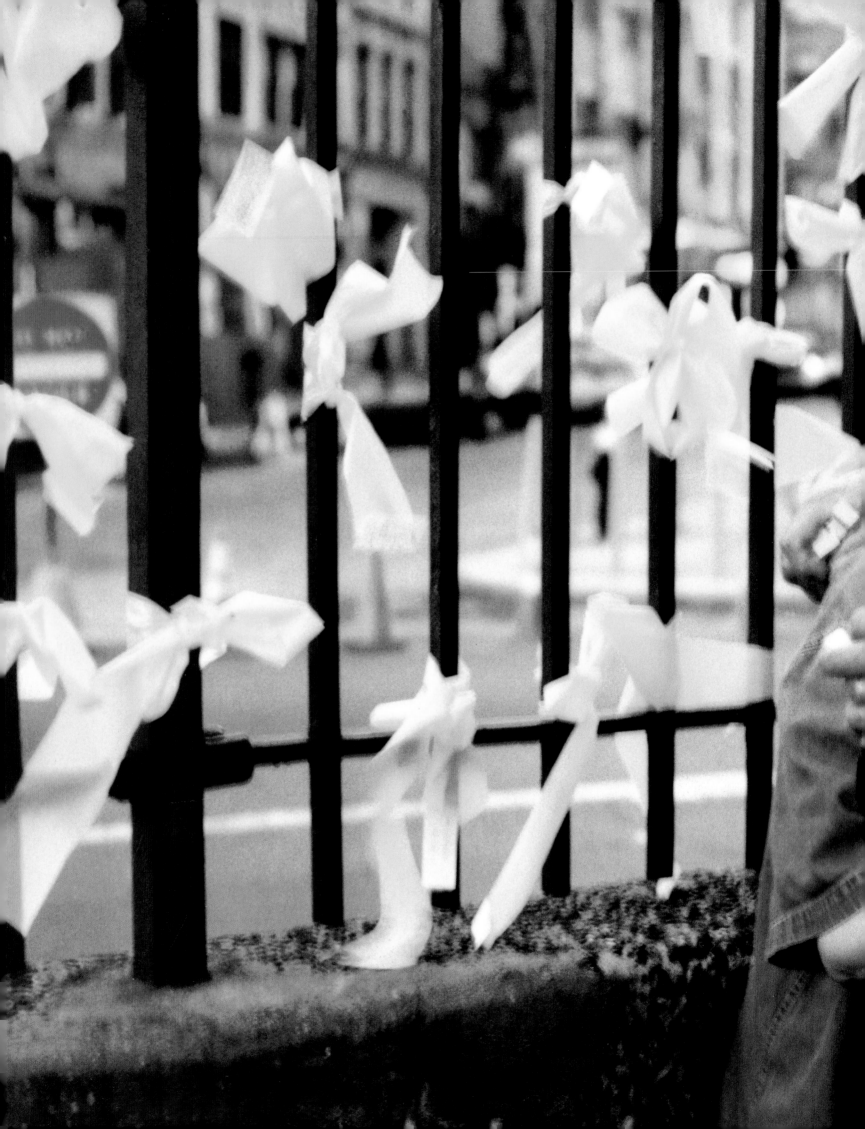

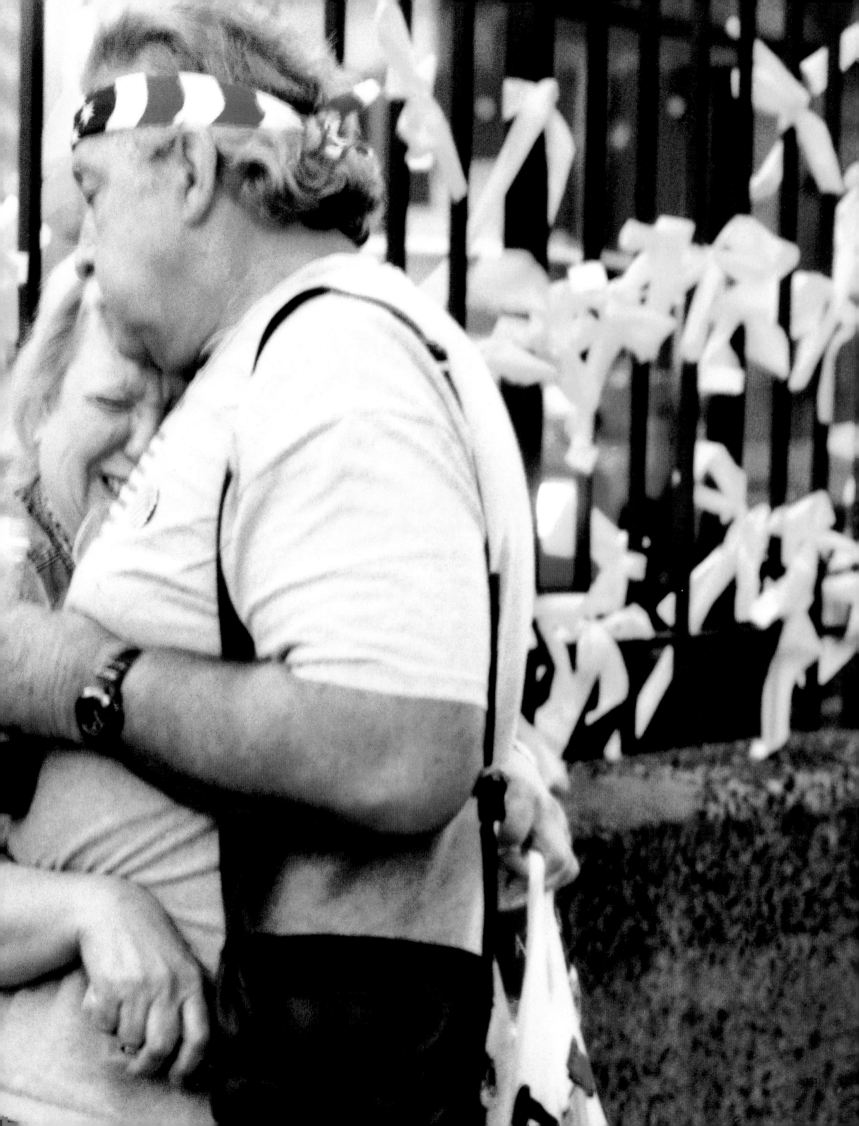

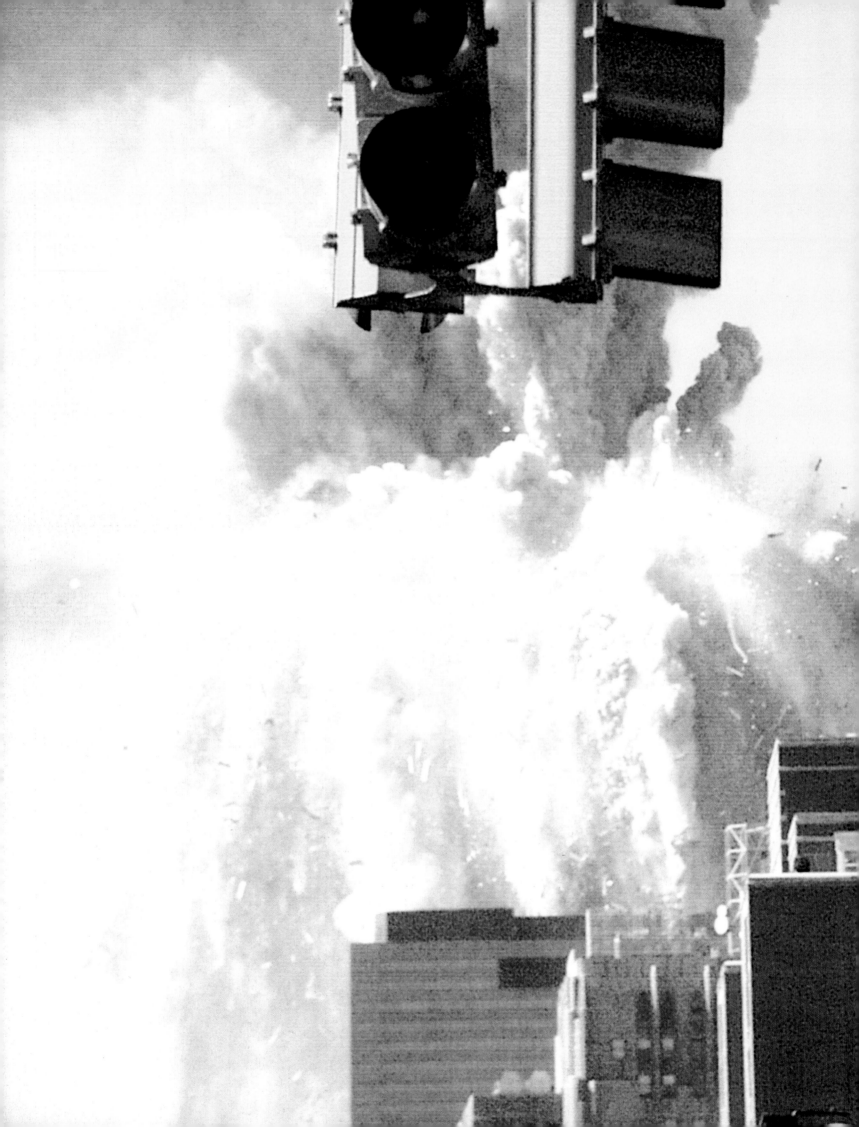

Journal Entry of a SoHo Resident

September 9th, 2001 — I invited my friend John Mari Campbell, a meditation teacher and mentor, to Sunday dinner. He likes to describe himself as a guide to the interior. John arrives around 5 p.m., a bit more reserved than usual.

"Well, I had a dream last night I will share with you, if you like. I dreamed that I was just north of that big beige building downtown by the World Trade Center. What is it called?"

"You mean the Woolworth Building? The neo-Gothic one with the copper roof and the gargoyles?"

"Yes, that's the one. Well, there I was in the neighborhood. I was looking downtown at the building. Suddenly, it began to crumble like an avalanche from the top down, crushing and killing mostly women on the sidewalk. It reminded me of the Tower Card in the Tarot. I especially remember a large black woman being crushed. The granite block was so big that I thought to myself, Damn, she won't even be a stain on the sidewalk.

"At this point I turned to a guy standing nearby and said, 'Hey, man, did you see that?' Then I looked up to where the building had stood and to my surprise, as we looked up, it was back where it was before. Restored to its original stature, perfect. Then it crumbled a second time, repeating the original sequence. And that was the end of the dream."

Having known John for many years, I know that this is not a dream one should take lightly. Like me, he has a history of precognitive dreaming. At times our dreams have even been related to similar events. I am a bit startled by the violence of the imagery and I say, "Well, I hope your dream is personal and metaphorical and not precognitive or collective!"

John says: "I don't know. It doesn't feel like personal material to me. I'm thinking it might mean that the stock market is going to crash or something dramatic like that."

September 11th, 2001

I awake with a bit of a start and look over at the big red numbers on my digital alarm clock. It is 8:43 a.m. The alarm is set for 8:45.

The phone rings. I look at the clock. It's 8:55. I pick it up. "Hello, it's Steve calling from San Francisco. Turn on your TV. A plane just crashed into the World Trade Center. I thought I should call and make sure you are OK."

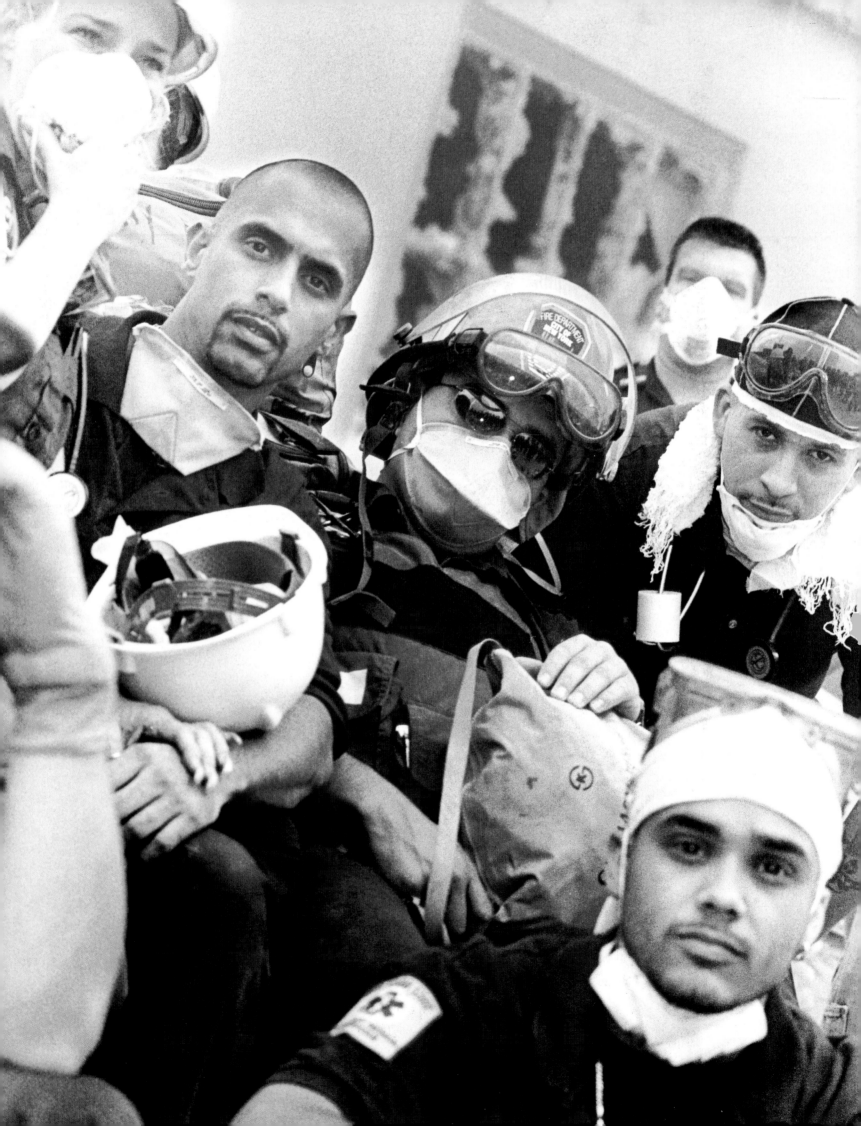

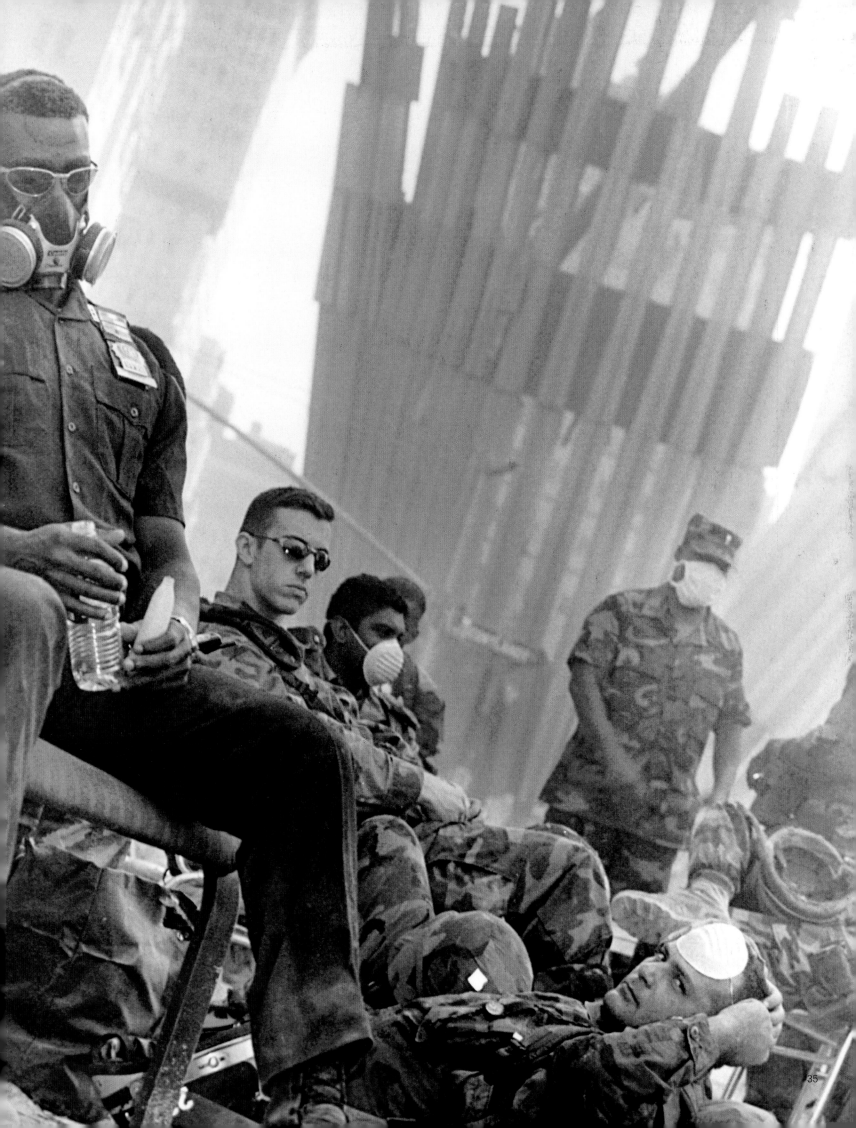

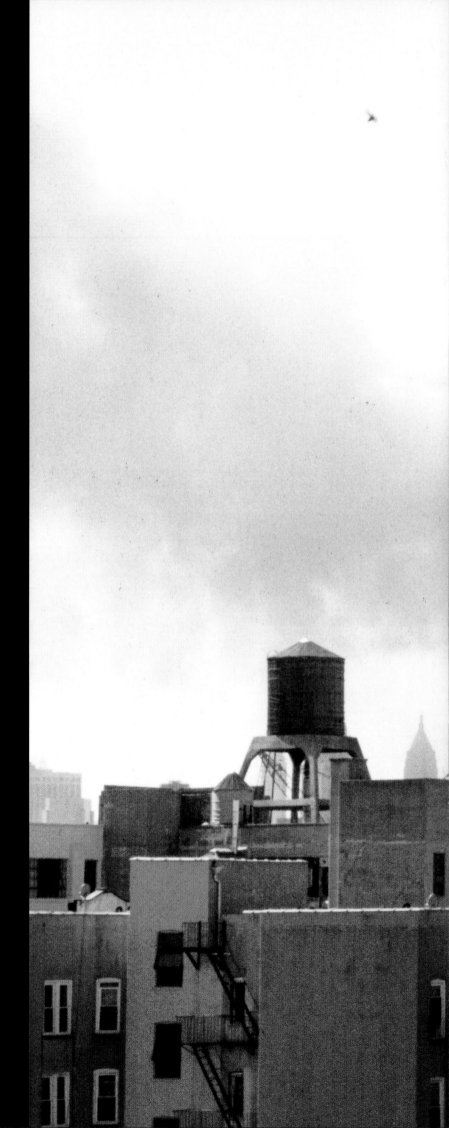

9-11-01

Once I had walked out of Manhattan, from midtown across the
Williamsburg Bridge to Brooklyn, I could do nothing but watch and
listen to the TV and to my coworkers who had come home with
me. I went to my roof every hour to escape the news, but at the
same time to look for myself at the clouds of smoke that couldn't
be turned off or blown away.

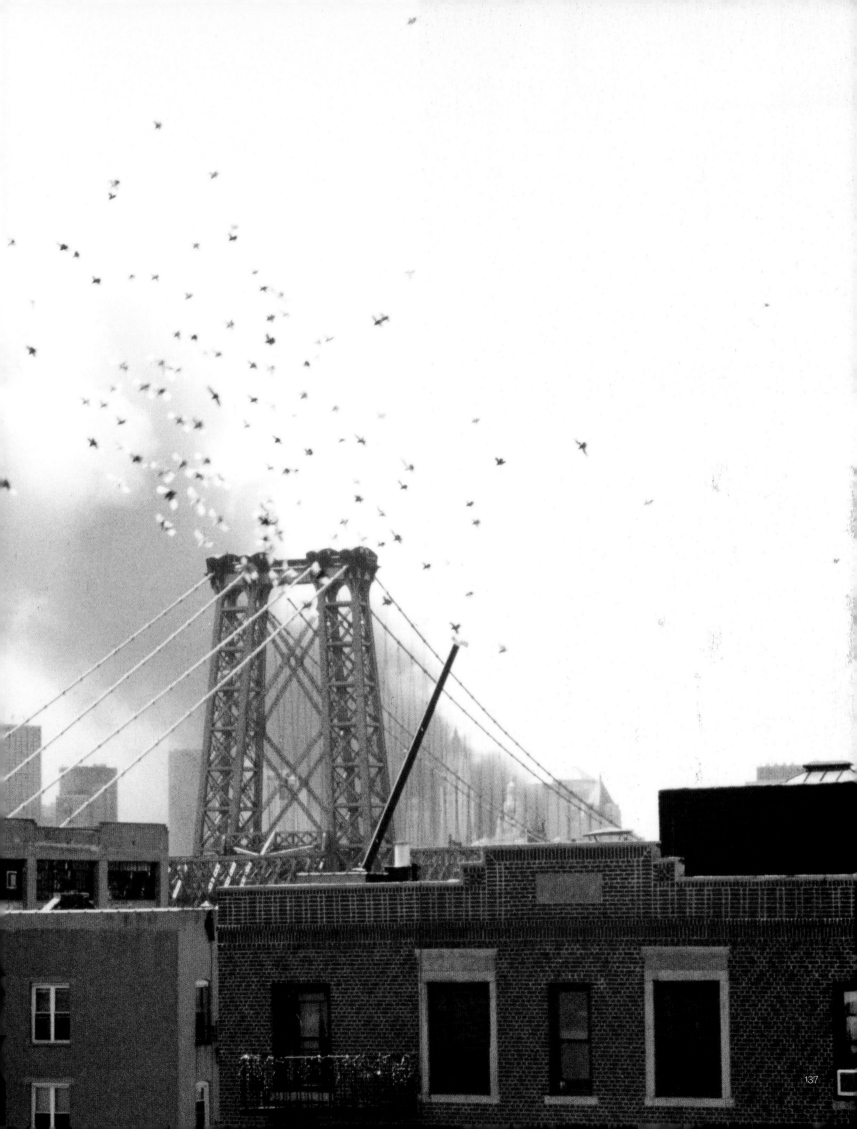

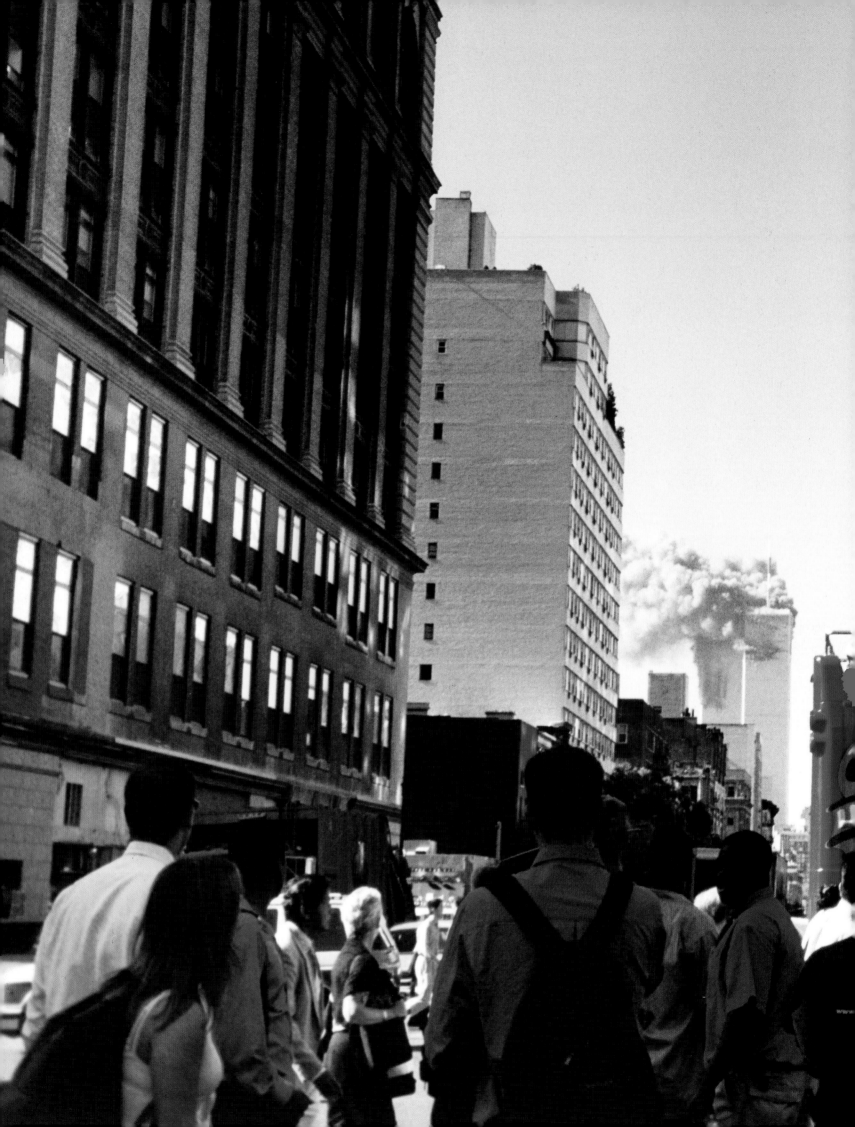

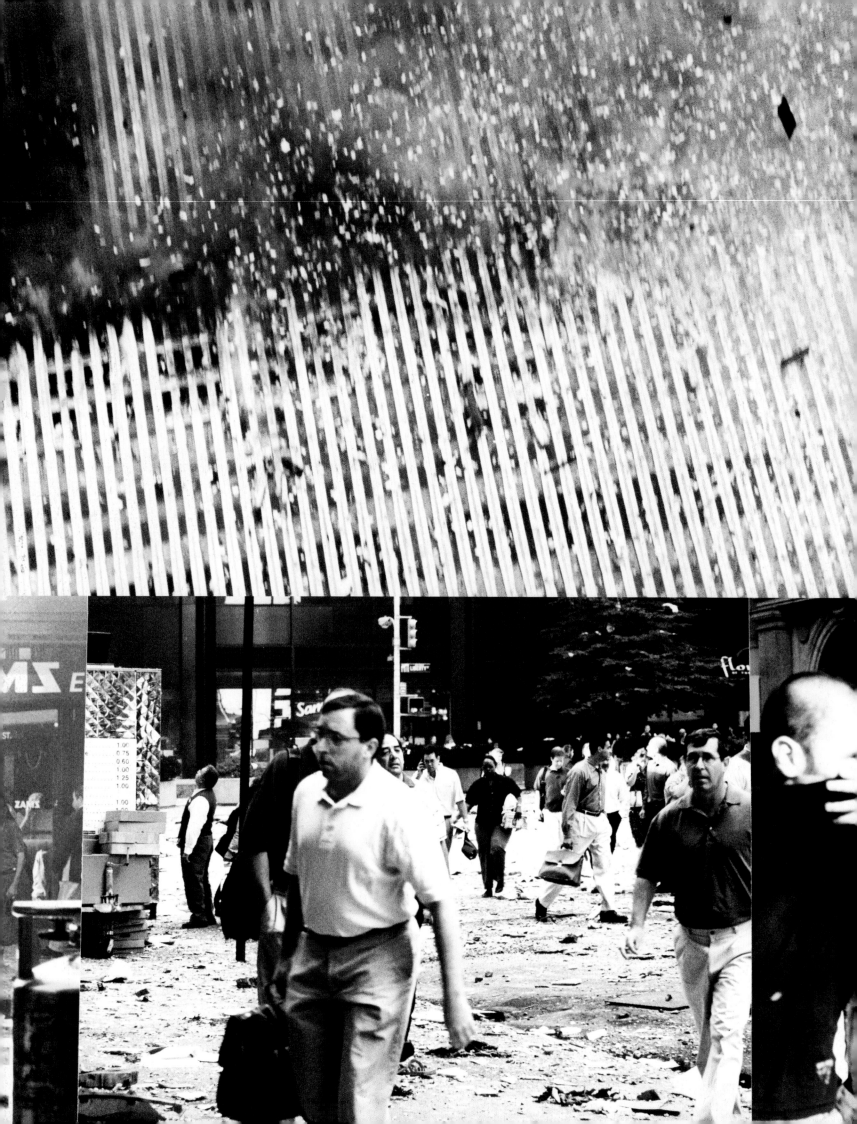

Email to friends and family members sent at 6:07 p.m. EST, September 11, 2001:

Yes, I'm OK.

What I experienced today is beyond words. I was sleeping on the seventh floor of my apartment, just two blocks from the WTC, when the first plane struck. There was a lot of smoke in the sky and tons of office paper was falling. Rather than watch from the safety of my window, I grabbed my camera and headed to the street.

The scene on Greenwich Street was chaotic. Debris was raining down, and as I turned the corner onto Trinity Street, I could not believe my eyes. There was a gaping hole in the side of one of the towers. I was clicking away. To get a safe vantage point, I ran down the ramp of a parking garage on Church Street, directly across from the WTC. A few others had gathered there to seek shelter, as scores of people were running out of the WTC in all directions. Dozens and dozens of people were jumping out of the upper floors of the struck tower. It was a horrific sight, and I was beginning to realize how serious this was. It was like watching the end of the world, but it was nowhere near over.

I was focusing my lens up on the towers when I heard a god-awful thunderous sound that was approaching rapidly closer. It was the second jet, and it sounded as if the sky was being torn open. It struck the second tower with such unbelievable speed and force, ripping through the building and exploding through the other side. A huge ball of flames and black smoke rolled up the side of the second tower and tons of debris flew outward. Hundreds of horrified people began running down the parking garage ramp toward me, to escape the falling debris. Only one problem: The metal garage door was down. The crowd began pounding on the door, frantically yelling for the door to be opened. It was becoming obvious that I needed to get out of there, fast. I will never forget the look of sheer terror on the faces of those people.

I wasn't about to stay there at the parking garage and face even more danger. I made a run for it, back to my apartment a block and a half away. I never knew what it felt like to "run for your life." Now I do. I managed to escape the falling debris by running between buildings. Again, the sounds; it seemed like the end of the world. Sirens, car alarms, screams, and pieces of the building crashing down so hard the ground shook. Flaming debris was falling far off to my left and right. Pulverized concrete flew by like a hailstorm. Police were screaming. I was in total shock; my mouth was completely dry, and I've never known such fear in all my life.

Thinking we were under missile attack, and more were on the way, I grabbed a couple friends and started out of the area. We stopped at a deli to get some water. As I paid, there was another loud, terrible roaring sound. The ground shook, the roaring grew louder, and we gathered in the back of the deli with more than 30 people who had come in to get off the street. Next, the shock wave from the collapsing tower came down the street in the form of ash, smoke, and debris, leaving the street completely dark. People became increasingly hysterical.

Ash-covered firemen handed out dust masks and instructed us to head toward the Brooklyn Bridge. The ground and everything outside was covered in two to three inches of ash. The sky was black as coal, a stark contrast to the light-colored ash that looked almost like freshly fallen snow. There was an eerie silence except for the faint sound of sirens in the distance.

Eventually, I was lucky enough to catch a train out of Penn Station and was crossing my fingers until we got to the Jersey side. As I looked back toward Manhattan, there was a plume of smoke that stretched upward and outward for miles from where the WTC once stood.

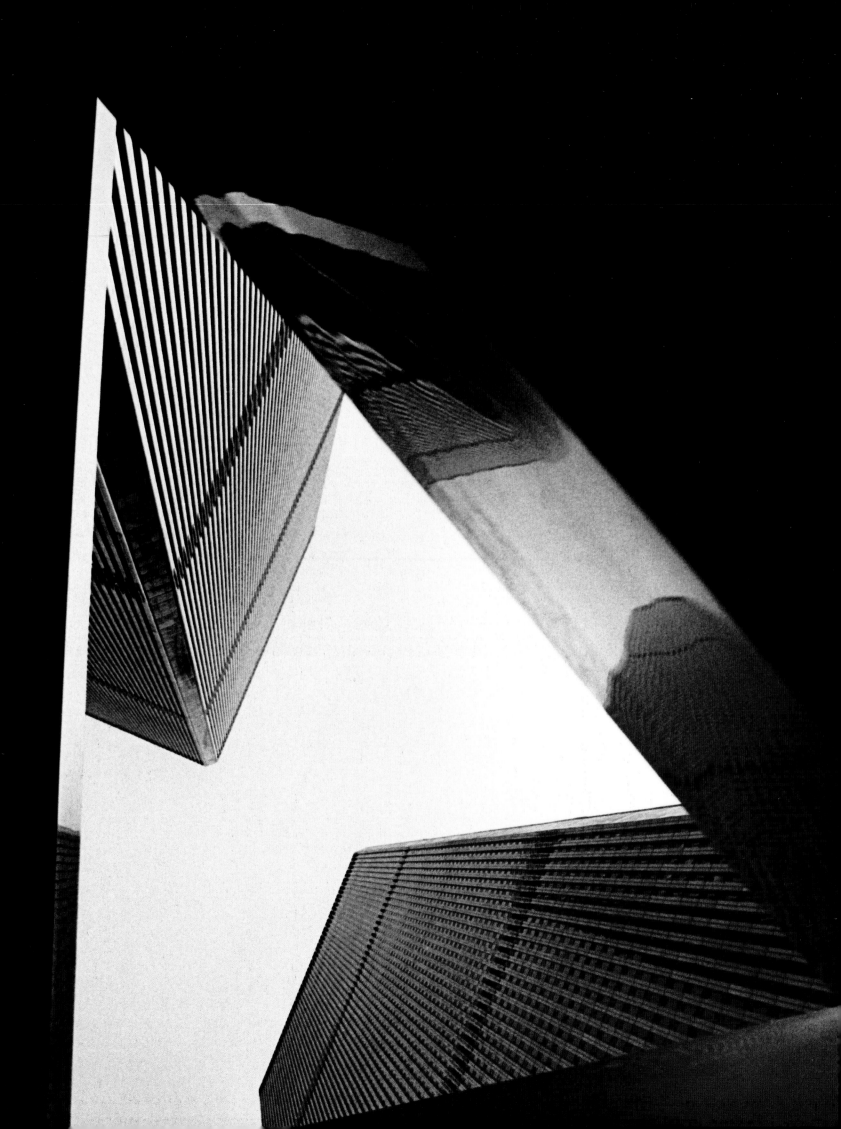

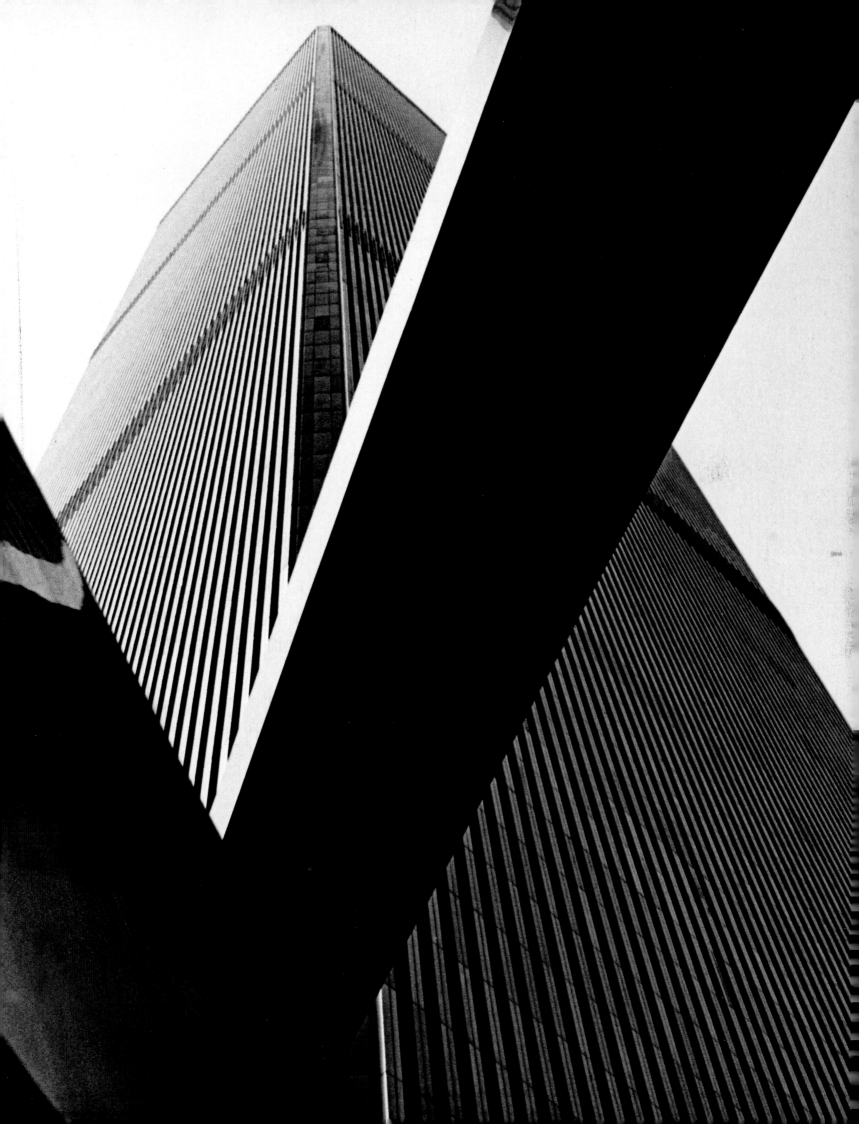

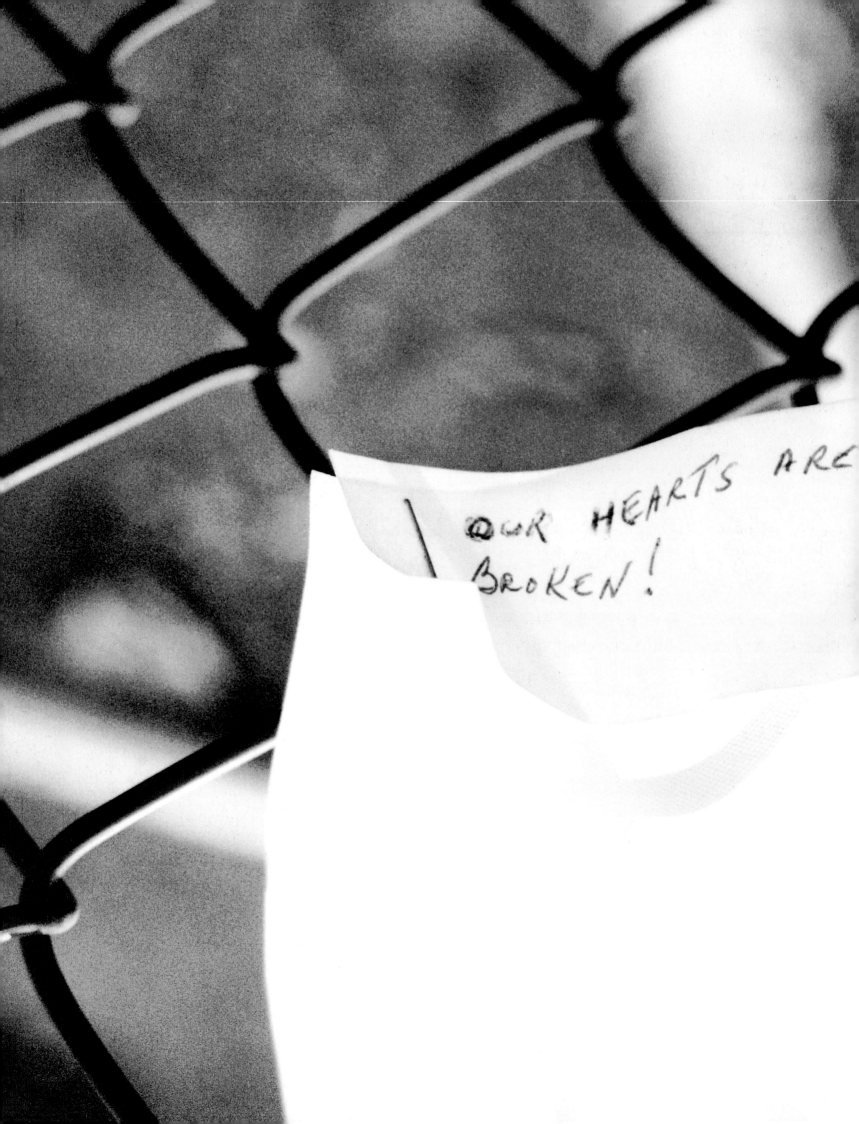

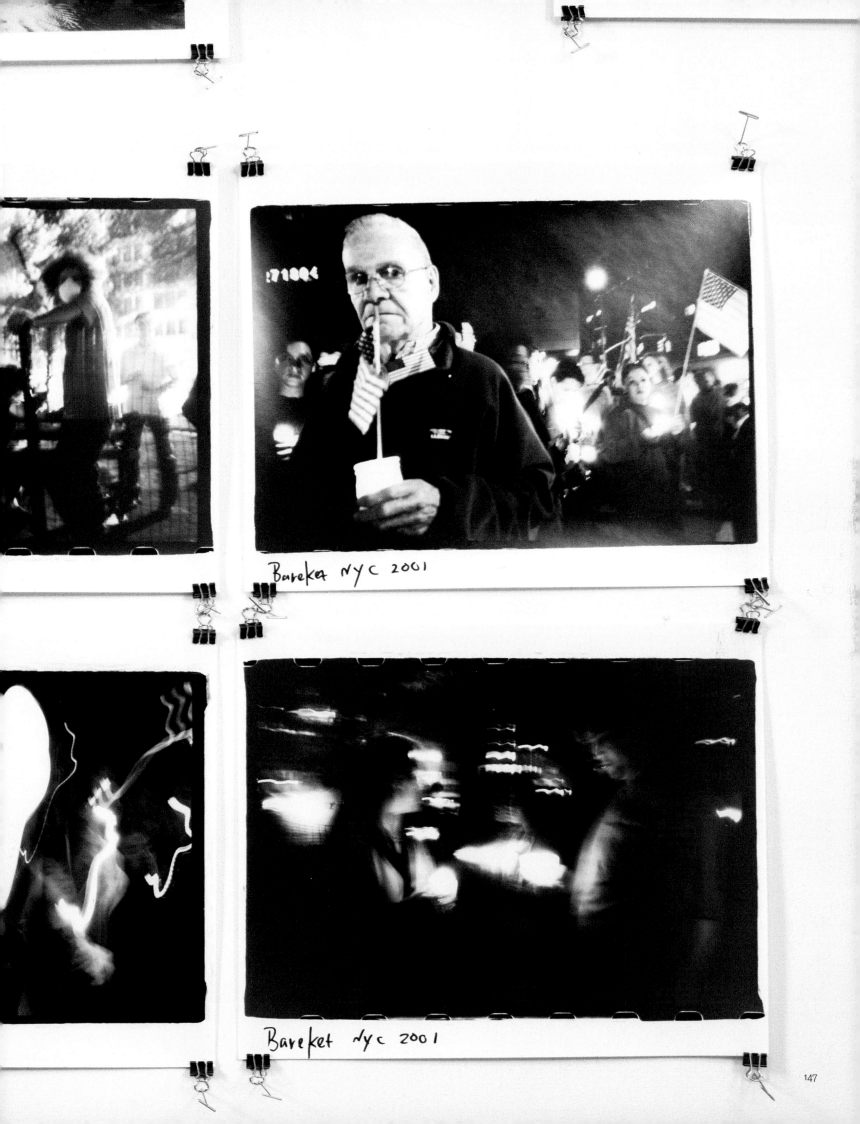

Bareket NYC 2001

Bareket NYC 2001

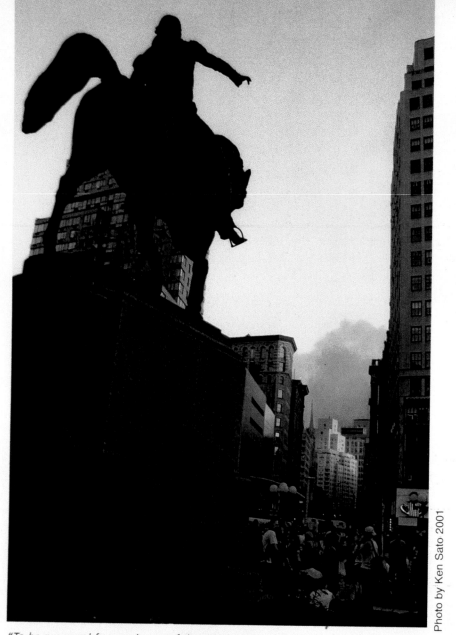

"To be prepared for war is one of the most effectual means of preserving peace."
-George Washington

"George Cries".
I saw this statue of Washington
in Union Square Park that afternoon,
and it almost seemed to me that
this "statue" of Washington was
as devastated as we all were that day.

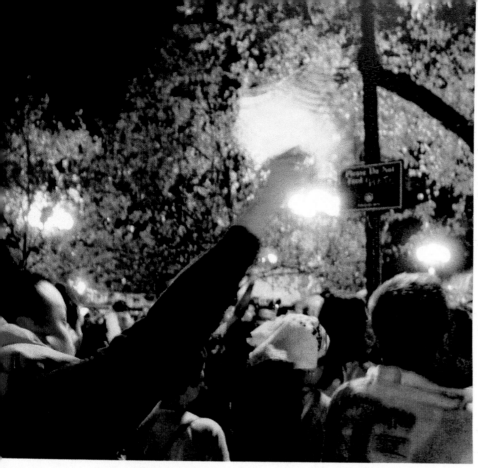

Photo by Ken Sato 2001

they ascende
cloud, and th
them.

13 In the sa
was a great ea
a tenth of the
earthquake se
people were k
rest were afra
ory to the Go
The second
hold, the third
ing quickly.

"Unwavering Pride"

I stood by this man and his daughter
at Union Square Park on the Sunday
after... His hand never stopped
waving the flag. There were hundreds
of people there, all of them showing
strength, love and Pride. It radiated.

"Revelation 11"

I haven't touc
years, because I
touch with religion
to it in curiosity,
a little bit... distu
of the recent eve

149

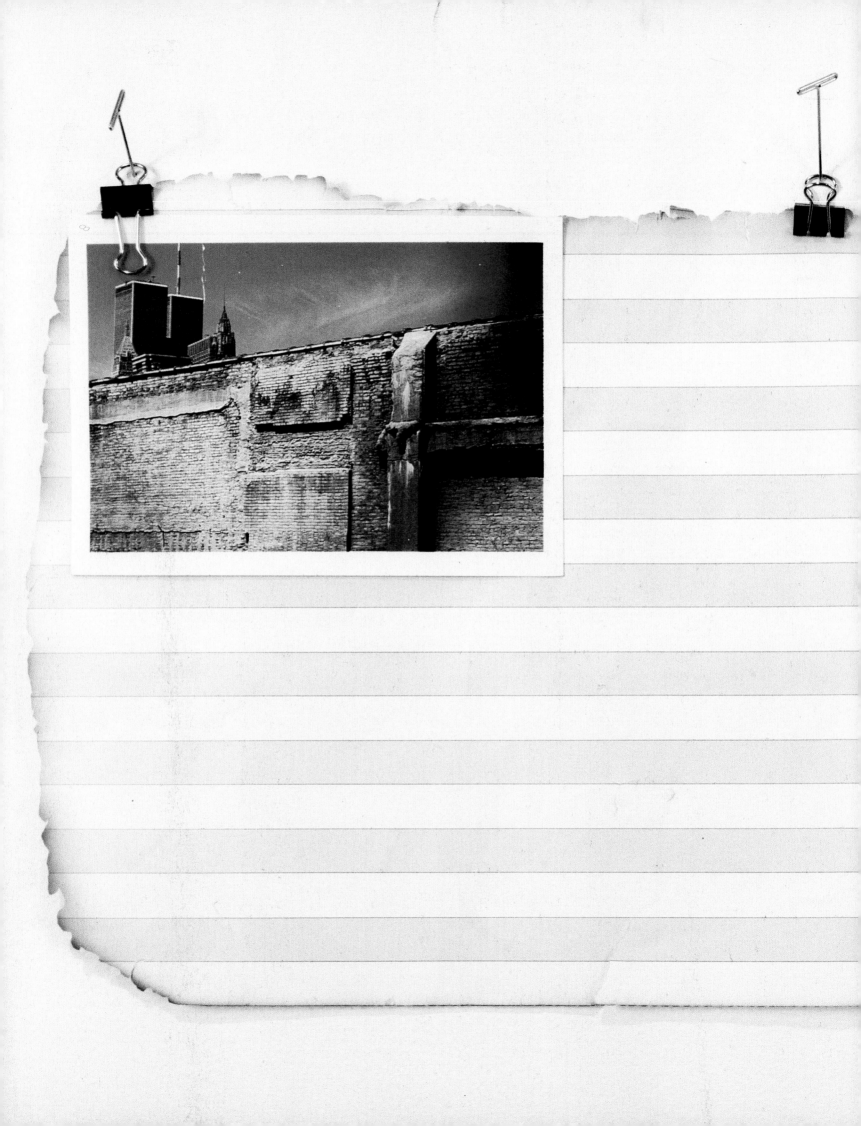

9/11

A piece of paper from the WTC,
turned into an American flag.

Dear President Bush,

The view of the WTC on the
postcard is the same as where I
found it - Dean St. in Brooklyn.
OUR FLAG WAS STILL THERE.

Sincerely, Tim Monti Wohlpart

TO VIEW IMAGES
HOLD VIEWERS
UP TO LIGHT.
⇒ ⇒

A call from my friend Jim woke me up on September 11 — the World Trade Center was on fire. I might have slept right through; instead I flipped on the TV and watched in awe as a plane hit the second building. I pulled on my shorts, grabbed my 3D camera, and went downstairs.

The street was churning with people, looking up, panicked, spreading news true and false. I took some pictures. A man next to me said, "The buildings are going to fall." He's wrong — I knew the buildings simply couldn't fall.

Like a fool, I walked closer. Suddenly, I was caught up in a stampede running north. "Run!" shouted many voices. There wasn't even a why, just "RUN!" Even police sprinted northward with fear on their faces.

I withdrew. It was too much. The smoke, falling people (falling people!), the chaos. I walked half-dazed back home, not knowing what else to do. When I reached my corner I turned and stared. Then the first tower fell. Somehow I knew I had my camera in my hands, and I held it over my head and shot.

Perhaps the pictures feel more real to me today than the event did at the time. It was so close — seven blocks — but like everyone says, it was like a movie. Impossible, fake, far away.

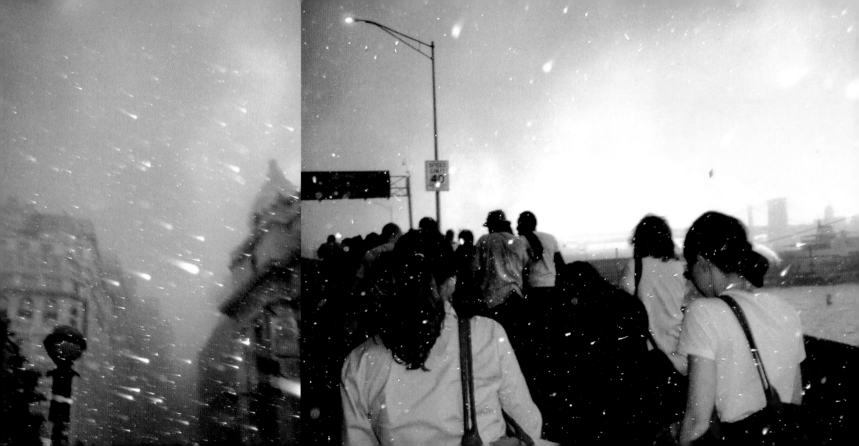

Time: 10:37 a.m.

This is a view of the South Street Seaport through the debris cloud, from the FDR.

Time: 10:49 a.m.

I finally escaped the debris cloud after I passed the Brooklyn Bridge. All of lower Manhattan was enveloped in smoke.

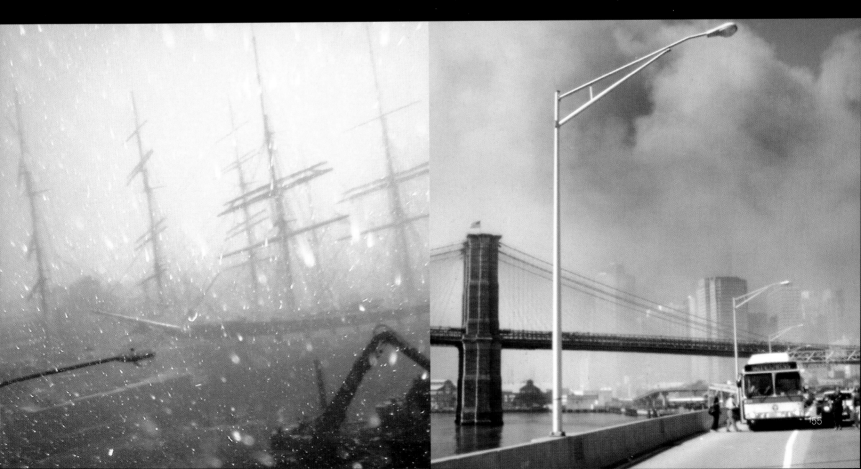

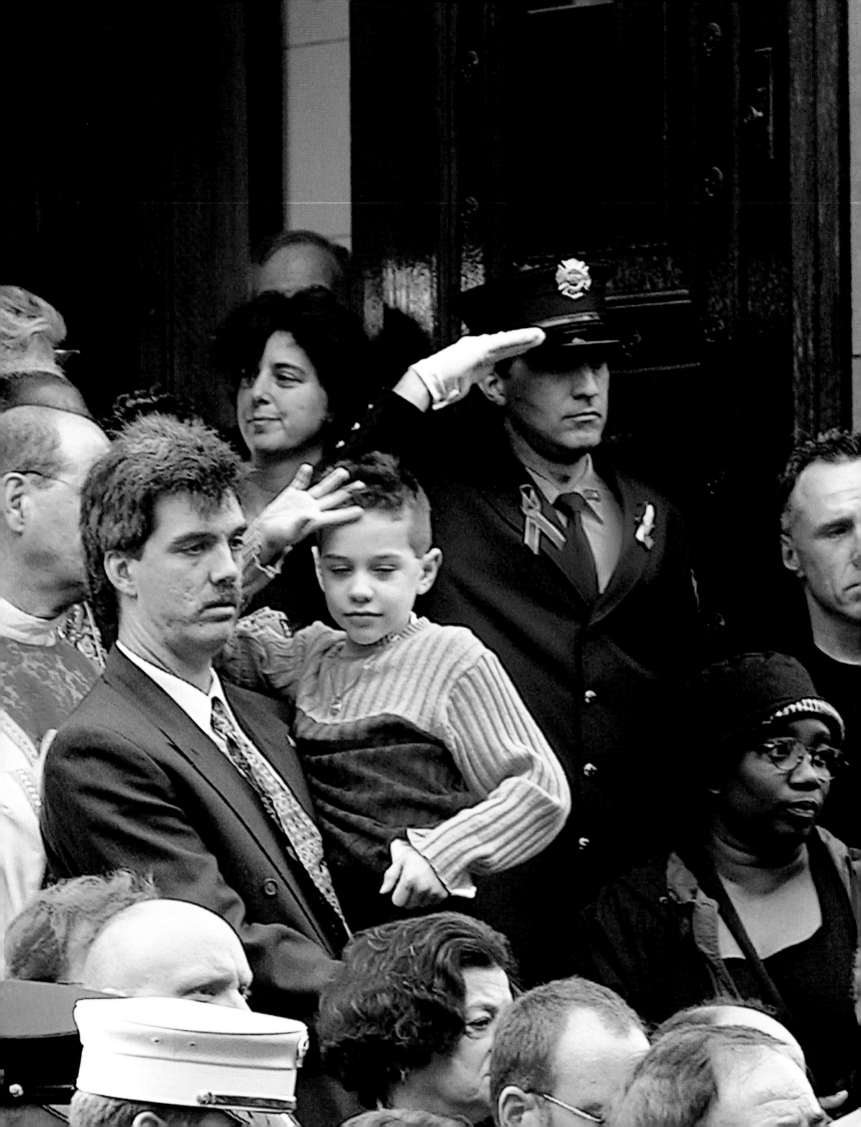

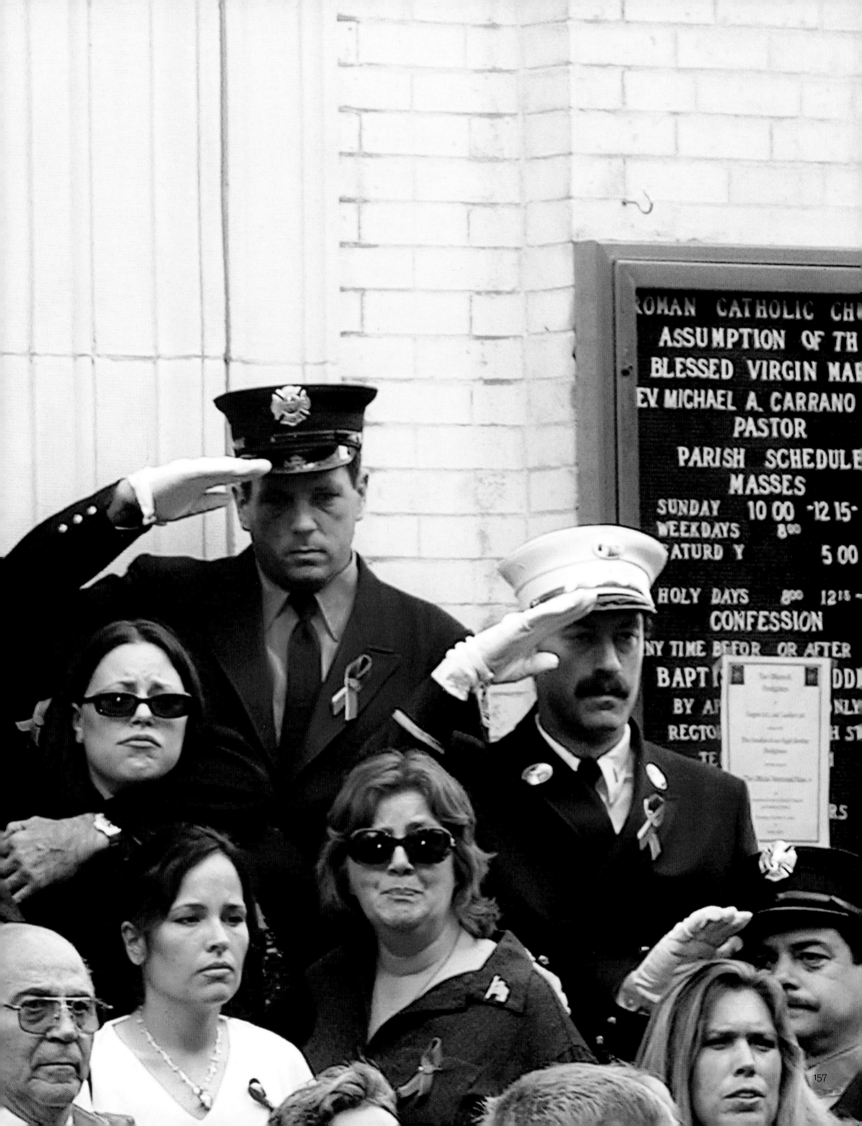

ROMAN CATHOLIC CHU[RCH]
ASSUMPTION OF TH[E]
BLESSED VIRGIN MA[RY]
[R]EV MICHAEL A. CARRANO
PASTOR
PARISH SCHEDULE
MASSES
SUNDAY 10 00 ·12 15
WEEKDAYS 8 00
[S]ATURD Y 5 00

HOLY DAYS 8 00 12 15
CONFESSION
[A]NY TIME BEFOR OR AFTER
BAPTIS[M] [WE]DD[INGS]
BY A[PPOINTMENT O]NLY
RECTOR[Y]

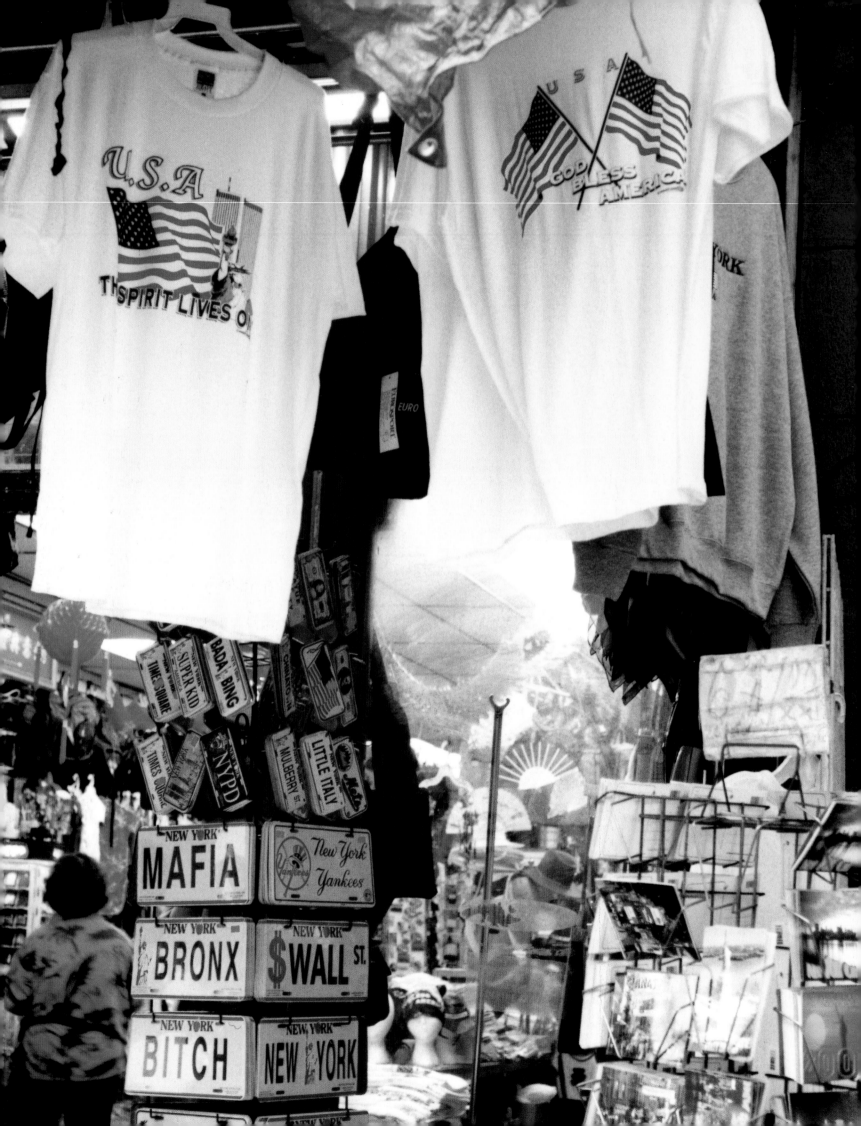

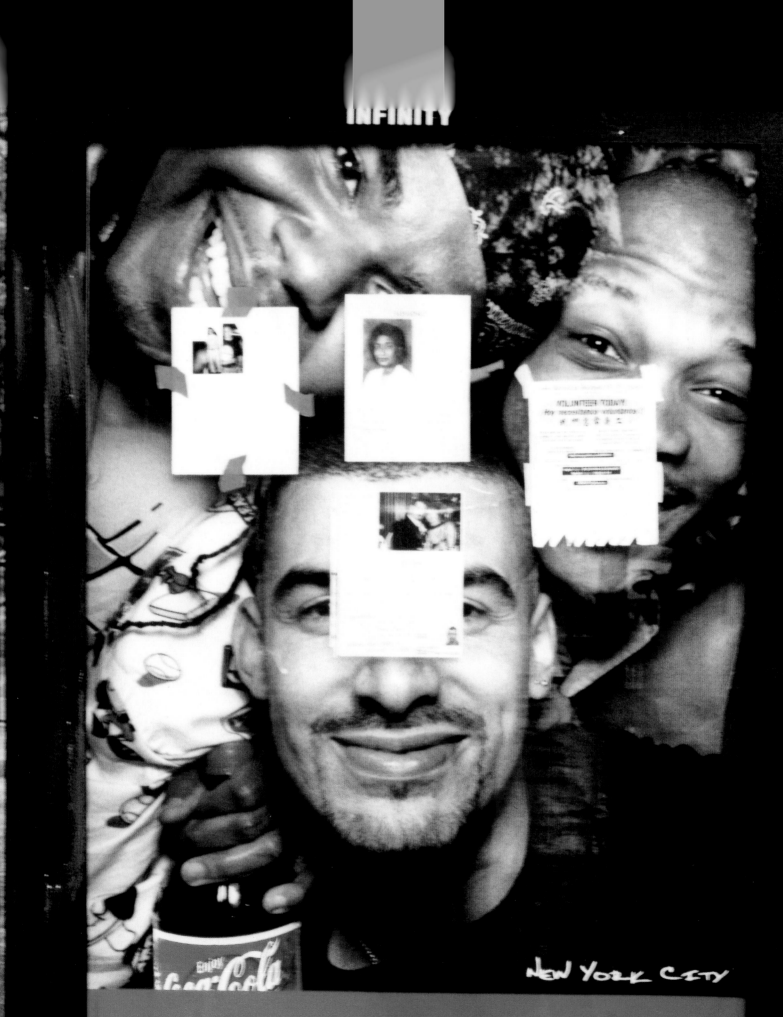

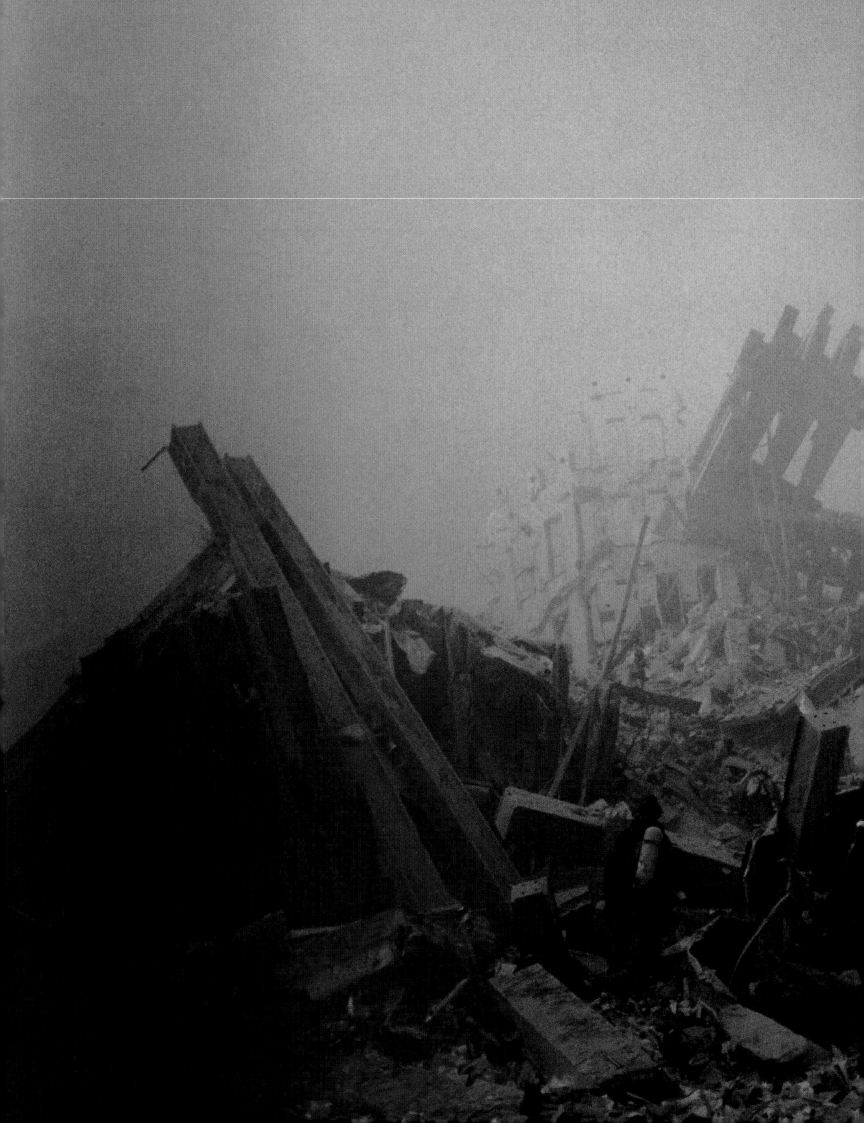

Watching in disbelief, I rode my bike down to Ground Zero. This is a picture of one of the first firemen entering the rubble.

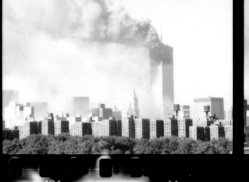

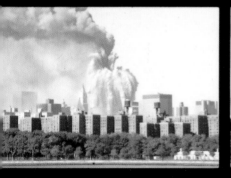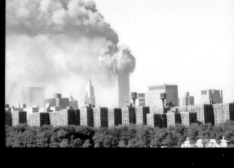

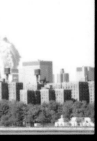

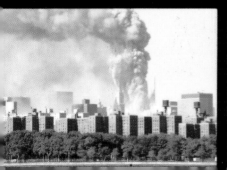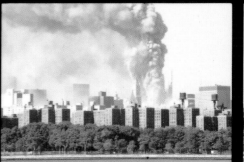

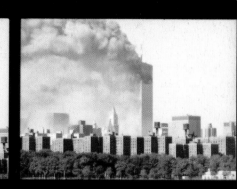
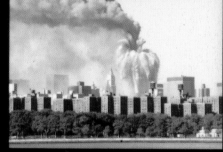
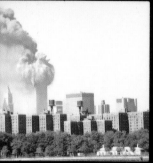
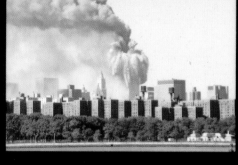
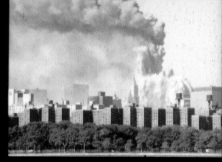
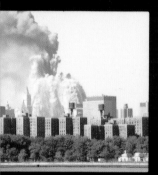
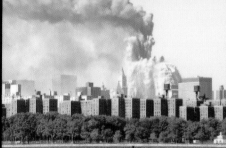
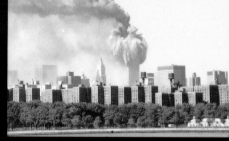
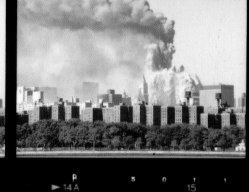
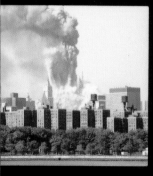
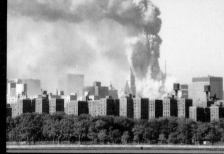
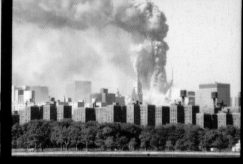
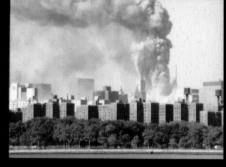
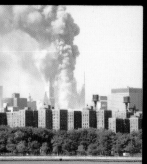
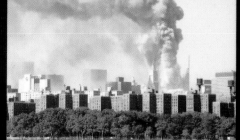
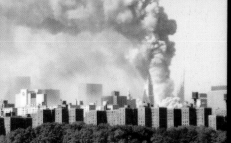
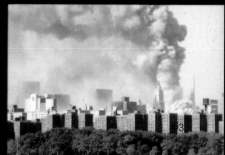

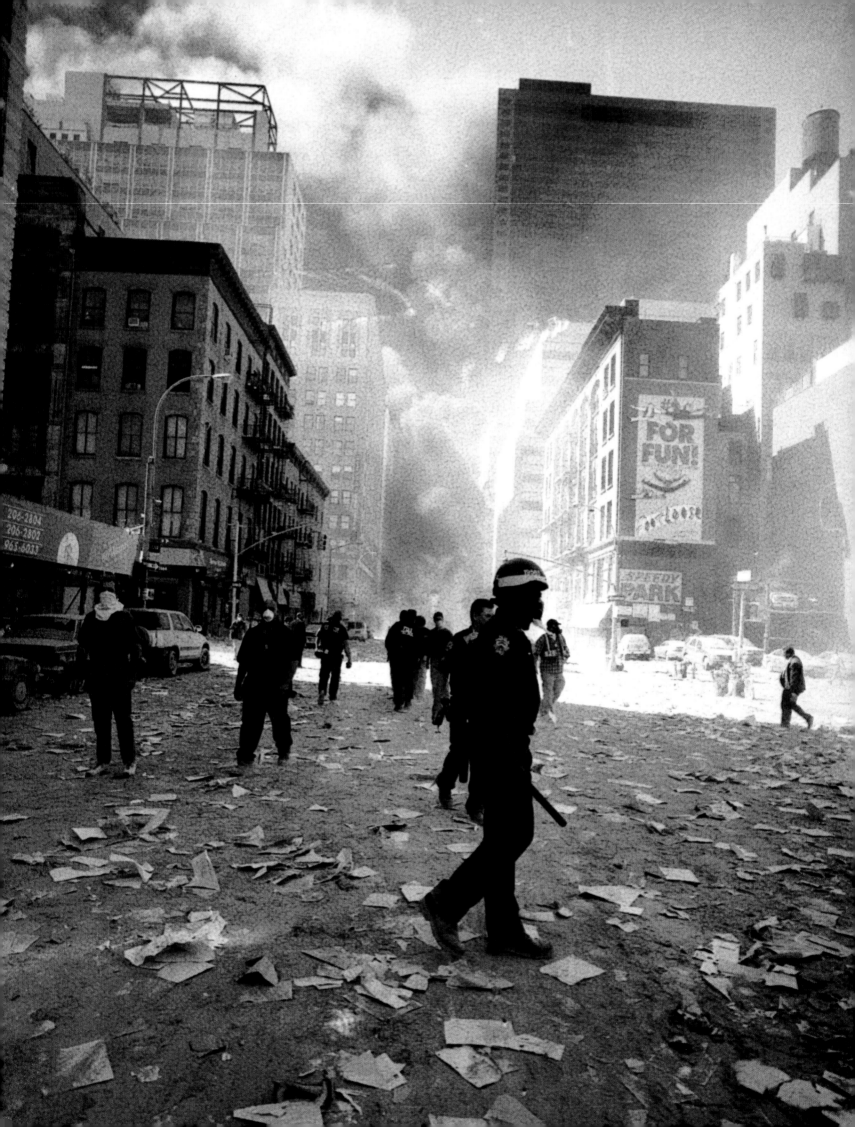

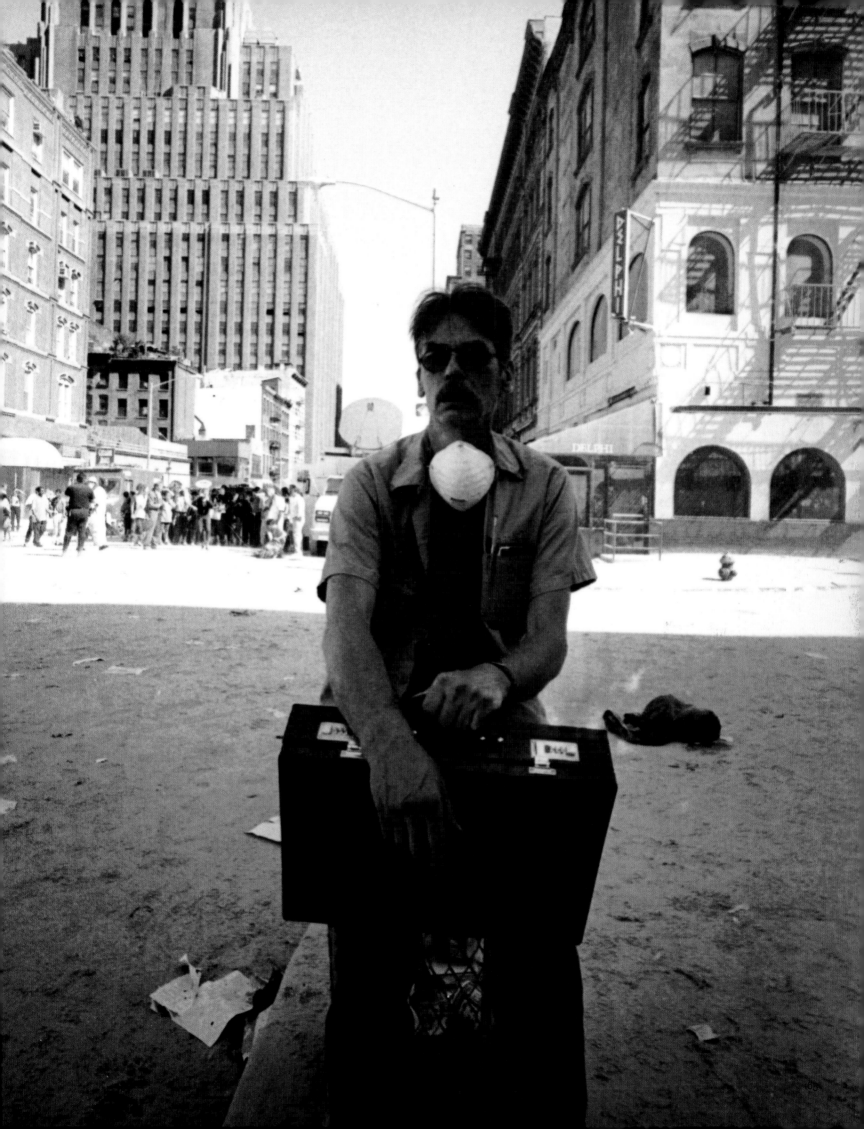

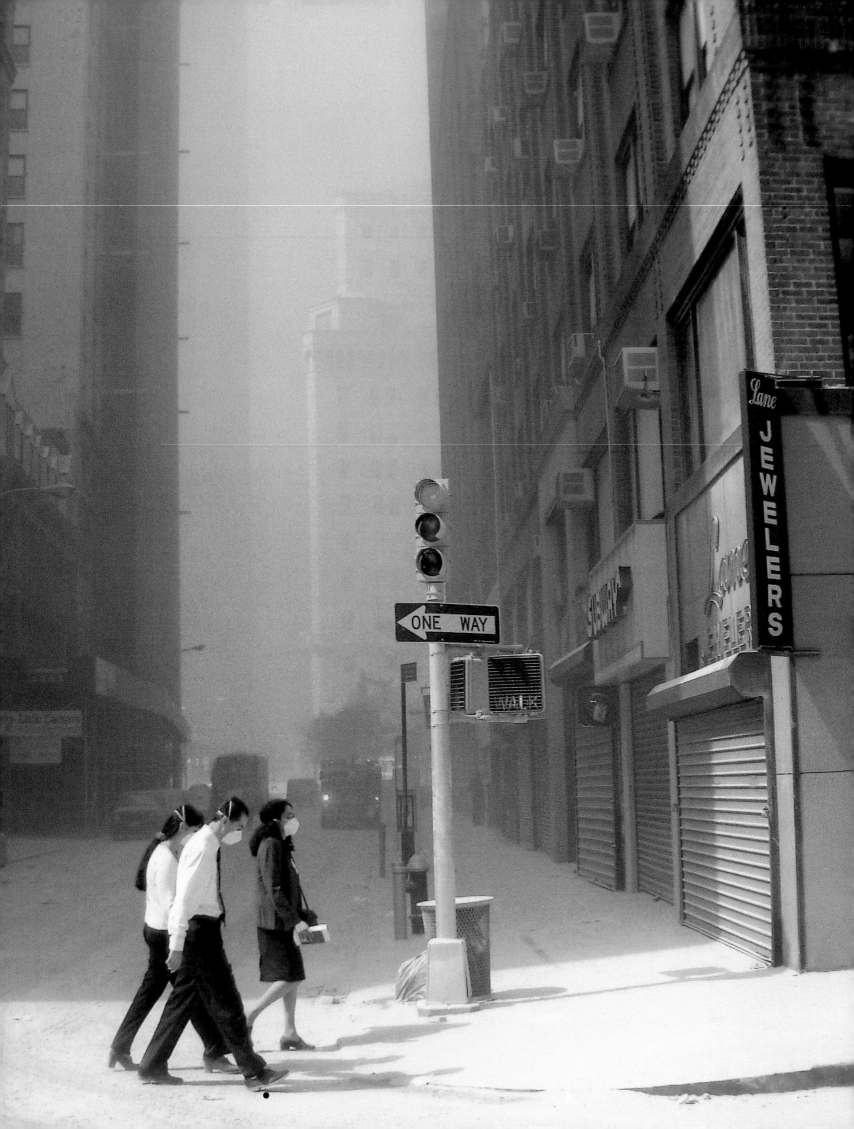

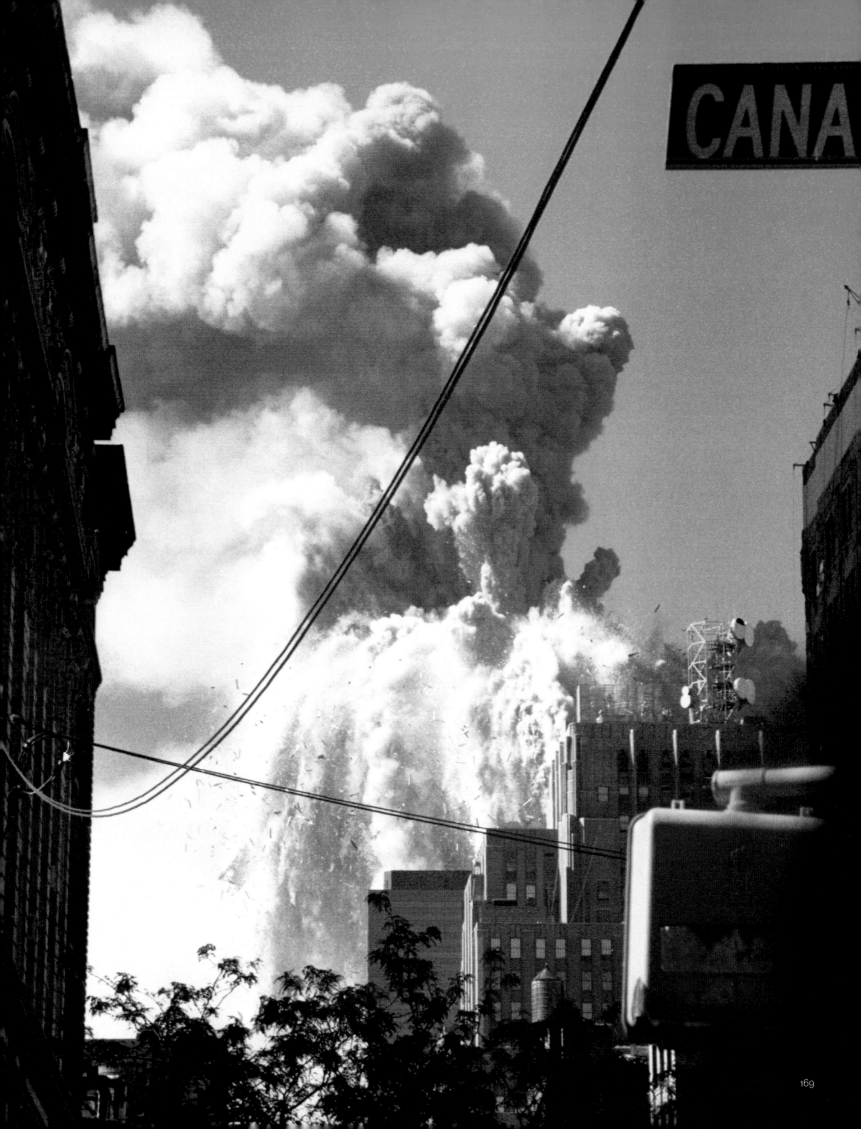

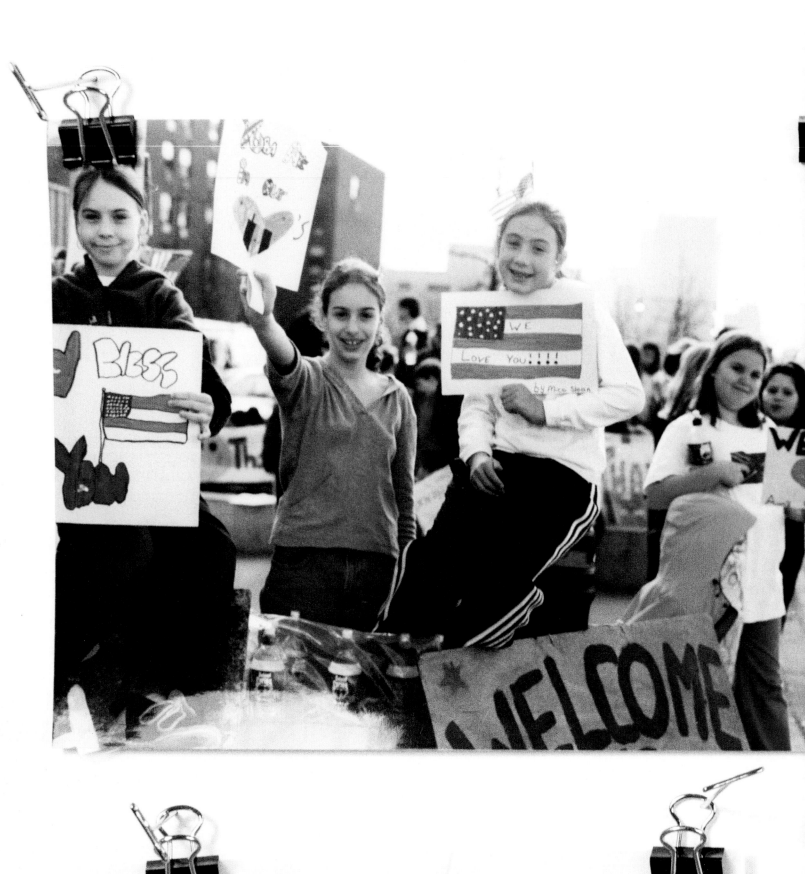

I went down to the Westside Highway in hopes of cheering on the rescuers. What happened was that their Responses - sirens, "we love you!" through their speakers and personal thank you's to all volunteers cheered me.

These are just a few of the volunteers who inspire me. They give hours to shout, "Thank you, you are the best!" often staying after midnight, in all kinds of weather.

The children are from Chemi's class of P.S. 3 on Hudson Street in Manhattan. They cheer at "Point Thank you" from time to time. These children erected a small Christmas tree which they adorned with signs. Later, many others added their own decorations.

People are good.

— Judith Sapountzakis
December 2001

OUR

ARE

171

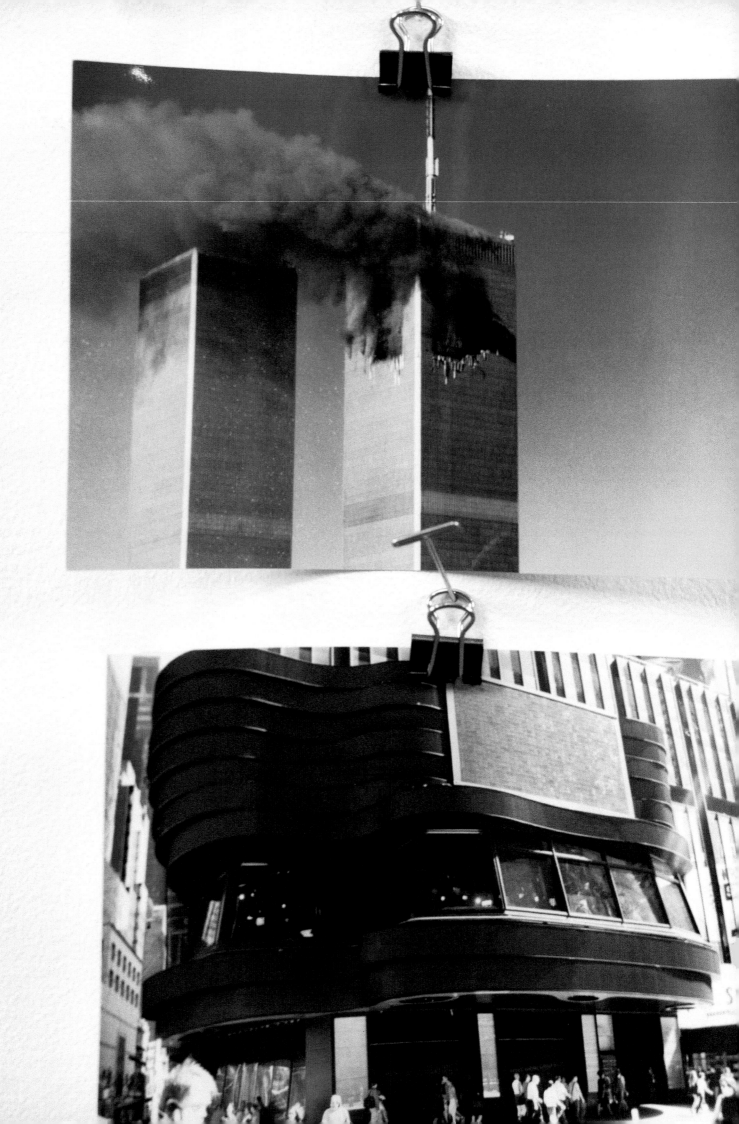

late afternoon Tues Sept 11, 2001... two of my fellow
government agents and I ventured to Times Square
from our "safehouse" after the longest morning we'd
ever experienced. I was stunned to see Times Square
almost empty of people and traffic, and the ABC
Jumbotron was completely black. I called my friend
Michael M. who works in the sound room of the studio.
"Hey, what's with your jumbotron?" I asked. He said,
"What do you mean? Your people told us to turn it off!"
"My people? What are you talking about?!" "Yeah, the
government called & told us to shut it down, too many people
were congregating in the Square to see the news
when the feds wanted them to disperse."
ANS

173

September 11, 2001
9:30 AM. Brooklyn Bridge
The first tower had just
collapsed. This photo
was taken looking back
at Manhattan.

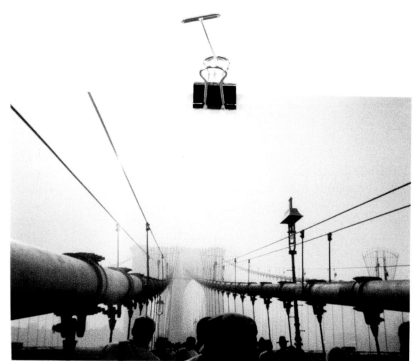

September 11, 2001
Looking toward Brooklyn
as I crossed the Brooklyn
Bridge. Women were
walking with no shoes -
barefoot. An elderly woman
was praying out loud.

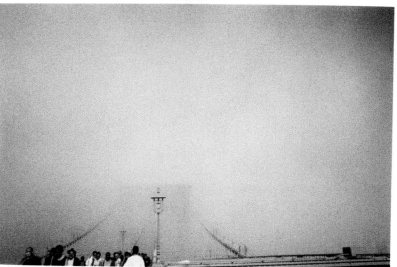

September 11, 2001
Brooklyn Bridge.
Looking at Manhattan.
I thought, "Will I die on
this bridge?"
Thought the world might
be ending —

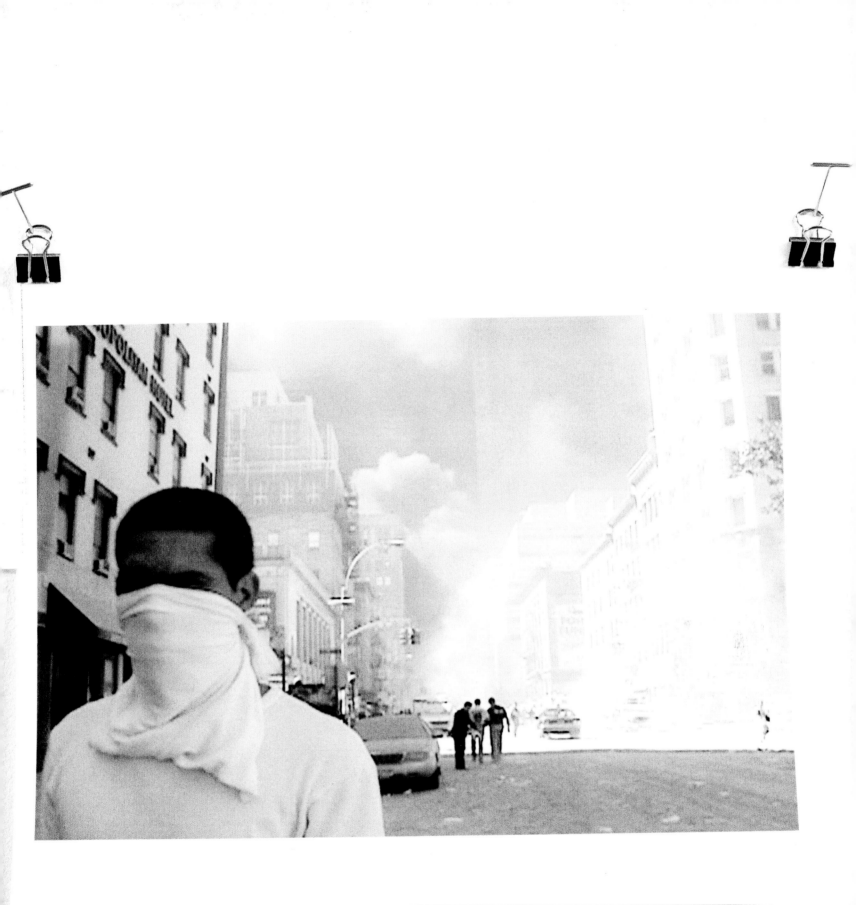

A SIGHTSEEING PLANE PASSES
THE TWIN TOWERS ON A
SUNNY SUNDAY IN 1997.

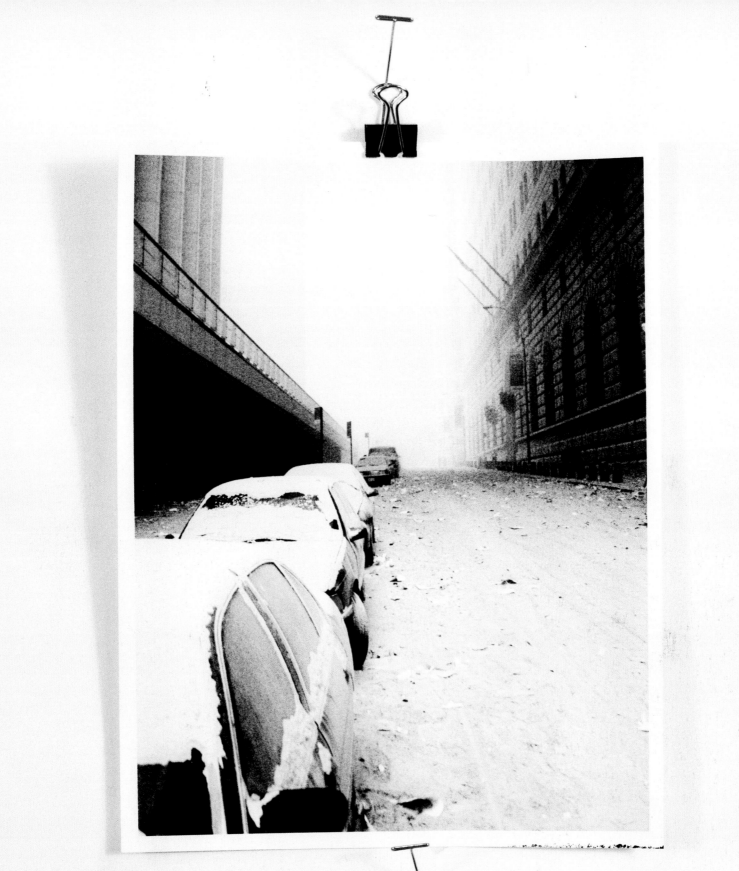

This is a view down a street in the
financial district during lunchtime on
September 11, 2001. Each corner I came
to held the same eiry scene, of void of
people and resembling the aftermath
of a nuclear blast.

Robert McMahan

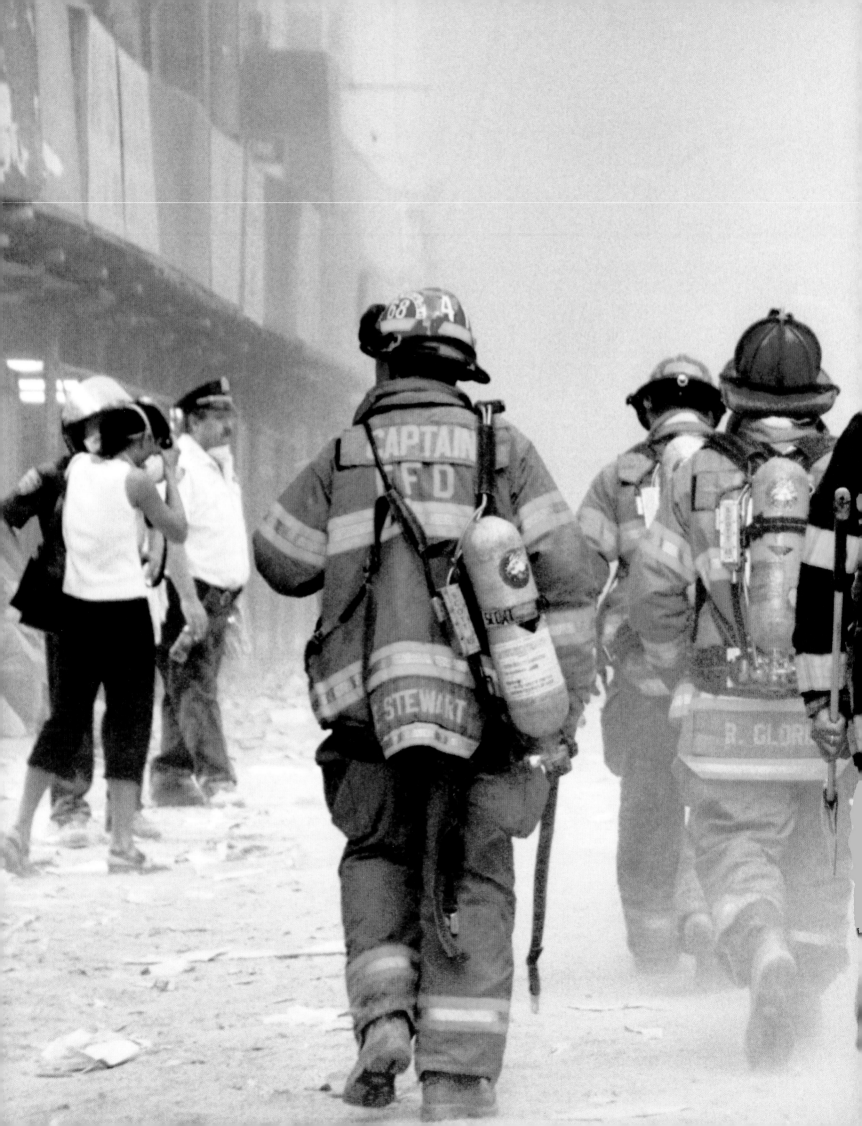

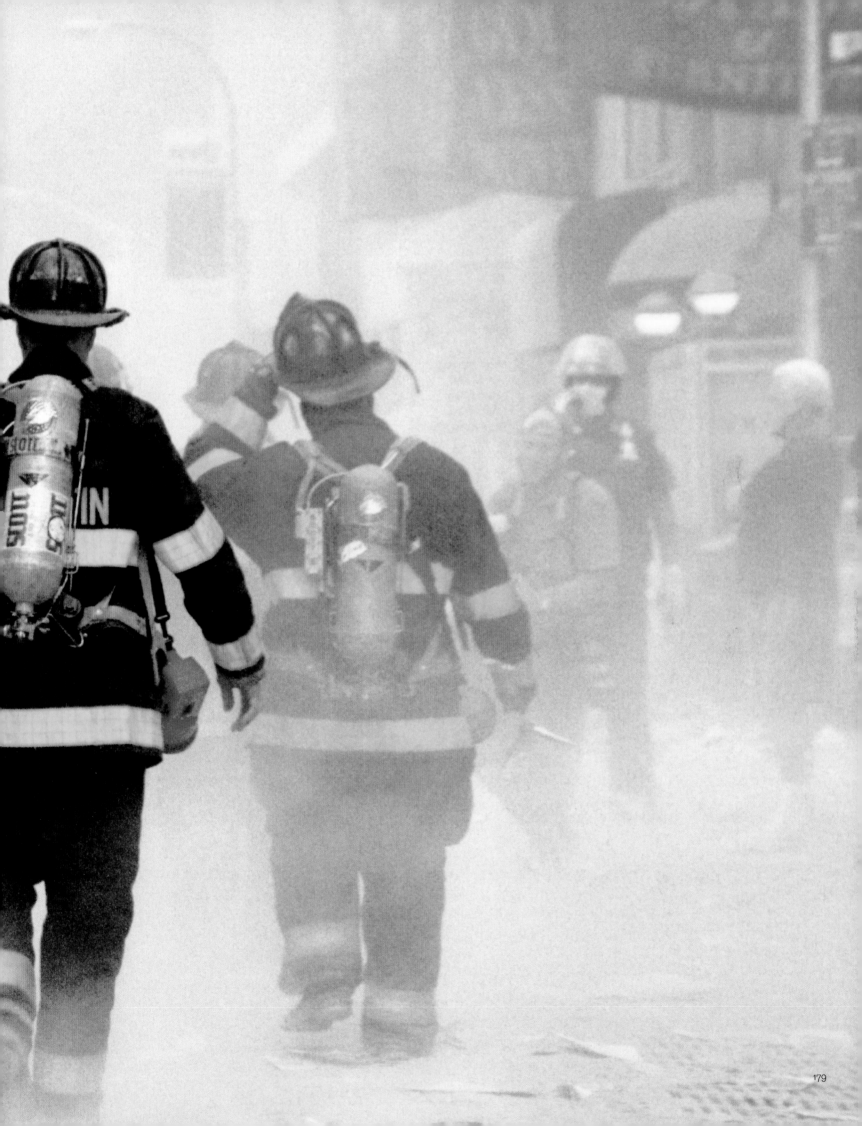

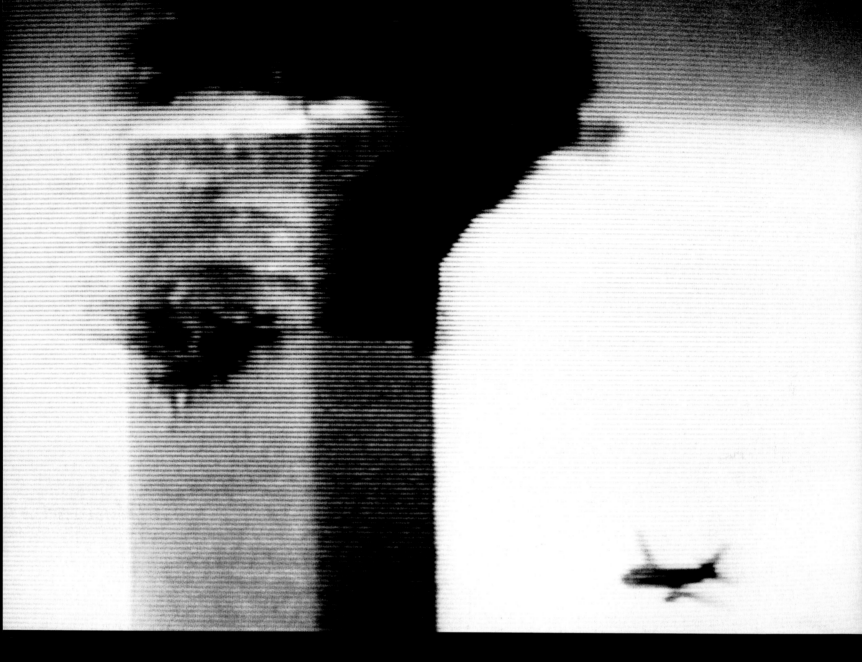

Numbness overcomes us.

On Monday, September 10th, my wife Audra and I walked on the Brooklyn promenade gazing at the icon-laden skyline hallmarked by buildings our generation witnessed being built.

I remember how, when I was a small boy, my father boosted me up on his shoulders so I could crane in at the cavernous foundation. Gazing at the biggest hole I had ever seen, I wondered how and why anything could be built taller than the Empire State Building. That same night we dropped Uncle Joe off at work for his midnight shift at Chock Full O' Nuts on Rector Street. I recall the secure, cozy feeling of riding around lower Manhattan in the backseat of my dad's car. My family stopped off at Horn & Hardart for a wonderful late night treat. I was a young boy living life innocently, unaware of the cold war and the fears it created for my parents and the rest of the adult world. Life went on. Uncle Joe kept working the night shift, and my family made the same routine nighttime trips to lower Manhattan over the years until Uncle stopped working.

Our family trips grew less frequent as the Twin Towers became bigger and I grew older. After their completion, I visited the towers like millions of others, climbing to the top in the fastest elevators we had ever used. It was the closest to the moon any of us would

ever get, and the tallest buildings our entire world had ever seen. We were dwarfed; unconscious of the enormous strength and pride those towers would ultimately represent. They were man-made. A tribute to the power of humanity.

In many ways what happened on September 11th is a depiction of the worst of humanity. The foundations have now become a mausoleum for thousands of innocent people. Unnatural dying suddenly became a medium for communicating. What horror for the survivors now having to live, suppressing aggression in the face of new understanding. Our enemy is not a country or an emperor. It's not even a bomb that looks like a weapon. It is an unrecognized fact that in our age of communication, oppressed people in the world are still throwing rocks at tanks! A primitive and desperate way of expression. Our inability to understand and question the oppression in the world has launched faceless murder.

Secure this day of hateful death in our learned memories and pray we can all remember the peace and harmony we are all born with. Remember that we all have suffered. Muslims, Jews, Italians, Irish, Mexicans, French, German, British, Russians — the list goes on. We must really live this. We must breathe this. Learn from this. Let

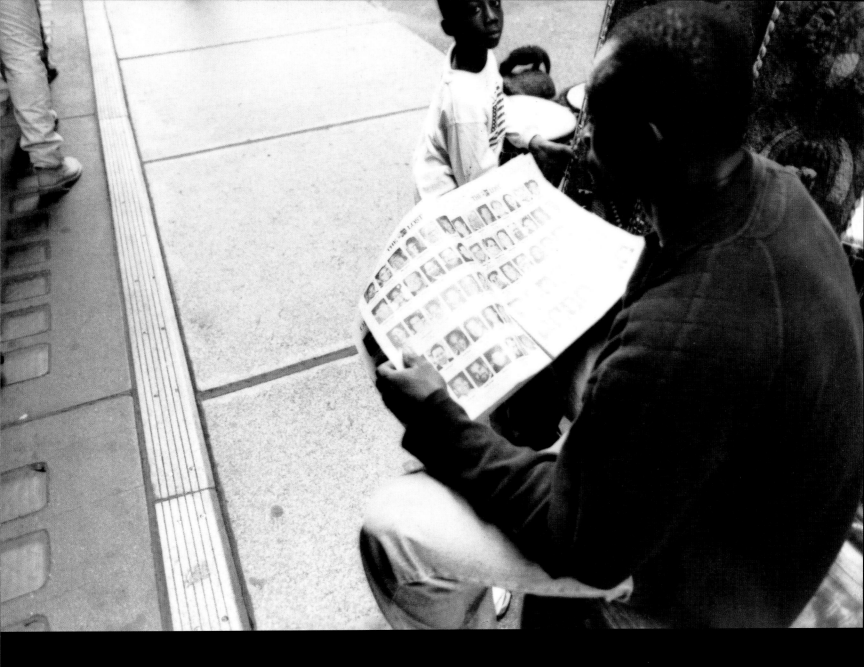

it not fall into some nostalgic memories covered over by a panic
triggering an ignorant drive to merely win. We must suffer loss and
reflect. Be thankful we have become painfully aware of the world
in which we live. Only then can we even begin to make it better
for all of us. Pray for the strength to remember your past, your
innocence, and the peaceful humility of being human.

below:
Interstate 17 north of Phoenix, Arizona

opposite:
Balbir Singh Sodhi (1949–2001)
Convenience store owner in Mesa, Arizona, and victim because he
wore a turban

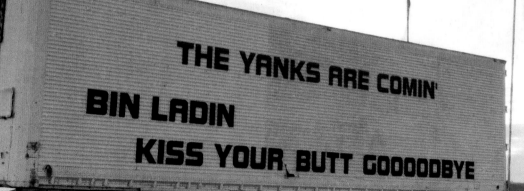

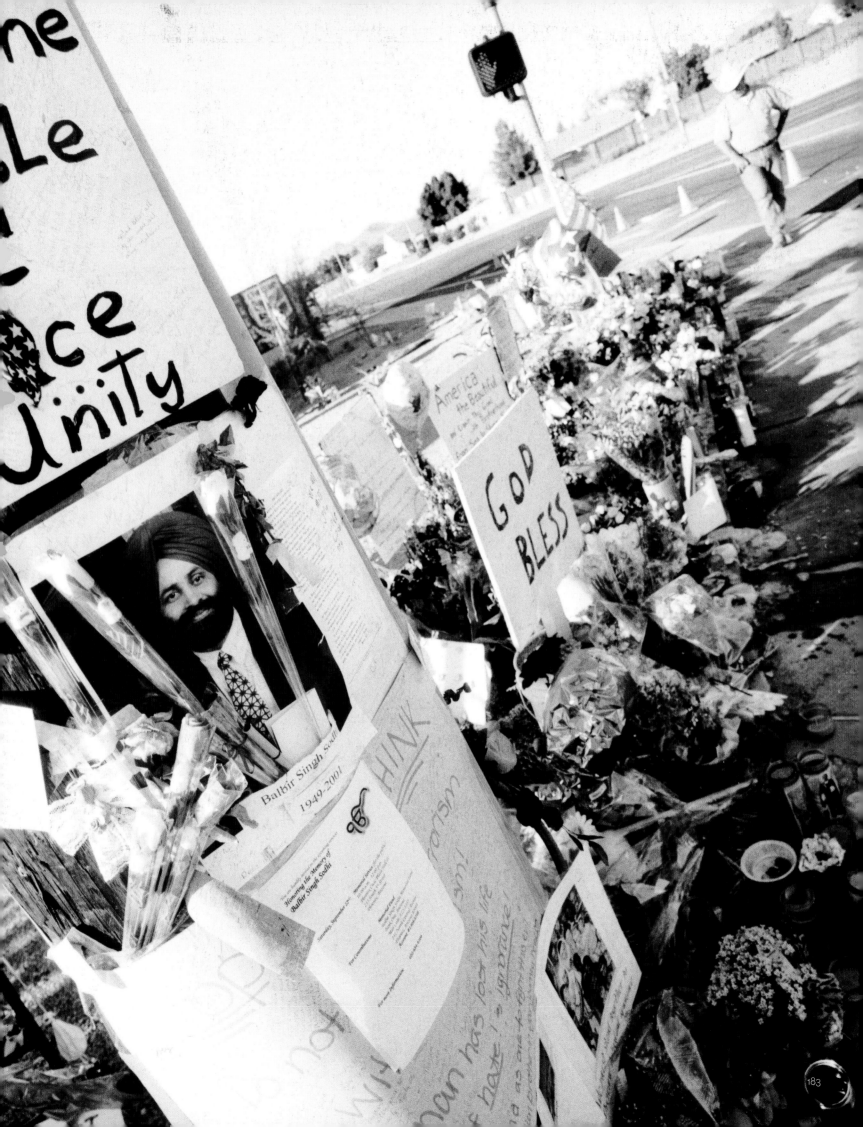

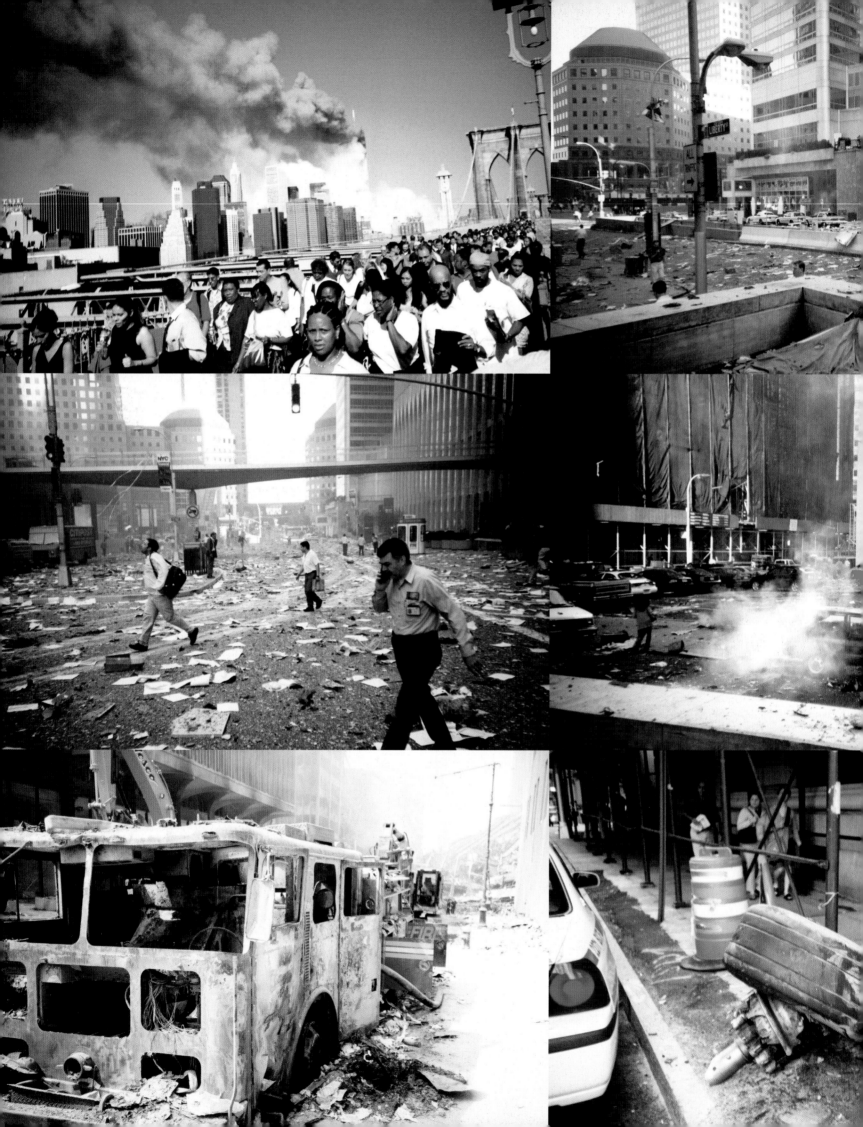

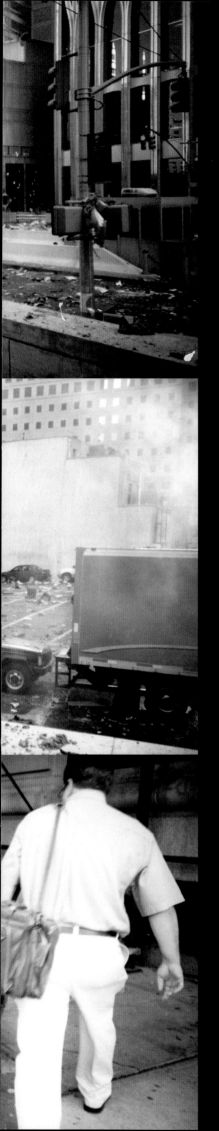

I, Witness

Like most people, the events of September 11, 2001, forced me to do things that I never thought I'd have to do and confront things I never thought I would have to face. However, unlike most people, it was my lot to have an up-close and personal view of the myriad tragedies of that day. Although I was lucky enough to escape bodily harm, there is an emotional, psychological, and spiritual wound that heals far slower than any physical damage. This is my story of the horrible events of that day and of my ensuing search for understanding and peace.

The morning began exactly like most. I awoke after a fitful night's sleep and commuted on the #1 train to the Van Cortland Street Station. When I arrived, the lobby of Two World Trade — also known as the South Tower — was oddly deserted. On crystal clear days such as this one, the lobby is usually full of tourists queuing up for the observation deck. But today was different and I felt very removed as I took the elevator to my company's cafeteria on the 34th floor to get breakfast. I then went to my desk on the 31st floor to begin my day. At exactly 8:51 a.m. I felt the building rumble and the lights flickered on and off. There was the unmistakable sound of a muffled explosion. My first thought was "That was a bomb." I then thought, "How could a bomb get above us?"

Then, as odd as it sounds, I tried to return to my work. Immediately, people started shrieking and the smell of smoke started to permeate the air. Someone yelled, "Oh my God, an airplane just crashed into One World Trade." I looked out of the west side of the building and saw green smoke and debris falling to the ground. Everyone began a frantic evacuation. As we were lining up to go down the stairs, an elevator opened up to my right and against my better judgment, I got on with about three other men. We descended to the lobby and I began to walk north toward the promenade when an African-American woman security guard yelled out, "Don't go that way, there are bodies everywhere!" I did a U-turn south and exited Two World Trade onto Liberty Street. At that point I remembered I had my camera and knew from past experiences that it is very important to record the scene of an accident as soon as possible. The photos here are a presentation of my escape south to Liberty Street, then on to West Street, where I witnessed the second airliner fly directly over my head and into the building where I had just been moments earlier. I fled south to Battery Park, where I wrapped around the south tip of the island and then north again to the Brooklyn Bridge. I crossed over into Brooklyn and walked down Flatbush Avenue until I arrived at my girlfriend's mother's house on Eastern Parkway. I then returned to Ground Zero on Thursday, September 13th, to turn in my photos to the FBI. I also felt a need to see the towers buried in the ground firsthand so that I could begin to grieve.

My story is just one of thousands from that horrible day. I hope my story helps those who witnessed these events from a distance or on television to understand the horror and violence that the survivors, rescuers, and the families of the deceased are forced to deal with every day. To the families who lost loved ones, I know that these photos might open up fresh wounds, but I hope by sharing that pain with the country and the world this type of event might be averted in the future. Only through understanding can we defeat hate. Unfortunately, to find complete understanding, we must look not only into the light, but also into some very dark places. May God bless us and have mercy.

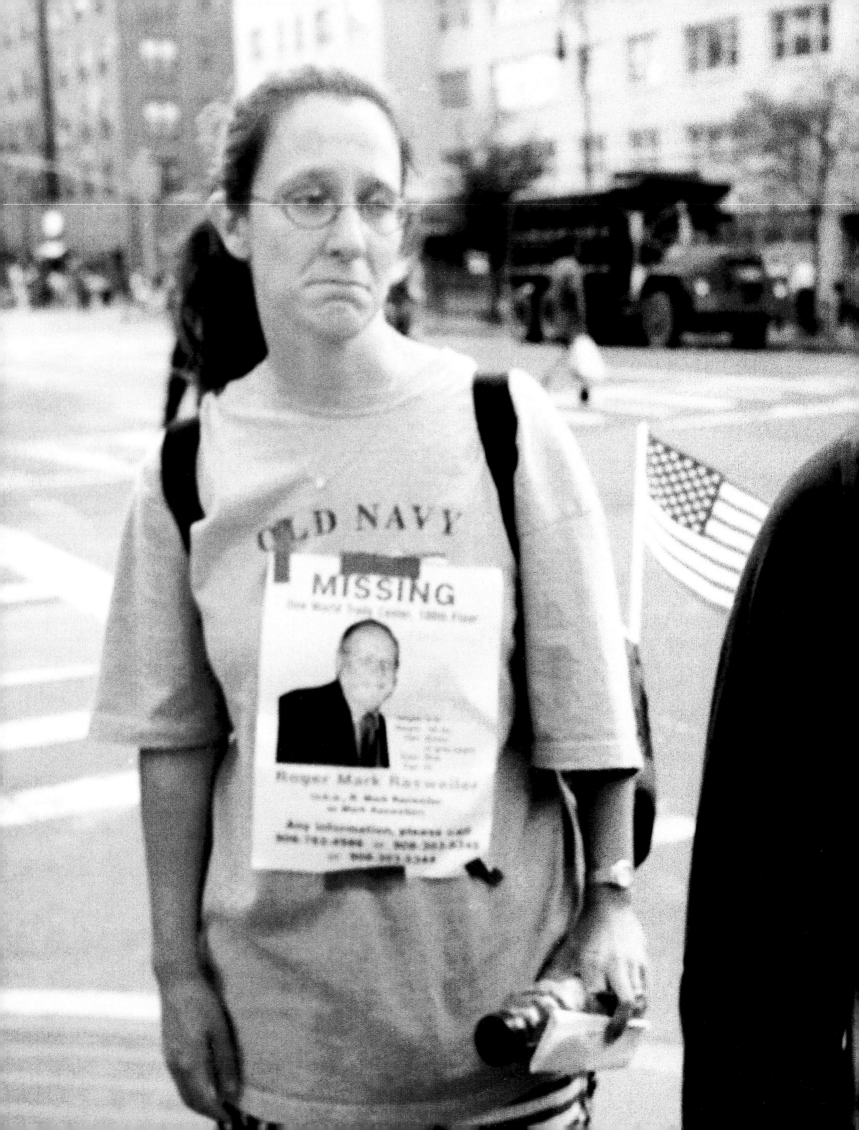

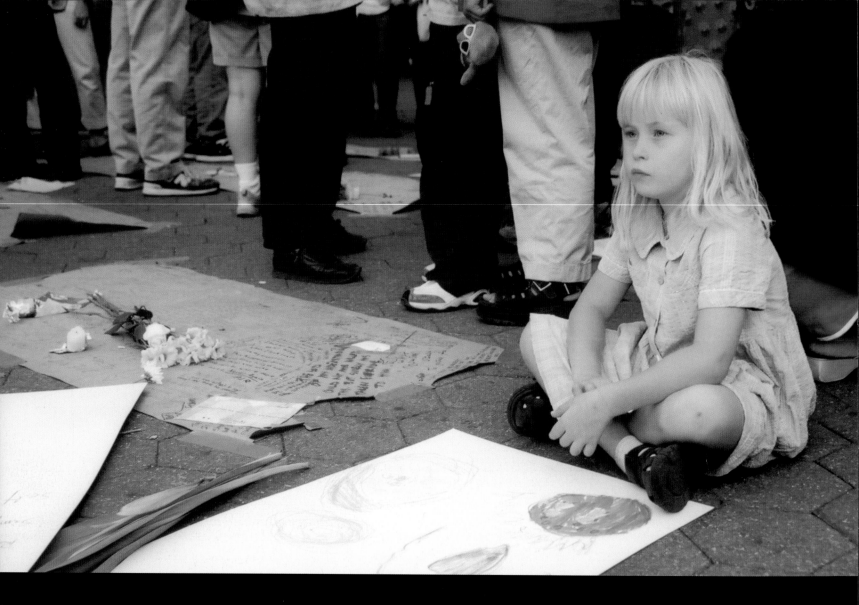

Union Square, New York City
6 p.m., September 12, 2001

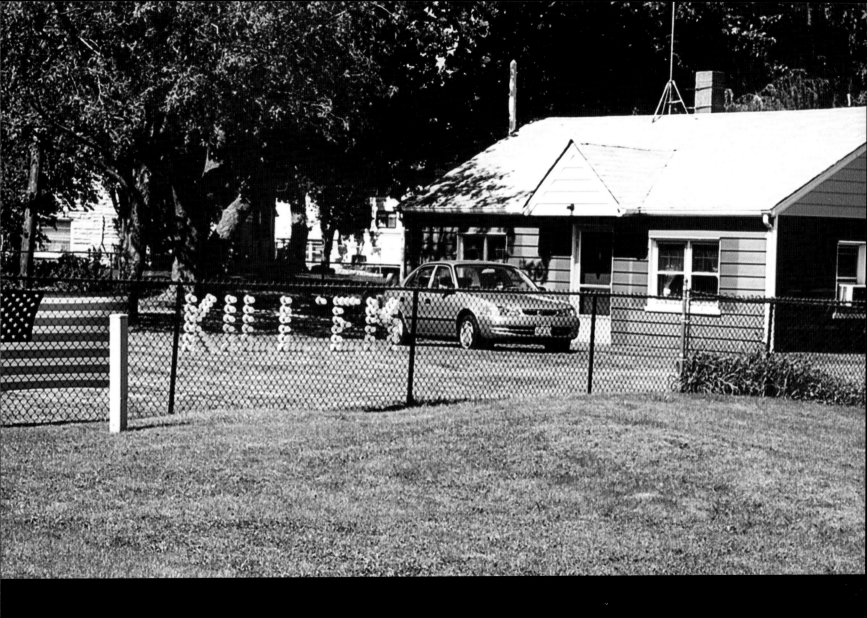

Merriville, Indiana
1 p.m., September 16, 2001

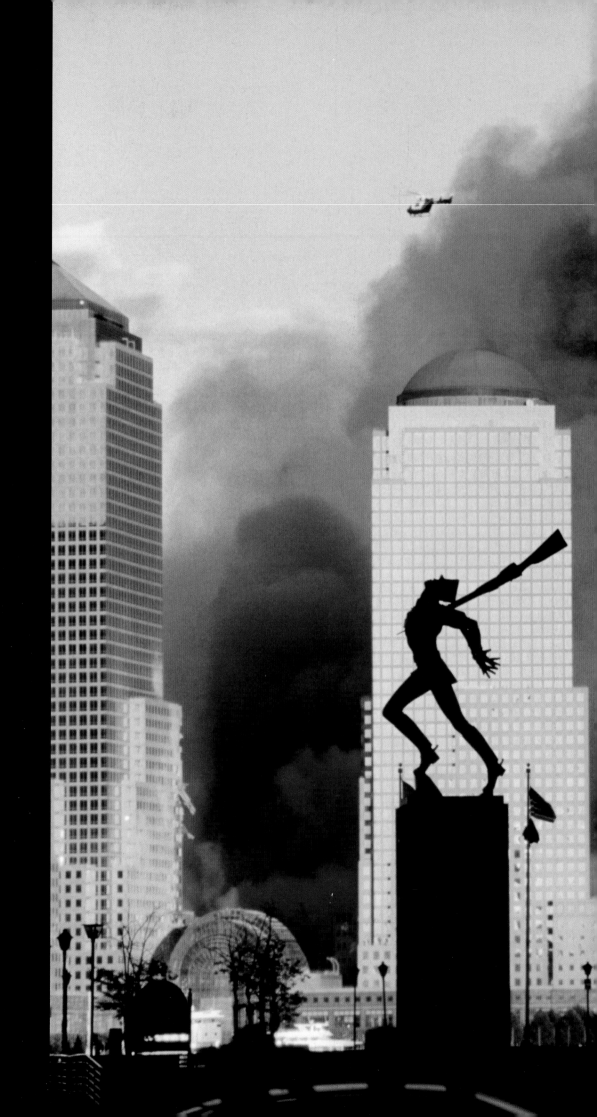

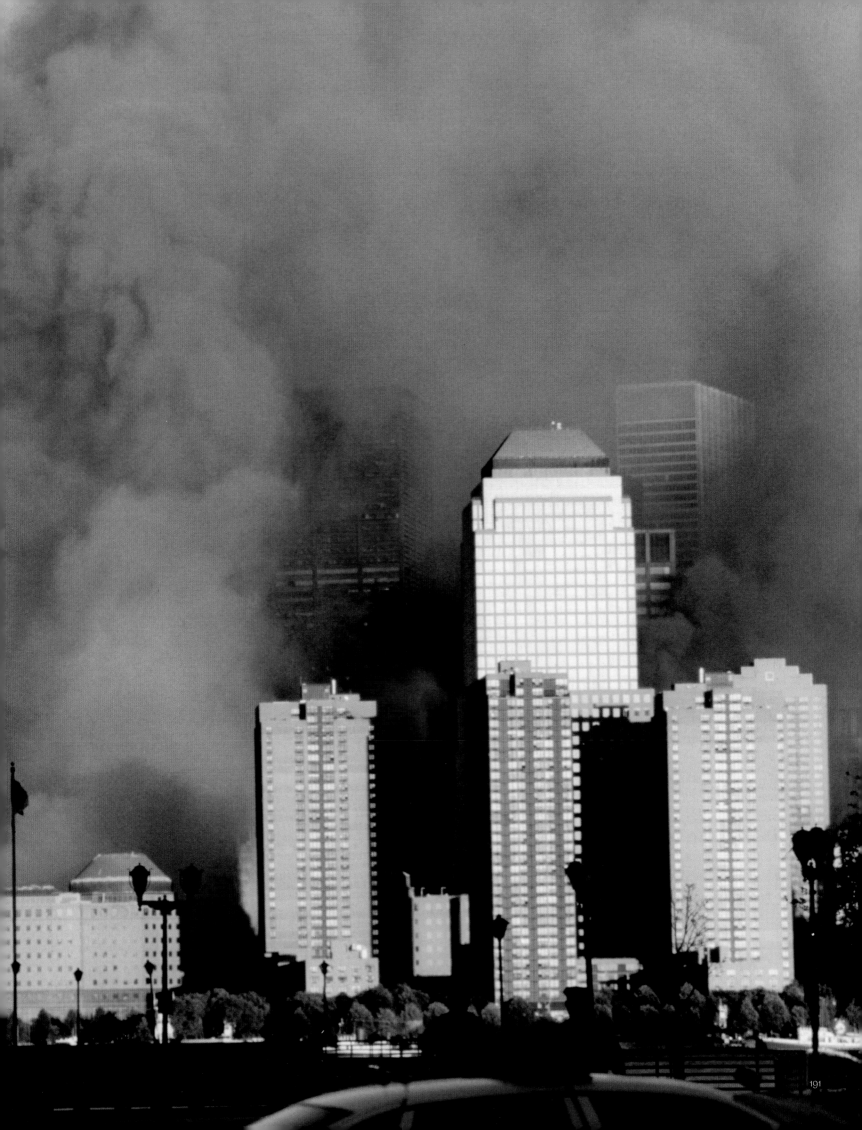

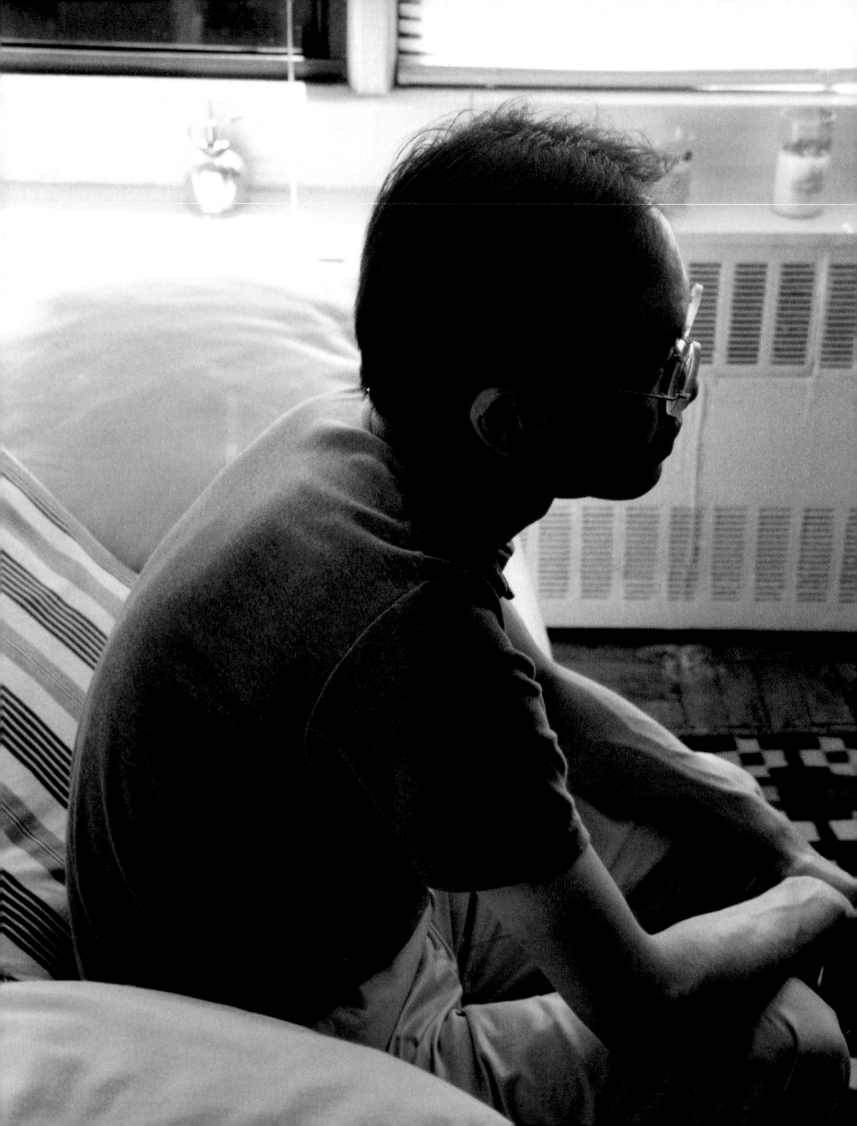

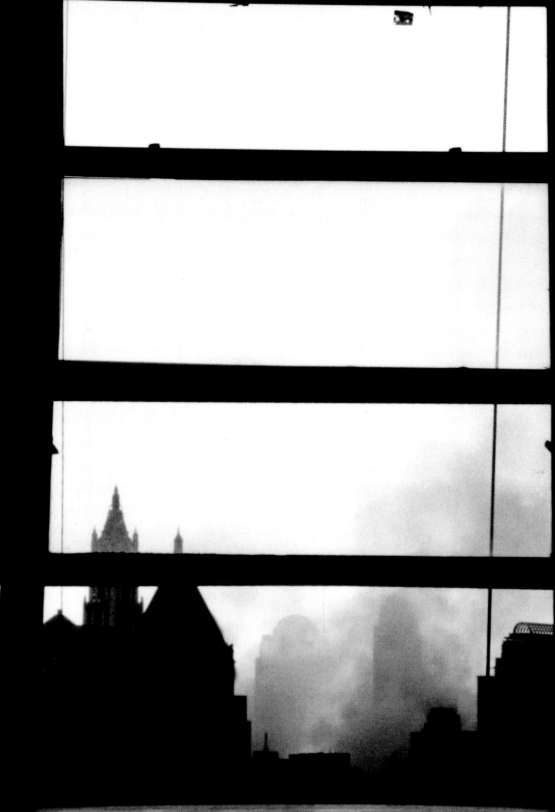

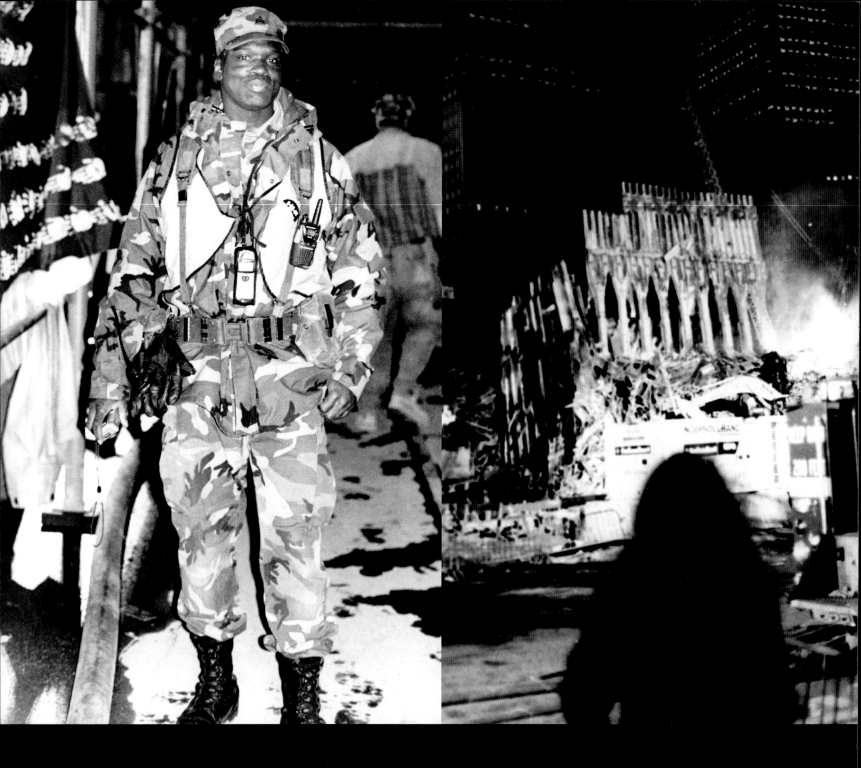

These photos were taken at Ground Zero, in October. My friend
Alex, the soldier, was stationed there since 9/11. All the rescue
workers, firemen, and police had such a good attitude . . . while
doing the hardest job on earth.

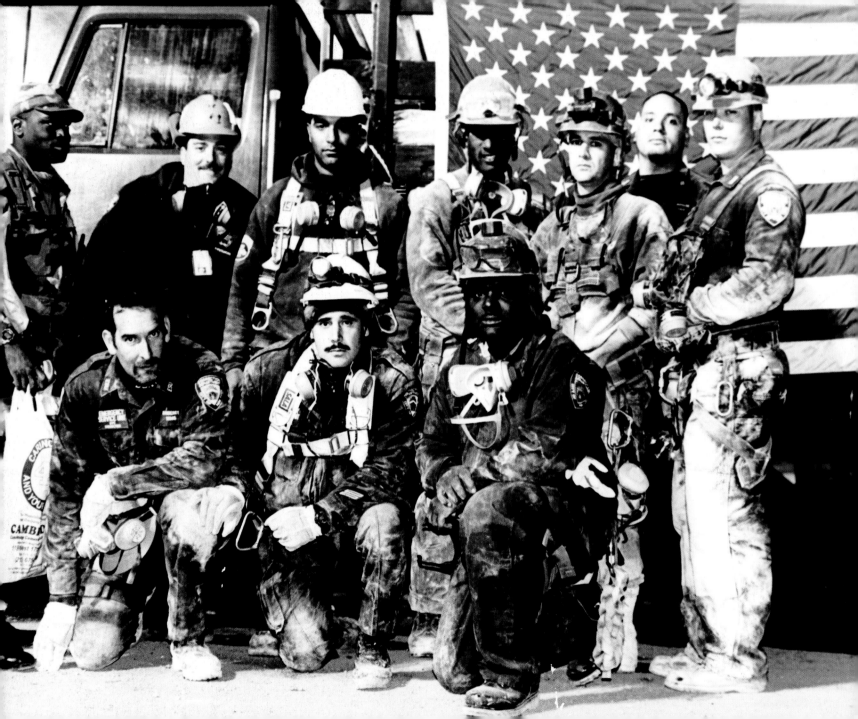

Without the creativity, generosity, and strength of our participants (above), the September 11 Photo Project would not exist. The project is also indebted to the following individuals and corporations whose contributions made this book and the project possible:

Nick Bravin, project associate director and general counsel, whose invaluable insight and tireless effort is reflected in the realization of both this book and the project; Walter Markham, project curator, who from day one repressed his artistic urge to curate; Jim Murray, project cofounder, for his inspiration; Dena Trakes, project media and tour director, whose energy knows no limits; Stephanie

Heimann, for expert editorial assistance for the book; Marcos Chavez and Aimee Sealfon of The Office of Design and Architecture (TODA), for their creativity and dedication in designing this book; Jim Salzano and his assistants, Mark Gilmore and Steve Singer, for photographing the gallery wall shots for the book; Sasha Bezzbov, for additional gallery photography; Ken Horowitz Photographic Services, for providing photographic print services for the book; Spectra Photography and Ofoto, for providing photographic print services to the project, Sidetrips Internet Hosting, for providing Internet services; Christopher John Electrical and L & D Home Remodeling, for renovations to the project's SoHo gallery space;

Index